大地擷萃

Hooker's Green *on* La La Land

洪東標

U0086072

目次

Contents ||

詩意寫實的行者

　　退休前的洪東標老師：已經是位令人敬仰的水彩名家。除了不斷地自我專業提升之外，也為推廣水彩藝術，著書、授業不遺餘力。退休後的東標老師：在理想與職志間益顯忙碌。然其水彩創作卻不被繁瑣的事務延宕而有所停滯；反倒是在創作之面向思考和質量內涵上，給足了自己一方心靈的豐饒。

　　洪老師對於自然美的詮釋，從來就不只是單純地再現一份視覺接收的影像。而是透過創作者本身之學養厚度，對客觀物件所提出的主觀理解。藉由此擇取的視點，分享出一幅幅經內化後，極具個人美學涵養和物像特質的作品。那是種心靈層面的掘土與沉澱，在每一次為景物所感動的瞬間 - 潺潺流洩而來。猶如身處於生機勃勃的大自然中，無窮止盡之生態錯雜蔓生。洪老師總能如料理達人般擇取最佳賞味期之形與色，在不影響主體原味的情況下，調加適切的配菜和佐料來完成一道又一道曼妙佳餚。

　　這份主體關照，自然源自於對滋養生命之土地的濃情與認同；因而觸動想載記的澎派創作欲念，就此邁開了圓夢的腳步，肩起滿裝熱情的行囊，步履其中（機車環島—台灣海岸寫生）並記錄著當下所融入的存在感動；以及抽離遙望（海上觀台—環台寫景）時提取那點滴若離之斯土情懷。這是飽含在地人文關照的禮讚自然，也讓人體解到洪老師心緒中的敏銳與細膩，在澄澈的水韻間鋪墊出土壤的溫度與生命的能量，深刻而宏觀。

　　在洪老師的作品中最為人稱道的莫過於其所散發之恬淡氣質了，不論是時空凝滯的古屋老巷、抑或是光影婆娑之幽林小徑，都有著一份信手拈來卻毫無違和感的自然氛圍。特別是在那一大片可觸摸、能擁抱的綠意裏，給人彷彿置身詩畫之中 - 草葉帶香、清風拂面而來的舒適感知。時而造境迷離、瞬時幽光冉冉，繼之曉綠空靈、村野桃源伊人家⋯。張張借景抒情、引人入勝，如置身詩境般地悠然神往而流連不已。讓人體會著有別於逼真寫實裏精準勾描外的怡然自適。也正是此積極正向卻仍從容豁達的人格特質，讓這一路虛心謙行而來的洪東標老師能不斷跳脫自有框限，耕耘出一畝又一畝水彩藝術的良田。

<div align="right">水彩畫家　林毓修</div>

A Poet with Poetic Realism

Before his retirement, Hung Tungpiao had already been a respected watercolor master. In addition to constantly sharpen up his professional skills and cultivate personal conservation, he also helped to promote watercolor art, write books, and spared no effort to teach students. After the retirement, he has been extremely busy juggling both his ideal and career. His watercolor creation, however, is not cumbersome with delays and stagnation but rather enriched by various thinking aspects and quality content.

Teacher Hung's interpretation of natural beauty is never merely reproducing a visual reception of images. By virtue of the creator's expertise and temperament, he expresses objects with subjective understanding. With this point of view, he shares a piece of internalization, great personal aesthetic conservation, and the characteristics of images. It is a kind of spiritual level of the soil and precipitation of watercolor land. Every time he is moved by depicting scenes at that moment – like gurgling flow of water. As if living in vibrant nature, his works surround infinite endless ecology of the complex. Teacher Hung can always choose the best "taste' with shape and color as what a cuisine master does. Without affecting the original flavor, he adds the appropriate side dishes and seasoning to complete a wonderful meal.

The subject of care is naturally derived from the passion and identity of the nourishing land. As a consequence, it stimulates his creative desire. Thus, he followed his dream with steady footsteps, shoulder full of enthusiastic luggage, to ride a motorcycle traveling around the island –(Sketching coasts of Taiwan) besides recording his being touched for the presence. Additionally, he viewed from the distance (Viewing Taiwan On the sea - Circling Taiwan depicting scenery) to extract feelings and care of the soil bit by bit. Such is full of praise for nature and local care. It also allows us to realize Teacher Hung's sensitive and delicate minds regarding creation. It's as if the clarity of water is paved with temperature of earth and energy in life, profound and macro-like.

In his works, the most acclaimed aspect is the tranquil temperament. Whether it is an old house or alley with stagnant time and space, or light shadow whirling upon the forest trails, there's a handy natural atmosphere. In particular, within that large, touchable, and embraceable greenness, it provides poetic impression for the audience - grass and leaves with fragrance, comfort of breeze blowing on the face⋯. Sometimes feeling blurred, and instantly you glance at glowing light, followed by morning ethereal and emerald ⋯villages in the wild and people in a wonderland⋯. Each of his works expresses a lyric style of scenery, fascinating and enchanting, as if the viewer is exposed to a poetic environment leisurely fascinated and lingering. The audience can feel that there's comfort in his works which is different from the realistic reality in the precise description. It is such positive and open-minded personality traits that lead modest Teacher Hung to continue to escape from his own frame limit, cultivating acres of fertile watercolor land.

<div align="right">Watercolor painter　Lin Yu Xiu</div>

水彩藝術創作的精、氣、神！

在新莊社大遇到洪東標老師後，開始水彩之路，約有 17 年了。很幸運這段時間，除了學習水彩技法構圖等基本功之外，可以近距離感受洪老師的藝術創作精神、毅力與堅持。就所見歸納如下：

1. 不以 30 年前，疊染光影與分割畫法時期，已登上藝術高峰為滿。放下分割形式，不斷開闢新題材，嚐試各種創新的可能。
2. 從擁抱自然到銀色月光下「夜景系列作品」：以精準技法，深厚涵養和高度創作熱情，表達對生長土地的深情。
3. 從細膩雄渾的「機車環島」海岸百景，到精彩壯闊的「油輪環島」海上畫台灣：上山下海，竭盡所能，以水彩藝術呈現台灣風景的魅力。
4. 不辭老遠台北新竹奔波，從事水彩藝術推廣教育。學生從十幾歲到 80 幾歲都有，在因材施教、有教無類之下，受益學生不計其數。
5. 致力臺灣水彩藝術國際化：辦理「2015 彩匯國際」世界水彩名家大展與「2016 世界水彩大賽」暨名家經典展：將台灣水彩藝術推向國際舞台，提升創作高度廣度與深度。同時也辦理研討會，由國內外大師分享創作心得，因此大家得以觀摩世界各國藝術創作的豐富多元。這是水彩界的創舉！期盼大家都能：以寬闊無私的胸襟，一起讓台灣水彩藝術放眼世界！

近年來，水彩藝術蓬勃發展起來了！創作者更需要：一、不斷精進技法心法。二、善待別人，願為團體付出的恢弘氣度。三、以愛為出發點，發揮駱駝的精神，不畏艱難表現作品的生命力。在此，向多年來無私奉獻的洪老師致敬！

水彩畫家　鄭萬福

Watercolor creation--- spiritual, vigorous, and divine!

Encountering Teacher Hung Tungpiao in a community college in Shinjuang, I started the watercolor road. About 17 years passed. Fortunately, in addition to learning watercolor techniques, such as compositions and other basic skills, I could closely observe the teacher's artistic creation, perseverance and persistence. I conclude as the following:

1. Thirty years ago, Teacher Hung had already been renowned with his stacked light and shadow plus split period. Nevertheless, he has not been content with standing on the art peak. He laid down the form of division, and constantly seek for new themes, trying the possibilities of innovation.
2. From embracing nature to the silver moonlight "night series works", he paints with precise techniques, deep conservation and a high degree of enthusiasm, to express his affections towards the land in which he grows.
3. From the delicate and powerful coastal scenery of "Traveling Taiwan by a motorcycle" to the magnificent "Tanker Circling" sea painting in Taiwan, he visited a huge number of mountains and the sea. Exerting himself, he has accomplished everything we can imagine to reveal the charm of Taiwan scenery.
4. Rushing to and fro from Taipei to Hsinchu he was engaged in watercolor promotion and education. His students range from teenagers to 80-year-old elders. Teaching students in accordance with their individual aptitude, and instructing them with no distinction, he thus benefits countless students.
5. He has contributed to the internationalization of Taiwan Watercolor Art: "2015 Colorful International" World Watercolor Exhibition and "2016 World Watercolor Competition" and elite classic exhibition. He presented Taiwan watercolor to the international arena, and enhanced the creation with a high degree of breadth and depth. In addition, he helped with seminars in which domestic and foreign masters shared creative experiences. Therefore, we can observe the world's rich and diverse artistic creation. This is the watercolor creation pioneering! We all look forward to everyone's broad selfless mind to facilitate Taiwan watercolor's being heeded by the world!

In recent years, watercolor art has flourished! Creators need to: 1. Constantly sharpen up sophisticated techniques and cultivation. 2. Treat others well, and be willing to sacrifice for the group welfare. 3. View love as a starting point. Imitate the spirit of camels, and be not afraid of difficulties encountered in creation to express vitality. Regarding these, I would like to pay special tribute to the selfless dedication of Teacher Hung!

Watercolor painter　Zheng Wanfu

自序

　　如果不計算單純的畫冊和工具書，這應該是我的第三本書，這一本書談的是自己的創作和理念和紀錄創作心路歷程；十八年前我開始進入社會教育體系中教水彩，多數的學生來自於職場退休人士，年紀大多與我相仿，在職場忙碌過後歸於平靜，開始尋回自己年輕時候的夢想，於是藝術創作成了他們追逐的方向，水彩的魅力和輕巧方便自然成了首選；我經常說：「畫水彩的人會長壽」，這句話有許多實證，因為水彩單純無毒，繪畫又能陶冶性情，同時舒壓，當情緒平穩安定後心理就健康了，身體也就跟著健康了。

　　長久以來，水彩沒有受到繪畫市場應有的重視，我個人認為是缺乏論述的基礎，所以期望這本書能拋磚引玉；2015 年我以問答的方式為內容，主編一本介紹台灣 16 位畫家創作理念的書【水彩解密─名家創作的赤裸告白】，出版後造成暢銷，2016 年再度主編第二本【水彩解密 2】依然受到很熱烈的歡迎，我思考這樣以問答對話的型式的書，淺顯易懂，讓喜歡水彩的民眾能深入的理解水彩創作的許多理念，所以我請學生匯整出七十幾個問題，有些是個人的疑問，有些是上課同學的提問，我逐一在書中回答，內容在經過分類後成為七個章節，從理念說起，認識水彩也認識這個水彩畫家，原本藝術就是個人主觀意念的呈現，多元的解讀和經驗呈現正是藝術廣大包容性最可貴的地方，我的解說在於倡導個人的心得和理念，沒有打壓別人，或是要爭誰說的有理說的對，因為這些都沒意義，重要的是讓大家都能看得下去，讀者可以自己篩選自己的認同。

　　這本書的誕生要特別感謝儀宇小姐的全力協助願擔任翻譯校定的工作，讓我出版一本中英對照書的願望得以實現，這個意義是要讓台灣的水彩走出去，語言當然是第一道門，打開這道門，外人看見了，有興趣就走進來，這不需要高超的理論，就是要務實的做，機會就會來。也感謝內人秋燕小姐的中文校稿，小女伊柔的打字和順稿，偉柔小姐、品芳小姐的美術設計，更感謝好朋友水彩名家明錩、毓修、萬福的序文為這本書增添光彩。

　　僅將這本書獻給十八年來與我亦師亦友的水彩班同學們，水彩讓我們成為好朋友。

Preface by Hung Tung-Piao

If several watercolor albums or reference books are not counted, this is the third book of mine. In general, it includes my theories and concepts relating watercolor and a record of my creation path. 18 years ago, I started to step into adult education, mostly teaching at community colleges or watercolor societies and groups. The majority of my students retired from their workplace and are about my age. In the tranquility of their retirement, they start to pursue art to fulfill dreams in youth. With unique charm and convenience, watercolor has become a first alternative. Oftentimes I said:" Those who paint watercolor will enjoy their longevity." It is self-evident that watercolor is simple and harmless with its materials. In addition, paintings cultivate temperament and relieve pressure. When the mood is stable then we become psychologically healthy. The physical health would also follow.

For a long time, watercolor has not been valued as it should be in the painting market. I personally assume it's due to the lack of theory and discussion basis. Consequently, I hope this book can initiate some. In 2015, I edited a book of creative ideas from 16 Taiwanese watercolorists utilizing a Q and A form. The book--- "Watercolorists' Creative Ideas - Undisguised Expositions" published and became best-selling. In 2016, I re-edited " Undisguised Expositions II" and it was still warmly welcome. I therefore ponder that this form of question and answer is easy to understand. It allows watercolor lovers to easily access plenty of ideas relating watercolor creation. Subsequently, I asked my students to collect approximately 70 questions. Some are personal questions; some are raised in my classes. In this book, I answered one by one. The content is classified into seven chapters, starting from theories and concepts. Through the chapters, you not only understand watercolor elements but also become acquainted with the watercolorist. In effect, art is the subjective concept of personal presentation; multiple interpretation and experience performances make art inclusive and valuable. My commentary rendition is to advocate personal feedback and ideas. There's no intention to suppress others, or to argue who is righteous or correct. It's because these are meaningless. The most vital is to lead everyone to read it, and the readers can filter their own thoughts or agreement.

For this book, I would be particularly grateful to Yi Yu's full assistance to the work of translation and revision, so that my wish to publish a book with English translation can be achieved. My intention is to allow Taiwan's watercolor to be heeded in the world. The language is certainly the first door. Outsiders will come in if intrigued. Such does not require a superb theory, but pragmatics. Opportunities would naturally follow. I also give special thanks to my wife Qiuyan's proofreading of Chinese manuscripts, my daughter Yi Zou's typing and revision, Miss Wei Zou's, Pin Fang's art design. Above all, I express my special thanks to good friends--- watercolorists Ming Chan, Yu Xiu, Wanfu. Their prefaces bring forth extra glamour and luster to this book.

I sincerely dedicate this book to friends and students in my watercolor classes in the eighteen years. Fortunately, watercolor makes us good friends.

Hung Tung Piao

由清朗淡泊迷離化境
─ 我看洪東標的人與畫

From Clarity, Unworldliness to Mysterious Fantasy

On the Personage and Paintings of Watercolorist Hung Tungpiao

水彩畫家 謝明錩　Watercolor painter Hsieh Mingchang, 於 2012

† 水彩文藝復興的舵手 Helmsman of Watercolor Renaissance

東標是我的戰友，三十年前正當台灣水彩的第一個黃金時代，我們各自作戰，以不同的創作理念與技巧勇闖藝壇，三十年後在台灣水彩逐漸式微之時，在當今風雲再起，勢不可擋的第二個黃金時代的顛峯，我們併肩作戰，參與轉變的發生，一同具證這個偉大時代。

Tungpiao is my comrade. Thirty years ago, when there's the first golden age of Taiwan's watercolor, we fought respectively with different creative ideas and skills. Thirty years later, after the gradual decline in watercolor, the prosperous situation arises again. It's as if the peak of an unstoppable second golden age appears. We fight side by side, involved in the occurrence of change, and witness this great era together.

當年水彩由盛而衰，是時代的影響是世界藝壇普遍「重觀代輕技巧」的思潮所致，當然也與台灣畫廊「只看重經濟利益」的短視有關。但，這一波水彩畫的文藝興卻是人為的，其中的關鍵人物即是洪東標。

In those years, when watercolor's prosperity declined, it was due to the influence of the times. The art world was generally "valuing concepts rather than techniques", and it was also related to the short-sightedness of those Taiwanese galleries' " economic interests first ". Fortunately, nowadays a wave of watercolor Renaissance prevails with manpower; one of the key figures is Hung Tungpiao.

六年前，洪東標、楊恩生邀請劉文煒老師和我一同創立了「中華亞太水彩藝術協會」，洪東標擔任了第一、二屆的理事長。

Six years ago, Hung Tungpiao, Yang Ensheng, invited Teacher Liu Wenwei and me to found the "China Asia-Pacific Watercolor Association". Hung Tungpiao served as the first and second director.

在短短的六年之內，洪東標以驚人的毅力，無私我的熱情，與無人能比的效率，策劃了無數次的大型畫展研討會、寫生，更出版了數十本的刊物，這其中有多次畫展還官方合作，具國際性，還觸及到台灣水彩史的建構與論述。

In a short span of six years, Hung Tungpiao marked with amazing perseverance, selflessness, enthusiasm, and incomparable efficiency. He also planned numerous large-scale exhibition seminars, sketches, and dozens of publications. There were even many exhibitions with official cooperation to make them internationally heeded. Thcy also touched on the construction and discussion of Taiwan watercolor history.

洪東標以個人含蓄、公正與溫馨的領導方式，凝聚了整個畫會，所有會員除了進行學術性的交流外，也變得感情深厚如同一家人。這種畫會運作的新模式，立刻成了其他畫的楷模。

Hung Tungpiao with his personal subtle, fair and warm leadership, embodied the entire painting association. In addition to academic exchanges, all members also developed deep feelings like family. How the association operated immediately became a model of other painting societies.

身為畫會的常務委員，對於洪東標的諸多決策，我永遠舉雙手贊成，他像一個火車頭，冒著的烟永不休止的往前衝，但令人驚奇的是，在大量的會務壓力下，他還能抽空創作，並且畫出數量驚人的傑作。放眼望去，他真是畫壇少見的，在藝術造詣、行政能力與人品涵養上的「三優」人物。

As one member of the Committee, for Hung's many decisions, I always showed total agreement. He was like a locomotive, steaming the smoke of never stopping, and bravely moved forward. But to my amazement, under so much pressure of a large number of business in the association, he could still squeeze time to create, and

painted astonishing masterpieces. Looking around, I find that he is really rare with his artistic attainments, administrative capacity and character conservation--- the "three excellent" figure.

† 疊染光影的魔術師 The magician of light and shadow

東標受過正統的美術訓練,他畢業於師大美術系與研究所。在七０年代台灣水彩的第一個黃金期中他以分割、造型手法,結合自然光影建立了個人的藝術風格。這種類似立體派的表現,讓我們見識到東標呼應美術史,卻又不屈從美術史的現代精神。

He was trained with orthodox art, and he graduated from the Department of Fine Arts and the Institute of Fine Arts at NTNU. In the first golden period of Taiwan's watercolor in 1970s, he established a personal artistic style in a split, stylistic way, combined with natural light and shadow. This kind of three-dimensional performance led us to witness his echoing art history, but also modernity to be not submissive to art history.

嚴格來說,東標處理分割是溫和的,他以美為出發點,尊重自然意趣,而且十足保留了水彩畫的透明特性,這和美術史上以「人為」手段拆解重組自然甚至與自然對抗是完全不同的,尤其以水彩做分割,更是難度十足,因為水彩不像油畫容易隨機改正,不小心即落得「髒」字了結,但東標的水彩精準控制了渲染、縫合與重疊,技法和分割塊面間的互透比例,處理的乾淨俐落而一氣呵成。由於有了穿梭畫面的透明分割,東標的畫不論是形狀、色彩、光源或者空間都顯得極具可變性,它們在冷、熱、方、圓、虛、實間擺盪、無一處凝重,無一處不充滿玄妙與趣味。

Strictly speaking, his processing divisions is moderate. The starting point is pure beauty; he shows respect for natural charm, and fully retains characteristics of transparent watercolor. This is completely different from rendering "artificial" means to dismantle and reorganize nature or even utilizing confrontation to be against nature. To do the division is especially difficult in watercolor because it is not easy to freely correct errors as in oil painting. Accidentally, the work would be

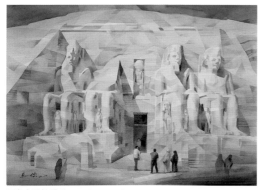

阿布辛貝的陽光 Abu Simbel's Sunshine 55x75cm 1994

finished "dirty". But Tungpiao precisely controls the rendering, suture, overlap techniques, and the reciprocal proportion of split forms are handled clean and neat. Because of the transparent splitting of shuttle screens, his paintings appear to be very variable in terms of shape, color, light, or space. The elements are whirling around in the cold, hot, square, round, real and virtual. Without a heavy sense, his works are filled with profoundness, mystery and fun.

靠著這種兼具理性與感性的「疊染光影」風格，東標在年輕時代闖出了名號。

Relying on such a rational and emotional "stacked light and shadow" style, he had marked in the water era in youth.

† 大自然深情的詮釋 Affectionate interpretation of nature

以疊染光影的風格而言，東標算是早早有了「改造自然」的能力與經驗，但，在骨子裡，東標其實是自然的傾慕者，這一點從他喜愛山林，熱愛旅行的嗜好裡可見出端倪，再者，他有著處女座不喜熱鬧的根本性格，大自然適合靜觀的內斂特質自然對他有著無窮的吸引力。

In terms of the light and shadow style, he had been considered early to own the ability and experience of "transforming nature". However, he is born to be a nature lover. There are clues as he has strong passions for mountains, forests and travel. Moreover, he is a Virgo, basically not fond of the hustle and bustle or worldly noises. The restrained and self-reflecting traits of nature is therefore philosophically enchanting to him.

2003 年，在經歷了半輩子忙碌的教職生涯後，東標有了一次參加屏東半島季活動的機會，在這難得可以自由自在遊逛山林作畫的期間，他愛上了寫生。

In 2003, after experiencing the busy instruction life, Tungpiao had a chance to participate in the Pingtung Peninsula Season activities. In this rare free time, he traveled to the mountains during the painting period, and fell in love with sketching.

2007 年，他登上玉山，目睹大自然的蒼蒼壯潤，心中興起了捨我其誰，以筆墨揮灑雄渾大塊的壯志。從此，他在大自然的浩瀚中涵泳，放棄了分割手法，衷心做一位造物主的虔誠子民。

In 2007, he reached the summit of Yushan (Mt. Jade), and witnessed the magnanimous nature. In his heart, a magnanimous piece of ambition also aroused---to magnificently depict Mother Nature with his pen and paint. Since then, he has been swimming in the vastness of nature. He then gave up the division forms, sincerely serving the Creator and worshiping nature.

† 境界的提升，東西方心境的遇合

The improvement of the realm, the mood of East and West encounters

大自然的提升是不可以抄襲的，但可以超越——相信東標和我一樣都體悟到這個道理，因為大自然雖美，但轉換成繪畫構圖時，它的謬誤卻比比皆是。「寧靜的夜」系列，是東標加入了自己的感受，揉合了氣韻，提升了境界之後所重新蘊釀出來的自然之美，它絕不同於自然本身，但觀者站在畫前無從抵抗，也無力分辨。

"The ascension of nature is not to be plagiarized, but it can be transcended." I believe we both recognize the above-mentioned truth. Nature is beautiful, but when it is converted into a painting, its fallacy is everywhere. In "Quiet night" series, he adds his own feelings, blends the spirit, and enhances the realm with re-brewing to describe natural beauty. It is different from nature itself, but viewers standing before his paintings can't resist and fail to distinguish.

換句話說，東標已成功掌握了「似與不似」間微妙的精髓，從分析自然、表現自然的傳統觀照，跨越到了「再造自然」，東西方心境遇合的境界。

In other words, he has successfully mastered the subtle essence of "seemingly and not alike". From the analysis of nature, and the traditional view of natural expression, he

strides across to the "re-creation of nature"; the states of mind with East and West encounter.

「寧靜的夜」可以說是東標自然繪畫系列的顛峯，其中尤以馬祖夜景中表現的那種孤獨蒼涼之美最令人心醉。從「銀色月光照東引」開始，東標掙脫了純寫生概念的桎梏，體會到「心象風景」的魅力。這幅畫的氣氛完全是人為的，但就像做了一場自然夢，人們在夢中永遠分不清是自然還是夢。

"Quiet night" series can be praised to be the peak of his landscapes, especially in the performance of Matsu Night Scenery. The lonely desolate beauty is the most enchanting and intoxicating. From "Silver moonlight in Dongyin", he broke away from the shackles of the concept of pure sketching, and realized the charm of "heart scenery". The atmosphere of this painting is entirely artificial, but the viewer is likely to dream about nature; people in the dream can never tell it is nature or a dream.

成功掌握了「銀色月光照東引」的幻境表現後，東標隨即雄心萬丈的畫出一幅曠世傑作「航向光明」。這是一幅雙全開大畫，東標以三張拍自馬祖的風景照片做參考組合成這幅畫，值得一提的是，這三幅照片全都是白天景致，東標憑著想像，把白天變成了黑夜，所有嶙峋山石通過「時光機器」的刷洗，頓失細節，徒留一片迷離。

Soon after he successfully mastered the illusion performance of "Silver moonlight in Dongyin ", he ambitiously painted a masterpiece "Heading light." In this double 2K big picture, he combined three pictures taken from Matsu. What is worth special

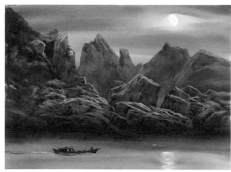

銀色月光照東引 Silver moonlight in Dongyin
55x75cm 2008

航向光明 Heading light 100x150cm 2008

mentioning is that these three photos are all with daytime scenery. By virtue of his imagination, he turned days into nights. All rugged rocks were scrubbed through the "time machine". Suddenly, details were lost, leaving only a blurred sight.

這是一幅氣勢萬千，不可多得的好畫，東標自從捨棄讓自己揚名立萬的分割手法後，此番真正得以再嚐一回呼風喚雨的滋味！

This is a rare, valuable painting, full of momentum. Since the renunciation of his split forms in which Tungpiao made himself renowned and remarkable, this time he really would call the wind and summon the rain again!

† 飛刷洗水─迷離幻境的創造者 Flying brush - the creator of blurred fantasy

成功塑造「航向光明」的夜色氣氛後，東標對於掌握「黑夜不黑，暗夜不暗」的手法有了更大的信心，只要給他一個構圖，一個真實存在的人間景象，他立刻可以倒白為黑，為清朗白晝統織就一片朦朧夜幕。

After the success of shaping "light of the night" atmosphere, he built more confidence in mastering "dark night is not dark". Just randomly offer him a composition, a real human scene, and he can immediately exchange white for black, converting the clear daylight into a hazy night.

「福正村的夜晚」是繼「航向光明」後的另一傑作，東標的時鐘指針精準指向午後七時的位置，他煨熄日火，輕拂水中餘溫，然後捻亮旅人手中提燈，織就一幕藍中有黃，冷中帶暖夜色方臨，日影猶存的景象。

"Fuzheng village night" is another masterpiece following "Heading light". Tungpiao's clock pointer accurately points at seven; the traveler simmered extinguishing fire, whisked water temperature, and then twisted on the lamp in his hand. Weaving on the scene with yellow in the blue, cold with warm, night approaching, he still presents a shadow in daylight.

「龍磬夜釣客」是另一幅描寫馬祖夜景的作品，,整幅畫近乎是被塞滿的，而且比起前幾幅作品，調子較灰，明暗對比較小，照理說它的戲劇張力較弱，但出乎意

龍磐夜釣客 Longpan Night Fishing 55x75cm 2011

料的，這幅雖然沒有瞬間爆發的「暗夜激情」卻能以它極致的迷離氣氛，一點一滴的「蠱惑」人心，終使人深深跌入無法自拔。

"Longpan Night Fishing" is another piece to portray Matsu night scenes. The entire painting is almost filled, and compared to previous few works, the tone is grayer, light and shade relatively small. The drama tension is supposed to be weak. But unexpectedly, although without the instant breakout of "night passion", it is able to exercise its extreme blurred atmosphere. Thus, it tends to "enchant" people bit by bit, and they finally fall into the depth and can't extricate themselves.

細細的感受這幅畫，有某種「波流」籠罩而來，包括夜色，包括涼意，包括水氣，它明顯的在畫上漂流，不只是感覺，不僅是想像，它是一種真實存在。當我們以「觸覺之眼」輕撫作品，匍匐式的「梭巡」畫面，我們即刻可以發現，那些皮紋就在那兒，由右至左或者由左至右。就是這一條條顯然被水洗去的痕跡，強化了流動的感覺，強化「籠罩」而來的諸般幻覺。

Deliberately appreciating this painting, we'll find there is some kind of "wave" enveloped, including the night, coolness, and vapor; it is clearly drifting in the painting. Not sheer feeling, not only imagination, it is real existence. When we touch the work with the "Eye of Touch", the creeping "shuttle patrol", we can immediately find that the stripes are there, from right to left or from left to right. It is the traces that are clearly washed away, strengthening the feeling of flow, and strengthening the illusion of "complete coverage".

這是東標發明的「飛刷洗水」技巧，從 2010 年開始，這樣的處理手法隨處可見，不論是描寫日景的＜溪谷晨光＞，描寫夜景的＜夜之青龍瀑布＞，描寫雨景的＜雨夜急行＞或者描寫霧景的＜寂靜的棧道＞都用上了這樣的技法。

This is what Tungpiao invented--- the "flying brush over water" skill. Starting from

夜之青龍瀑布 Night of the Dragon Fall　75x110cm　2010

寂靜的棧道 Silence of the path along the cliff
55x75cm　2010

2010, this unique technique can be seen nearly everywhere. Whether it describes the day of "Valley dawn, " or "Night of the Dragon Falls," or a rainy scene--- "Rainy night" or "Silence of the path along the cliff", such a technique is utilized.

彷彿「姜太公釣魚，離水三尺」，東標以一把溼水的毛刷，蜻蜓點水式的僅讓毛尖輕觸畫面，然後飛掃而過。在嚴密控制的疏密強弱下，原已處理完善的圖畫表面，就會浮現一條條水線，而且若有似無，隱約可見。靠著這些線，東標成了迷離幻境的最佳代言人，主導了日落以後半個世界。

As if it is "Great-grandfather Jiang fishing three feet above the water ", he paints with a wet brush, only superficially touching the tip of the picture, and then quickly sweeps through. With the tightly controlled density, the original picture whose surface has been perfectly dealt with will emerge a line, as if none, vaguely visible. Relying on these lines, Tungpiao has best voiced the fantasy, leading the world after sunset.

† 虛境、實境、幻境與化境 The illusion, reality, fantasy, and perfection

凡走過必留下痕跡，人的一生即便跌跌撞撞，事後回顧也能看出因果，理出些脈絡。東標是個性情中人，一生為愛而畫，心隨境轉，原本無意披荊棘為自己衝開一條飛黃騰達之路，但他只做不說，內斂謙和的個性，加上不畏煩瑣，不怕困難的精神使他成就了許多別人無法成就的事。

Those who walk through the field will leave traces behind; even with a stumbling life, we can figure out the cause and effect when reviewing back, reasoning out clues from

the context. Tungpiao is a man of temperament, painting for love all through his life. He originally had no intention to soar aloft and blaze a way through obstacles. Nonetheless, he is a man of few words and indeed puts ideas and ideals into practice. With introverted humble personality, coupled with spirit of no fear of cumbersome stuff, or difficulties, he accomplished a huge number of tasks that others fail to achieve.

沈寂十多年的水彩畫壇，因著他努力經營的中華亞太水彩藝術協會，起死回生，成了當今最熱門的場域，而他一生的藝術進程，由虛境（分割系列）導入實境（寫生系列），再由實境轉成幻境（夜景系列），最後再由幻境進入化境（飛刷洗水技法的加入），可以說也是意外的明晰而理智。當局者迷，想必東標一頭栽入無法自我分析這些進程，但比諸這些風格演變，他作品予人的感覺也在逐步轉換，大體而言由薄而厚，由亮到暗，由表層漸入內裡，由雀躍轉入沈鬱，由簡潔明晰變成撲朔迷離，深不可測。

In the last decade, watercolor world was silent and diminished; since Tungpiao worked hard to operate the Asia-Pacific Watercolor Association, it has been drawn back to the spotlight and has become the most popular field. Looking back to his art process, we'll find that it starts from the virtual environment (split series) into the real series, and then transforming reality into a fantasy (night series), and finally involving illusion into the perfection (the technique of flying brush over water joined). The process tends to be accidentally clear and rational. Tungpiao, an insider in the maze, must not be able to self-analyze it. Similar to the evolution of these styles, the feelings after viewing his works are gradually converted. In general, his works are from thin to thick, from bright to dark, from the surface into the inside, from the jump into the reserved, from simplicity and clarity into a profound, unfathomable mystery and fantasy.

— 謹以此文，獻給東標老友，文中感性蓋過理性，激情所至，不知所止，尚祈見諒！
I would like to dedicate this article to Tungpiao, my old friend. In the text, my sensibility is over sense, out of sheer passion. Not knowing where to stop, I pray for pardon!

A

關於藝術理念

Qs and As relating theories
and concepts of art

「... 從廣義上講，無論是人物、風景或是靜物，要想畫好都必須百分之百來自自己生活的體驗，使用自己所處的當代生活中，以具有感情和美醜的審美傾向，發現美並能激發自己的創作熱情，...」

「...In a broad sense, whether painting characters, scenery or still life, artists must obtain inspirations from their own life experiences. Within the contemporary life, make use of your feelings and aesthetic tendencies to screen beauty and ugliness, and to stimulate your own creative enthusiasm.」

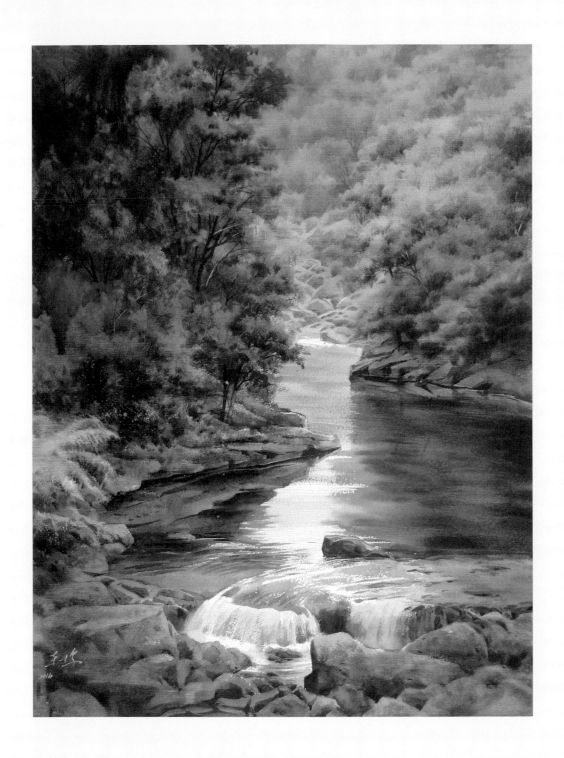

洪東標｜幽溪清泉　76x56cm　2014

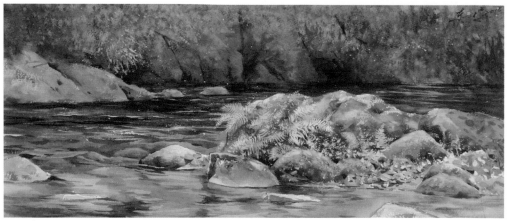

洪東標│河灣的綠意　24x55cm　2015

A1. 你認為構成「藝術」的要件是甚麼？

我個人認為藝術一定要有極為嚴格的高標準，尤其在 20 世紀藝術被顛覆之後，我們要堅持幾個原則。什麼原則？就是說藝術一定有相當嚴格的標準來界定，不是隨便任何人找張圖亂塗亂灑，他就可以稱為藝術品。所以我想它有先決條件如下：藝術是要具備有創造能力的人，在產生意念後透過媒材和表現技巧展現出來的作品。他傳達了思想和情感，能激發觀賞者的共鳴，在接受高標準的規範檢視和界定後，方有價值。同時具備人類文明發展過程中的時代特點。

我覺得藝術發展和人類文明的發展是同步的，藝術表現的就是這個世代人類所共同認定的一種概念，藝術家用藝術的方式把它呈現出來，為這個時代的文明做註解，它的價值才會存在。

A1. What do you opine as the quint-essential elements of art?

I personally contend that there must be very strict high standards concerning art, especially in the twentieth century when art has become subversive; we have to adhere to several principles. What principles? The first and foremost is that art needs to be defined with extremely rigorous standards. The paper or canvases that any person chaotically draws or sprinkles on cannot be called works of art. Accordingly, I believe art has the prerequisites as follows: it includes the innovative

ability of a creator who conceives the idea of certain media and thus demonstrates a work through the media and his/her performance skills. He/she conveys ideas and emotions that inspire the viewer's empathy or resonance, which is indeed valuable after accepting high standards of normative scrutiny and definition. Simultaneously, art develops with the development of human civilization in the process of the characteristics of the times.

I'm also convinced that the development of art and human civilization are synchronized. The artistic expression is the common understanding and concept of a particular generation. Artists present it artistically, annotating that era of civilization. Hence, its value thus exists.

A2. 你對現代藝術有何看法？

現代藝術存在著值得思考的問題。在古代西方文明中，圖像藝術是以輔助文字的不足，宣達信仰與美德情操，藝術讓人平靜的，不管你是博士，還是只有小學畢業，在看畫的過程中都可以去感受畫所傳達的意境、畫家所傳達的訊息，和感動人的那些因素跟條件。可是現代藝術過於主觀的強調個人感覺，往往在圖像上讓觀賞者不知其所以然，可能還需要藉由長篇大論的文字說明，看了以後才慢慢理解原來這個畫家在表現什麼，有時候還是不能認同。

現代藝術鼓勵了許多沒有經過嚴格繪畫訓練的人，可以自由發揮自由創作，就像說，卡拉 OK 大家都在唱。每個人都可以唱，想唱時就可以唱，結果唱的鄰居受不了。為什麼鄰居會受不了？因為你沒有達到藝術界定的美感標準。歌手唱的很好聽，我們就會去買他的 CD，因為我們肯定他超越應該要有的美感標準，藝術一定要有個標準。這個標準在哪裡？傳統藝術有，可是在現代藝術的抽象繪畫裡面，我們很難去尋找那個標準在哪裡。現代好像比較會說會寫文章，比會畫畫還重要，即使我是學藝術的人，都無法告訴各位答案。

喬治．艾理斯．博寇 G.Ellis Burcaw 教授在《博物館這一行》一書中將工業革命後的藝術區分為三個類型：純藝術、大眾藝術和民俗藝術；純藝術的真諦就在於創造，

不斷的超越、探索、開拓領域，但它是冒險的尋求一個機率，尋求能在未來能成為主流價值的藝術，卻也往往讓許多畫家死的很慘，書中他以實例來說明在 1870 年到 1900 年間，約有四萬名專業畫家在巴黎，在短短的幾年間大約生產了二十五萬件作品，事實上只有二十個畫家受到青睞，道格拉斯‧大衛說：「絕大多數的當前創作的藝術品幾乎可以確定將會是垃圾」，即使美術館收藏了也可能束之高閣，進入冷凍庫或淘汰。

A2. What are your opinions concerning modern art?

There is a huge thought-provoking problem in modern art. In the ancient Western civilization, the purpose of image art was to assist the lack of words, and it served as the propaganda of faith and virtue. Art generally makes people feel serene. Whether you are a doctor, or graduate from a primary school, in the process of viewing paintings, all can appreciate the mood and message conveyed by the painter along with factors and conditions that touch. But modern art is too subjective, overemphasizing personal feelings. Oftentimes viewers do not understand the image itself, and may need to use a long text to illustrate. After reading the text, they later slowly realize the intention of the original painter and his/her performance. Sometimes the audience still cannot agree with the creator or their works.

Modern art encourages many people who have not been trained in rigorous painting and are free to play freely, just as the case with karaoke in which almost everyone sings. Everyone can sing whenever he/she likes, leading to the result of their neighbors' intolerance. Why their neighbors cannot endure? It's because some do not meet the aesthetic standards of artistic definition. If a singer sings very well, people may pay to buy his/her CDs, because they are certain that he/she would go beyond the aesthetic standards. Similarly, art must have a standard. Where hides this standard? It lies in traditional art, but in the abstract works of modern art, it is very difficult for us to find where the standard is. It seems that certain modern artists provide better speeches and articles than their works of art. Even though I'm an art learner, I cannot explain such a phenomenon or offer an answer.

Prof. E. Elis Burcaw, in the book "Introduction to Museum Work," divides art after the Industrial Revolution into three categories: pure art, popular art and folk art. The essence of pure art lies in the creation, and the spirit of continuing to transcend, explore, or develop the field. But it is adventurous to seek a chance to become the mainstream of art in the future. Such a risk also often causes quite a painter to live or to die miserably. In Prof. E. Elis Burcaw's book, he illustrates that between 1870 and 1900, there were around 40,000 professional painters in Paris, and approximately 250,000 pieces wcrc produced in just a few years. In fact, only twenty painters were greeted with enthusiasm. Douglas David once said: "Most of the current works of art can be identified almost as garbage, even works in the museum can also be shelved, totally ignored or eliminated."

A3. 你對現在許多畫家在室內應用照片來創作的做法，有何看法？

19 世紀曾經有人說過，照像機的發明等於宣告「繪畫已死」，因為當時繪畫可以做的，照相機做的更快更精準。事實上到 21 世紀的今天，繪畫沒有被攝影取代，繪畫跟攝影成為相輔相成的夥伴關係，所以我們很多人都利用照相機來輔助創作，包括我也是，我們都不要否認這個現實。但是參考照片來創作雖然方便，但是卻無法避免很容易受到照片的影響，而淪為畫照片而像照片的結果。

近代有畫家應用幻燈機或投影機直接將攝影影像打在底稿上，描稿作畫，我們都必須接受，因為我認為藝術家必須適應整個大環境的改變，和科技的進步來輔助創作，但是在創作和傳達的過程中不能出差錯，否則，就很難讓民眾理解和接受。

A3. What do you think about the practice of many artists' utilizing pictures to create works in studios today?

In the 19th century, it was said that the invention of cameras was tantamount to declaring that "painting was dead". Because what the painting could do at that time, the camera would do faster and more accurately. In fact, in the 21st century, painting has not been replaced by photography. Painting and photography have developed

complementary partnership, so many of us use cameras to help the creation, including me. We do not deny such reality. But using reference photos to create, although convenient, cannot avoid being easily affected by the photo, and therefore photo-like works are the mere results.

Recently, some modern artists have utilized the slide projector or projector to draw photographic images on the draft. I would say that we have to accept the phenomenon. It is because I think artists must adapt to the so-called environmental changes, and technological progress to assist their creation. Nonetheless, it cannot go wrong in the creation and the process of communication. Otherwise, it is difficult for people to understand and accept the fact.

A4. 你對使用投影機來打稿創作的做法，有何看法？

早在十七世紀就有荷蘭畫家利用攝影的原理，將大型暗箱放在街上構圖畫出街景，現在畫家利用科技的進步來輔助創作，投影構圖方便又快速，成了許多畫家的創作技術；但是我認為畫家過度依賴影像投影來描搞，會讓畫家漸漸喪失造型修正的能力，因為透過相機鏡頭取得的影像在畫面結構上接近真實，但是廣角鏡頭會扭曲影象，而且真實影像在比例上也不盡完美。

畫家都需要在手繪構圖時進行調整修飾，以自己的美學涵養修正畫面構圖以更趨於完美；使用投影描搞會因為方便省時容易造成畫家過度的依賴，而不自覺的失去自己修正機會和表現對造型調整的能力。

A4. What do you think of using the projector for drafting?

As early as the seventeenth century, Dutch painters used the principle of photography, and a large black box for the composition of streets. Nowadays, some painters choose to use the progress of science and technology to assist their creation. Projection composition is convenient and fast, and has become one creation technique of a great number of painters. But I think those painters' over-reliance on the image projection to depict, will

gradually make them lose their ability to modify the shape. Images obtained through camera lens in the picture are close to the real ones, but the wide-angle lens will distort the image, and the real image in proportion is not perfect.

Painters need to adjust in the hand-painted composition. The adjustment is made according to their own aesthetics, and they can amend the composition to make it close to perfection. While drawing on the projection description is easy to save time and offers convenience, it tends to cause artists' over-reliance. As a consequence, they may unconsciously lose opportunities of self-correcting and performing abilities to adjust the shape.

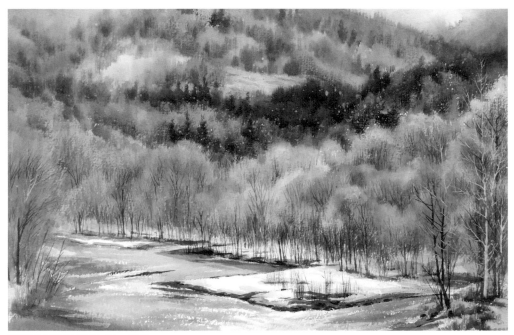

洪東標｜初春的小溪 29x45cm 2016

A5. 你認為一個畫家如何追求「時代性」與「獨特性」？

「時代性」與「獨特性」幾乎所有藝術創作者的追求目標，事實上每一個人都是獨一無二的個體，無論從事何種創作，從自我的生活感受出發，表現那個時代他們所看到的景象，也努力地探索媒材應用的可能性，也因此發展出源遠流長的藝術面貌，這些不同時期的畫家們都將隨著時代的脈動展現著時代的新面貌，傳統

的水彩依然循序漸進地在展現新的未來性，這是自然形成的表現自己的藝術，「時代性」在於你生活的空間和時間裡所感受到的感動，與「獨特性」是以你個人最擅長的表現技巧來呈現，絕對不要人云亦云。

從廣義上講，無論是人物風景或是靜物，要想畫好都必須百分之百來自自己生活的體驗，使用從自己所處的當代生活中，以具有感情和美醜的審美傾向，發現美並能激發自己的創作熱情，這是不變的真理，因為藝術創作最生動最美的因素全蘊藏在生活之中，是畫家將之發掘使大眾引起共鳴的法則，憑空不能獲取的。接著是如何表達，表現技巧就是溝通技巧，如同文學家的修詞、演說家的口語能力，展現了個人特有的表現特質，這是需要不斷的創作方能體驗和實現的理想。

A5. In your opinion, how would a painter pursue "keeping pace with the times" and "uniqueness"?

"Modernity" and "uniqueness" are the goals of almost all artistic creators. In fact, everyone is a unique individual. No matter what kind of works to create, they obtain inspirations from their life to perform scenes they see in those times. They also make efforts to explore the possibility of media applications, and therefore develop a long history of art. In these different periods, painters feel the pulse of the times, revealing a brand new appearance. The traditional watercolor still moves progressively and constantly displays new possibilities for the future, which is the natural formation to express art. "Modernity" lies in space and time in their life to feel and be touched, and "uniqueness" is utilizing their personal skills to perform best. Absolutely do not follow the masses or trend.

In a broad sense, whether painting characters, scenery or still life, artists must obtain inspirations from their own life experiences. Within the contemporary life, make use of your feelings and aesthetic tendencies to screen beauty and ugliness, and to stimulate your own creative enthusiasm. This is the never-changing truth because the most vivid and beautiful elements are all hidden in life. Painters explore and find such a principle to cause resonance among the public. It can't be obtained out of thin air.

And then it's the subject of expression. Performing skills are communication skills, as writers' use of words, and the speakers' oral abilities to deliver. They reveal unique characteristics of individual performances, which requires continuous creation to experience and achieve the ideal.

A6. 你認為風景畫最好的創作方式應該是面對大自然的實景來寫生或是在畫室裡畫照片呢？

我覺得兩個方式都是很好的創作，問題是當你在寫生不能只是模仿自然，參考照片不能只是畫照片，十九世紀因為照相技術不是很發達，印象派的畫家為了追求大自然的光和色彩，主張實地到野外寫生，因此寫生風氣漸盛，現在二十一世紀照相科技相當進步，照片可以紀錄很完整的自然現象，提供給畫家相當豐富的參考價值，所以樂於在野外享受自然的畫家也好或是在室內吹冷氣免於風吹日曬雨淋的創作也對，重點是風景畫不能只是在「模仿自然」而是要把畫家的主觀意志來「詮釋自然」。

A6. Which is the best approach to create a landscape --- to face the reality of nature to sketch or to paint a picture in the studio?

I think both methods are very helpful in creating works. The problem lies in the fact that when sketching, you cannot just imitate the nature. While referring to photos, you cannot just draw photos. Back in the nineteenth century when photographic technology was not very developed, in order to pursue the light of nature and color, Impressionist painters advocated going to the field to sketch. As a result, the sketch gradually became popular. Nowadays, photographic technology is quite progressive in the twenty-first century. Photos can record very complete natural phenomena, and provide a very rich reference to the painter as well. Some artists are pleased to enjoy nature in the wild while others prefer to paint in air-conditioned rooms to avoid scorching or chilly weather. The point is that a landscape painting cannot just "imitate nature" but rather present "the interpretation of nature" from the subjective will of the painter.

洪東標｜迎陽承露 37x53cm 2015

A7. 風景寫生常被解釋是「面對自然來抄襲」或「記錄自然」，這樣的寫生能被確認是一種創作行為嗎？

我常在面對寫生時，有兩種態度，就看當下的空間條件和時間情況，一種是速寫性的紀錄，以最直覺的感覺，快速的鋪陳，掌握當下的的色彩和光線明暗，由於時間短暫，將細節簡化後，畫面色塊結構分明，明顯展現出速度和自信的筆觸，繪畫性趣味十足；另一種方式則是在時間和空間都允許的條件之下，我會面對大自然深思熟慮的來構思我的作品，包括如何取景，調整構圖，營造光線氛圍，增加色彩和點景安排…等等；第一種方式比較接近是自我的基本功訓練和淨化視覺雜訊的訓練；第二種是比較思慮性的排除直接描寫的模仿創作。

但是我覺得，寫生仍是創作，因為在 360 度環景的空間，取景時框住一個畫面的當下，這樣的選擇都跟畫家的個性和素養有關，這就是創作的第一步了。寫生給人帶來機敏的思維，銳利的觀察力，豐富的想像力，快速處理的手法，概括的能力，

是從事造型藝術的人不可缺少的基本功。有了攝影後，不少人，少畫或不畫速寫了；但其實在有限的時間與環境的壓力下，會讓你更大膽的放手去嘗試，而使技巧更純練精湛。

A7. A scenery sketch is easy to be interpreted as "facing nature to plagiarize" or "recording nature". Can such a painting be confirmed as a creative piece of work?

When facing the sketch, I generally hold two kinds of attitude, depending on the current space and time conditions. One is the sketch of the record: Armed with the most intuitive feeling, a quick lay out, I try to master the current color, light and shade. Because time is short, the details are simplified, and the picture block structure is clear, obviously showing the speed and confidence of the strokes. Painting is thus full of fun and artistry. The other way is when time and space are allowed under the conditions, I would face the nature and deliberately conceive my work, including how to plan, adjust the composition, create a light atmosphere, increase the color and arrange scenes or people ... and so on. The first approach is closer to the basic skills of self-training and purification of visual distraction. The second method is sort of more considerate to exclude a direct description or imitation of nature.

However, I hold that sketching can still be considered as creating works. Since in the 360-degree view of space, framing a spot of scenery in a picture at that moment is a choice related to the artist's personality and literacy. This is the first step in creation. The sketch provides the ingenuity of thinking, sharp observation, rich imagination, quick handling of the plan, and general abilities. Such basic skills are indispensable for those who are engaged in the visual art. With the photography, many people sketch less or even do not sketch anymore. But in fact, within limited time and under the pressure of the environment, you will be forced to try more boldly and therefore even become more skilled and superb.

A8. 你說創作必須堅持的原創精神是什麼？

我覺得一張畫要感動別人，一定是要先感動自己，才能夠感動別人的，複製別人的感動是很虛偽的，原創就是將自己的體驗分享給他人的創作態度，就算是時地不宜的情況，都必須堅持不使用他人照片；我以 2008 年個展的「玉山行旅」為例，有觀眾問我，這些作品是寫生的嗎？我跟各位講，絕對不可能，因為你上玉山那麼高（3,952 多公尺），背著裝備、衣服和帶的東西，你已經沒有足夠的體力再去背畫袋、畫架；場地、時間，體力都不適合。所以這批作品，都是當時有所感動，拍照後回來畫的。

如果你不上玉山，你可以在網路上找到幾百張爬上玉山的山友分享的照片，你都畫不完，可是抄襲別人的照片你如何說服別人說那是你的作品？從取景的角度和畫面的構圖都是別人的創意，當年我是三天兩夜自己爬上玉山時拍的每一張照片都是以繪畫為目的，構圖取景拍下來的，在按下快門的時候，已經是創作的開始。十多年來我一直自我要求，我畫的每一張照片都是我拍的，我絕對不借用他人照片來創作：第一，那不是你的原創；第二，那跟你的感動無關，所以我要鄭重的再說一次，要先感動自己，才能感動別人。我們應該堅持的這樣的原則。當我們面對美景，從相機的取景框裡觀察自然，到按下快門時，我們的創作已經開始了。

A8. What is the original spirit that you must insist on creating works?

I feel that if artists intend to touch people with their paintings, they must first be moved by their own. To copy someone else's being moved is very hypocritical. With a creative attitude, artists' originality is to share their personal experiences with others. Even when it is not an appropriate situation, we must insist on not using other people's photos. Take 2008 Exhibition of "Yushan (Mt. Jade) Travel" as an example, the audience asked me, "Are these works sketched?" Honestly speaking, it is absolutely impossible. Because when you are so high on Mt. Jade (3,952 meters), carrying equipment, clothes and stuff, you have not enough energy to carry the backpack or easel. Scenes, time, and physicality are not suitable. Those works, therefore were finished after I came back from that trip. But I was really touched then

洪東標｜日照大尖山 55x75cm 2016

and took those photos at that moment.

If you do not visit Mt. Jade, you can still find hundreds of photos shared by mountaineers on the internet. A great number of them can be used for paintings. But when copying the photos of others, how can you tell people that it is your work? It's because both of the perspective and composition of that picture are someone else's creativity. In 2008, it took me three days to climb Mt. Jade on my own. Taking each photo with a planned composition is for the purpose of my painting. When pressing a shutter, I already started the creation. More than ten years, I have been self-demanding--- every painting was painted with the photo I took; I absolutely do not borrow other people's photos. For one thing, it is not originality. For another, it has nothing to do with your being moved. Hence, I would like to repeat once again: we must first move ourselves to be able to touch others. We should stick to this principle. When we face beautiful scenery, viewing from a camera's viewfinder to observe nature, and then press the shutter, our creation has begun.

A9. 如你所説創作可以參考照片，那應該如何避免變成是抄襲照片？

在時間與空間不足時，畫照片是權宜的方式，現代科技是帶給畫家許多方便，但是我們畫的是一張畫，而不是一張照片，照片只是參考。其實照片也有很多陷阱，經常在強烈的陽光下拍攝的照片會有曝光過度的全白和曝光不足的全黑的無色彩狀態，，加上現代的相機幾乎都是廣角鏡頭，把空間感加大了，同時物象也就變形了，這些問題讓許多人不自覺地陷入相機鏡頭的偏差影像裡。

尤其是寫生經驗不足，或觀察經驗不夠時，常常畫照片的時候就成了追求照片的內容，以照片作目標，當畫完成以後，就會畫得像那張照片，這時你以為你成功了，其實你是失敗了。因為你會被攝影師取笑，因為你花很長的時間所完成的作品，他幾秒的時間就做到了，而畫家的功能也就會被照相機取代。我堅持「畫」是創造出來的，而不是模仿出來的，更不是無中生有，而是改造自然，讓風景更美。照片是記錄自然，這個自然的影像，可以做為參考資料。但是最後畫出來的畫，不是「像」，而是畫家心中理想的美，不只是那照片原有的內容。我的好友－水彩名家謝明錩常說：**「照片是用來超越的，不是用來抄襲的。」**，我認為避免抄襲照片的方法，第一就是改照片，這是所有利用照片創作畫家的第一課，從構圖調整入手，其次是光線明暗，色彩等。

A9. As you mentioned that people can create works by referring to photos, then what should we do to avoid just copying those photos?

When time and space is insufficient, utilizing photos is an expedient way. Modern technology indeed brings painters a lot of convenience, but artists intend to portray a picture, not a photo. The photo is a mere reference. As a matter of fact, there are traps in a photo. Oftentimes taking photos in the strong sunlight will make excessive exposure with the white color and underexposed black---the colorless state. Besides, modern cameras are almost equipped with wide-angle lens. The sense of space is therefore increased and deforms the images. These problems cause many people to unconsciously fall into deviation images of camera lens.

In particular, when the sketch experience is insufficient, or the observation experience is not enough, people often pursue the contents of the photo and regard the photo as a goal. Thus when the painting is completed, it will be painted like that photo, then you think you succeed. On the contrary, in a sense, you fail. You will be laughed at by photographers since you spend such a long time completing the work with which they may accomplish within just a few seconds. Artists' function will thus be replaced by the camera. Accordingly, I insist that "painting" is created, rather than imitated or innovated out of nothing. It is the transformation of nature so that the scenery becomes more beautiful and appealing. Photos record nature; this natural image can be used as a reference. The emphasis of the final product, however, is not being "alike", but the ideal beauty of the artist, which transcends the original content of that particular photo. My good friend, watercolor master Xie Mingchan, often states: "Photos are used to go beyond, not used for plagiarism." I also contend that there are methods to avoid copying photos. The first is to change the photo, which is the first class of all painters who use photos for creation. Start from the composition adjustment, followed by light and shade, color and so on.

洪東標｜水之森林 37x55cm 2010

A10. 一件好的風景作品，你認為必須具備哪些條件？

我經常在畫面中經營一個情境，讓觀賞者在欣賞作品時宛如自己可以走入畫中，去感受、去體驗大自然與我的情感連結，這應該是很具體地與生活經驗連結，尤其是屬於我們台灣人特有的生活情境跟空間。所以一個畫家在畫面裡面表現的就是追求心中「理想美」的境界，我期望在作品裡呈現的不只是形體跟空間、色彩，而能夠更具體的表現出季節、時間、天氣、溫度和濕度，是一個可以讓觀賞者融入的情境，這呼應了中國傳統美學中的「天人合一」，這個「天人合一」就是中國人的一個生活哲學觀，好的作品必須擁有一個思想架構作支撐，讓觀賞者體會和共鳴。

A10. What do you think are the essential conditions for a good landscape painting?

I often deliberately create a situation so that when viewers are in the appreciation they feel as if they can go into the painting. They are led to experience the nature and my emotional connection, which should be very specific and has links with life experiences. Above all, those connections belong to our unique living situation and space in Taiwan. Consequently, what a painter presents inside the picture is the pursuit of so-called "ideal beauty" in his/her heart and the realm. I expect to present in the works not only the shape, space, color, but also more specifically the

洪東標｜溪谷晨光 24x56cm 2014

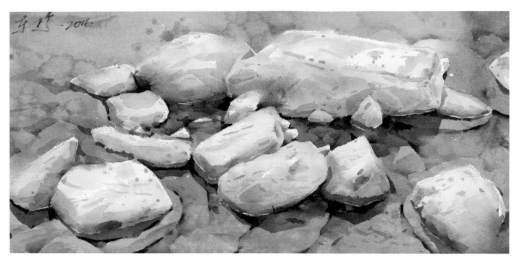

洪東標│藍調上的溪石 22x45cm 2016

season, time, weather, temperature and humidity. Such Is a scenario that allows viewers to integrate into a situation, which echoes traditional Chinese aesthetics --- the "harmony between man and nature". This "oneness harmony" is a Chinese philosophy of life. Good works must have a thought structure to support them so that the viewers experience and resonate.

A11. 你說能創作有品味的畫作，要先具備美學素養，要如何培養個人的美學素養？

一個畫家的美學素養也就是一個畫家的品味，是需要去充實涵養的，我認為就是對美的閱讀經驗，有人問一位在故宮鑑定古藝術品的專家說，你如何知道甚麼是假畫？是贗品？他回答說：「如果你看過真的，就知道什麼是假的，如果你看過好的作品，就知道什麼是不好的」。因此養成一種閱讀好作品以提升自己的品味，就是培養個人的美學素養最好的方法。

A11. As you contend that if artists intend to create a painting with taste and style, they first should develop aesthetics, but how can we cultivate personal aesthetic qualities?

A painter's aesthetic accomplishment is the taste and style of that painter, which needs to be enriched and conserved. I think it is the experience of appreciating

beauty. An audience asked an expert at National Palace Museum about identification of ancient art: "How do you know which is a fake painting or work?" He replied, "If you have seen a real one, then you would know what is a fake; and if you have seen a good work, you know what is bad." Therefore, developing a sense of appreciation for good works and enhancing their own tastes is the best way to cultivate personal aesthetic accomplishment.

A12. 為什麼選擇作為一個藝術家，並以水彩創作？

我在台灣師大的學習過程中，面對許多媒材，選擇水彩這是一個自然而然的選擇，過程很平和，應該說就是一種天性的使然，在師大求學，當你面對大學科班教育提供給你的各種創作媒材的課程，你需要有所抉擇，思索著個人的未來，當時我並不需要煎熬就可以的決定，我經常跟學生分享的經驗，我之所以選擇水彩一來是我窮，水彩比較經濟，二來是我怕死，因為水彩比較乾淨健康，其實選擇水彩就是天性使然，自然而然的你就能融入其中，無怨無悔地投入。

A12. Why do you choose to be an artist and create works with watercolor?

When I was in the process of learning at National Taiwan Normal University, facing many media, the choice of watercolor was a natural one. The process was very peaceful or it should be said to be a natural tendency of my temper. In the divisions of university, when you face college classes provided with a variety of creative media courses, you need to make a choice, thinking about the future of the individual. At that time, I did not need to make tough decisions or face a dilemma. I often share the experience with my students: I chose watercolor because for one thing, I was poor. Choosing watercolor is more economical. And secondly, I am afraid of death. Watercolor is relatively clean and healthy compared with other media. In fact, choosing watercolor is a natural call for me; accordingly, I can be integrated into it with no regrets at all.

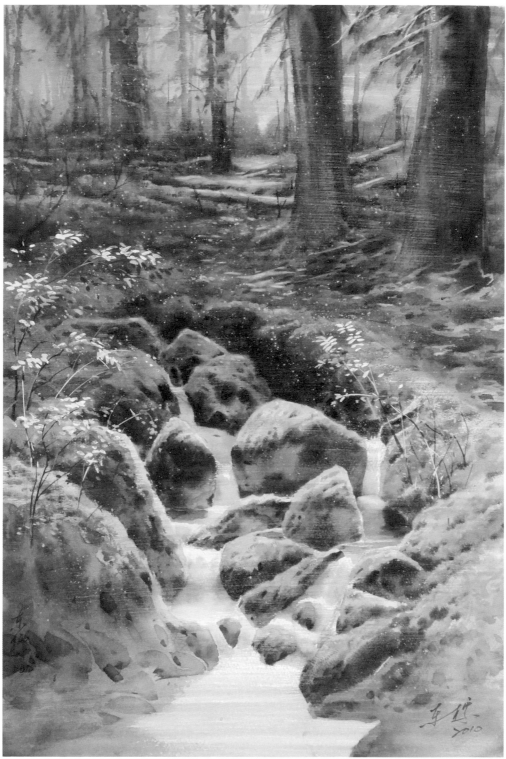

洪東標│涓涓小河　55x38cm　2010

B

畫家的生活成長

Painter's life experiences

「… 屏東縣文化局在墾丁舉辦的《半島藝術季》邀請我到那邊住三個禮拜，我先後去了三次、每次三個禮拜，在那裏每天除了畫畫，沒有什麼事情，空餘時間就騎著腳踏車到處轉，所以對那裏每個地方都很熟。…」

「…Pingtung County Cultural Bureau in Kenting organized the "Peninsula Art Festival" and invited me to live there for three weeks. I went there three times; each time I stayed for three weeks. There was almost nothing to do except for painting watercolor. In my leisure time, I would ride on a bike to travel around, so I was very familiar with each place there.」

洪東標｜待春　37x53cm　2014

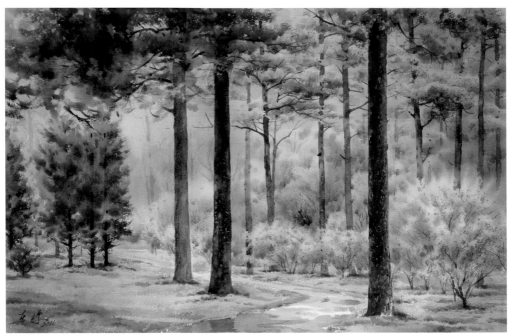

洪東標｜梅在武陵 36x56cm 2016

B1. 在台灣的舊社會裡，你的童年成長環境跟你選擇藝術創作有什麼關聯性嗎？

其實在我的生長裡，並沒有太多的藝術環境，我在一個有五個孩子的電力公司公務人員家庭裡排行老么，小時候喜歡畫畫並沒有受到開明的父母任何干預，只是也從沒敢開口要去拜師學畫，塗塗抹抹的渡過青澀的年華，學生時期參加比賽獲得的獎勵和父母的鼓勵使自己對畫畫保有高度的興趣。

高三時面臨大學聯考，一百多個志願就只填寫兩個美術系的學校， 在當年各級學校裡均沒有美術資優教育的環境中， 報考美術系加考術科， 除了需要個人的興趣外，到畫室去拜師學個一兩年是免不了的必備條件， 否則真不明白除了鉛筆外，還會有一種用木炭來畫的素描，我則是從高二起每天利用午休時間及例假日， 到學校美術教室看著其他在畫室學畫的同學們畫素描， 自己跟著練習， 偶而會有位工藝科的黃錦華老師 在路過美術教室時，進來講評幾句，我便覺得受益匪淺。

1975 年的夏天，我重考，目標依然鎖定師大美術系，站立在考場教室的後排和流行性感冒近 40 度的高體溫戰鬥，三小時的素描考試繳卷之後，被同學送進醫院急

診打點滴，內心沮喪到極點，對考試毫無把握，當放榜時我在一千八百多名報考美術系的學生中脫穎而出，錄取在三十五個師大美術系的新生名額內，這個甘美的結局讓我走入繪畫的這條不歸路，無怨也無悔了。

B1. In Taiwan's past society, is your childhood environment related with your choice of artistic creation? What is the relevance of it?

In fact, in my childhood or adolescence, there were not many artistic surroundings. I am the youngest among five children in my family, and my father worked in a public power company to support us. Growing up as a child who liked to paint, I was not intervened by my enlightened parents, but also never dared to find art teachers to ask for apprentice or learn painting. Smearing or drawing through my adolescence, I participated in competitions to obtain certain awards and encouragement from my parents. Thus, I was inspired and have kept great interests in art.

Faced with university entrance exam, this 12th grader in senior high picked only two schools of fine arts in more than one hundred choices as goals. There was no art gifted education environment then. If you applied to the Department of Fine Arts, you needed to take the Entrance Exam plus art tests. In addition to your personal interest, learning one year or two in the studio was a must. Otherwise, I really did not understand besides pencils, there were paintings with charcoal sketch. Starting from 11th grade in senior high, I made use of lunch time and holidays to go to the school art classroom watching others work in the studio. The students there drew sketches, and I practiced along. Occasionally an arts and crafts teacher Huang Jinhua passed by, came in the studio and offered a few comments. I obtained valuable experiences and thus learned a great deal.

In 1975 summer, I took the Entrance Exam again, still aiming to go to National Taiwan Normal University --- Department of Fine Arts. After standing in the back of the examination classroom and fighting influenza with nearly 40 degrees of high temperature for three hours, I finally handed in my sketch test paper. Soon

afterwards, I was sent by classmates to a hospital emergency room for a drip. Such was my depression that I felt zero hope for the results of that exam. Much to my amazement, I was picked up from more than 1,800 students applying to Department of Fine Arts. Only thirty-five freshmen were chosen for arts division at NTNU. This very sweet end led me onto the art path of never return --- no blame, no regrets.

B2. 你求學時代影響你最大的師長是誰？

在師大的大學四年才是我邁向藝術之路真正學習的開始，有幸的與一群優秀的學長及同學同住在宿舍，受到許多啟發和激勵，當時適逢水彩畫在師大受到學生的熱烈歡迎，許多國外出色的水彩工具書和畫集被引進國內，許多師大學生都沉醉在水份淋漓，色彩暈染變化多端的趣味中，當今國內許多青壯年紀的水彩畫家多出於這個風潮中，白天受老師的教誨，晚上則與學長同學討論，假日相約外出寫生，其間的快樂可想而知，每次過了寒暑假，回到學校，每人幾乎都是厚厚一疊的作品，不但比多也要比精。

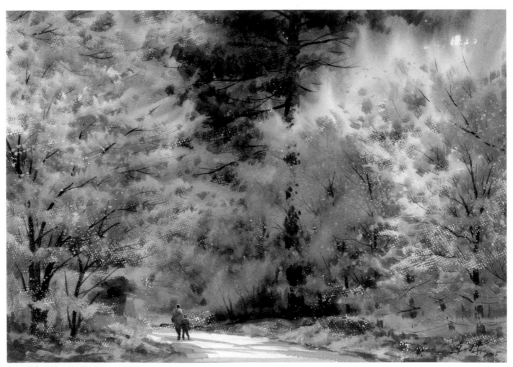

洪東標｜武陵之春 37x53cm 2015

學習過程中劉文煒老師在大一時嚴謹的教學讓我紮下良好的素描與水彩基礎，並且讓我在選擇以水彩作為終生創作媒材上影響很大；陳景容老師的人體繪畫，陳銀輝老師油畫課，陳慧坤老師素描課、李焜培老師的水彩課，李石樵老師，李梅樹老師們的油畫畢業創作課都讓我的學習生涯受益良多， 在日後的教書生涯裡亦不時以這些大師們為榜樣。

其中李焜培老師影響我最多，也帶領我義無反顧的投入水彩創作的領域，李老師不但是一位出色的畫家，一位成功的老師，更是位提攜後輩不餘餘力的長者，溫文儒雅，兼具詩人般的談吐，幽默睿智，他淡泊的人生觀就如同水彩一般雅緻，他享受創作的快樂，人生如亮麗的色彩一般，亦師亦友的對待學生，引導每一位學生發揮自己個性，創作出不同的風格，因而使當今水彩畫界更形多彩多姿，也使我在師大畢業後認教至今，多年來一直從事水彩創作不遺餘力。

B2. Who do you think is the greatest teacher in college that has a great impact on you?

Four years in college is my way to learning art officially. Fortunately, I lived with a group of outstanding seniors and classmates in the dormitory and was encouraged and inspired by them. At that time, watercolor was warmly welcome by NTNU art students. Many foreign excellent watercolor reference books and paintings were introduced into the domestic field. A number of students then were immersed in so much fun of water dripping, color blooming and so forth. Today, quite a famous middle-aged watercolor painters were cultivated in that fad. During the day, we were inspired by instructors' teaching; at night, we discussed with senior classmates. On a holiday, we went outside for the sketch. During that period, happiness could be imagined. Each time after a summer vacation, when back to school, each person was very likely to carry a thick stack of works. Not only did we compete for the quantity, but we also compared the quality.

During the learning process, Teacher Liu Wenwei in the freshman year instructed with rigorous teaching. He influenced me a lot for building the base of my sketches

and watercolor skills, and allowed me to choose watercolor for a lifetime creation medium; Teacher Chen Jingrong's painting portraits/figures, oil paintings of Chen Yinhui, the sketch class of Chen Huikun, the watercolor class of Li Kungpei, the oil painting classes for graduation creation of Li Shichau, Li Meishu have all made great contributions to my study and career. I respect and follow the above-mentioned masters as role models in my later teaching.

Among them, teacher Li Kung Pei is the most influential to me, and he also led me to plunge into the field of watercolor creation. Li is not only an excellent painter, a successful teacher, but also spared no effort to help artists in the younger generation. Gentle and refined, with poet-like conversations, humorous wisdom, his indifferent view of life is similar to watercolor brimming with elegance. He enjoyed the creation of happiness, and his life was full of bright colors in general. Treating his students like friends, he also guided each of his students to reveal their own personality, to create different styles. In this way, watercolor in Taiwan has become more and more colorful. As a consequence, I graduated from NTNU and have been teaching to date. I am engaged in watercolor creation and spare no effort as well.

B3. 你能列舉你最喜歡的古代大師嗎？為甚麼？

我最喜歡的古代大師是十七世紀荷蘭畫家維梅爾。他的畫裡給我很多感觸和啟發。我常用他的作品〈編織的女孩〉在上課時跟學生分享。一個長相平庸的普通女孩子，專注於編織工作時，卻是很美的，而成為一張世界名畫。「專注」、「全心投入」的本身，就是值得肯定的美德。當畫家用心把她畫出來，一種藝術氛圍和內涵的完美呈現。這是一股可以撼動人心的共鳴。印象派大師雷諾瓦曾經稱這幅畫是「世界上最美麗的一幅畫」。

其實維梅爾的很多作品都在展現這種專注的神情。例如〈天文學家〉，正對照桌上那本書星象儀在研究星象，光線從窗戶透射進來，呈現一種寧靜祥和跟專注的氛圍。維梅爾的許多作品裡面都有這樣的特性。例如〈畫家的工作室〉，荷蘭在17世紀是個海上強權，地理學非常的進步，人們有看地圖的習慣，所以牆壁上掛

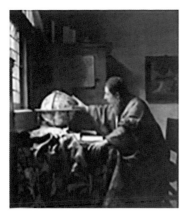
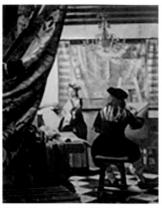
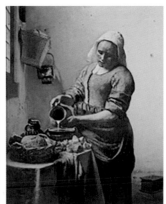

維梅爾 Vermeer｜天文學家 Astronomer　維梅爾 Vermeer｜畫家的工作室 Painter's Studio　維梅爾 Vermeer｜倒牛奶的女傭 Maid of Milk

著荷蘭地圖反映了時代背景。從布幔看到那個光從外面投射進來，模特兒擺了個姿勢在那個角落，專注的畫家和專注的模特兒各司其職，各盡本分，形成非常寧靜的氣氛，想必一根針掉在地上都聽的到。現在這幅〈地理學家〉也一樣，他在研究、思考，同樣的光線，同樣的室內氣氛，包括後面櫃子和上面的星象儀，都令人感受到那樣專注的氣氛。

同樣的精神出現在這幅〈倒牛奶的女傭〉。一個平凡的女傭，在倒牛奶的日常動作，卻那樣小心翼翼。是在準備早餐、午餐或晚餐都不重要，表現出的是一種平凡而實在的一種寧靜的氣氛。

我覺得做事的態度是很重要的，更讓我感動和喜歡的是室內的氣氛的描寫。這幅畫中描寫懷孕的藍衣少婦在讀一封家書。當時荷蘭是個海上強權，後面的地圖也有暗示的作用，可能她的丈夫是個海軍，或航海家或是水手，那麼看家和書信對她是非常重要。而光線跟氣氛都很動人。其實古典的繪畫作品中，那樣的氣氛、那樣的場合、那樣的內容，我們都會被感動。

B3. Can you list your favorite ancient master? What are the reasons for your specific fondness?

My favorite ancient master is Dutch painter Vermeer in the seventeenth century. His paintings offer me a great deal of feelings and inspiration. Oftentimes, I share one

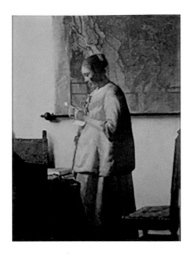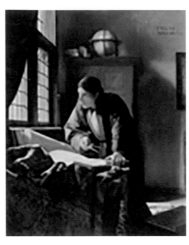

維梅爾 Vermeer │
讀信的藍衣少婦 Woman in Blue
Reading a Letter

維梅爾 Vermeer │
地理學家 Geographer

of his works with my students--- A mediocre ordinary girl focused on her weaving work. But such a painting is extremely beautiful and it has become world famous. "Concentration", and "dedication", is virtue worthy of praise. As the painter painted the lady with his heart, it forms artistic atmosphere and perfect connotation of such presentation. This is a power to touch people and cause resonance. Impressionist master Renoir praised the painting as "the most beautiful painting in this world."

In fact, many of Vermeer's works reveal such look of concentration. For instance, the "astronomer" is consulting a book about astrology and gazing at an astrology instrument at table. There is light transmission from the window, showing a serene and peaceful atmosphere. Vermeer's many works have such characteristics. Take the "painter's studio" as another example. In the 17th century, the Netherlands owned sea power; geography was very progressive, and people formed a habit of looking at the map. Therefore, the map of the Netherlands on the wall reflects the background of that time. From the mantle, we see light projection from the outside. A model poses in that corner. The concentration of the painter and focused model both do their duties, forming a very quiet atmosphere. Presumably even if a needle fell to the ground, it could be heard. The painting "Geographer" is the same. The man is concentrating on studying and meditating. There's the same light, the same indoor atmosphere, including the cabinet and celestial globe in the back. They all lead viewers to feel the atmosphere of attention.

The same spirit appears in this piece of "Milk maid". An ordinary maid, in the daily movement of pouring milk, is so cautious. No matter what she is in preparation (for breakfast, lunch or dinner) is not important, showing a kind of being ordinary and real--- serene atmosphere.

I think the attitude of doing things is very important; what moves me and makes me particularly like this painting is the description of indoor atmosphere. This picture describes a pregnant woman dressed in blue reading a book. At that time, the Netherlands was a country boasting sea power. The map on the wall also has a hint of such a role. Perhaps her husband is a navy, or navigator or sailor, then the housekeeping and correspondence are very important to her. The light and the atmosphere are very moving. In fact, classical painting works with that kind of atmosphere, that kind of occasion, that kind of content, will certainly move us.

B4. 是什麼情況讓你又再度喜歡寫生與擁抱自然？

寫生幾乎是所有藝術科班學生的美好經驗，但是自從在學校教書以後，機會就越來越少了。2003 年，我有新的轉變。屏東縣文化局在墾丁舉辦的《半島藝術季》邀請我到那邊住三個禮拜，我先後去了三次、每次三個禮拜，在那裏每天除了畫畫，沒有什麼事情，空餘時間就騎著腳踏車到處轉，所以對那裏每個地方都很熟。當時還沒有《海角七號》這部電影，但是片中每一個場景我都很熟，知道在哪裡。一般人知道墾丁森林公園、社頂公園、貓鼻頭、鵝鑾鼻等等，但是我還發現了許多不為人知的很美的地方；有朋友要去墾丁，我都會告訴他們我的這些「私密景點」。

在墾丁寫生，讓我像回到學生時期，再度體驗背著畫架去寫生的感受。我非常感動，就這麼親近大自然，在那裏非常自由自在把自己放在大自然裏面、去感受，很自然地不必思考太多所畫出來的作品。分割的表現形式是理性的，你必須去思考這一筆下去所形成的痕跡、塊面的協調性，層次做得夠不夠，都是比較理性思考的；而自然主義是比較感性的，用自己的直覺來畫畫。

當時都是以直覺、率性方式的筆法、線條簡潔快速，不容許精雕細琢。我常常運用濕度中再重疊乾筆的技法表現近景質感，強調寫生時非常重視所謂「渲染」跟「乾筆」的運用，所以在這個大渲染裡面，背後的空間那個山、樹渲染的後面，下面草地有乾筆重疊的運用。此時我對水彩有新的觀念。有些人認為水彩就是輕描淡寫，輕飄飄的，水份很多、暈染，就是這樣而已，可是如果你認為水彩只能這樣而已，它永遠就只有這樣。 你一定要想，除了這些，我還能怎麼畫，開發出來未來的可能性。

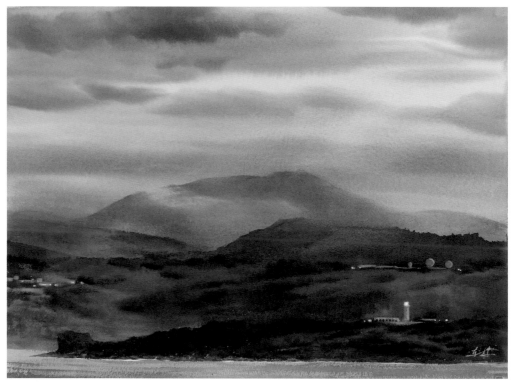

洪東標｜恆春微曦 55x75cm 2016

B4. What situation causes you to like sketching and embrace nature ?

The sketch is nearly a wonderful experience for all art students, but ever since I started teaching at school, there have been fewer and fewer opportunities for sketching. In 2003, I experienced a new change. Pingtung County Cultural Bureau in Kenting organized the "Peninsula Art Festival" and invited me to live there for three weeks. I went there three times; each time I stayed for three weeks. There was

almost nothing to do except for painting watercolor. In my leisure time, I would ride on a bike to travel around, so I was very familiar with each place there. At that time, the movie "Cape No. 7" had not been shot yet, but I was very familiar with each scene in the film. Most people are acquainted with Kenting Forest Park, "community top park", "cat nose", "goose nose" and so on, but I found a great deal of unknown beauty in many places there. When a friend plans to go to Kenting, I would share with him/her my "private attractions".

Sketching in Kenting brought me back to the student period. Once again I experienced carrying an easel to sketch my feelings. I was very touched, feeling so close to nature, where I was free to put myself in, just to feel. Naturally, I did not have to think too much to paint the works. Expression of segmentation forms is rational; you have to think about the traces of the formation, the coordination of the surface, whether layers are enough… It is more rational thinking. By contrast, naturalism is more emotional; artists paint with their own intuition.

At that time, I painted intuitively, with seemingly reckless strokes; lines were simple and quick, not allowing uncompromising attention. I often made use of humidity and then repeated skills of "dry pen strokes" to show close-up texture, emphasizing very important skills so-called "wet-in-wet /rendering" and "dry pen" in sketching. Therefore, in big rendering, the mountain and trees in the back were painted with wet-in-wet. Grass underneath was painted with the use of "overlapping pen". At this point, I formed a new concept of watercolor. Some people think that watercolor is extremely "light", floating in a lot of water, and that is the case. But if you think in that way and view that's what watercolor can only do, it will only be that case. You must think, besides these, how can I paint and develop possibilities or its potential.

B5. 除了創作，你認為人生最快樂的事是？

對一個畫家而言，快樂的事很多，但是創作絕對是一種無法比擬的快樂，畫一張好畫會讓自己興奮的不得了，除了這個，欣賞一部好電影，看一本好書，作一場

愛作的事，和一群好友暢談人生和藝術，高歌一曲等，其中在旅行中尋找美的元素，找尋到繪畫的題材，激發自己的創作動能，也是一種非常快樂的事，近年來從學校退休，有更多的時間融入在創作和旅行中，旅行便是一種生活的必需，行萬里路再畫萬卷畫，人生至樂。

B5. In addition to creation, what do you think are the happiest things in life?

For a painter, there are a number of joyful things in life, but creation is definitely unforgettable pleasure. Painting a good picture will make artists incredibly excited. In addition to this, enjoying a good movie, reading a good book, doing things I like, and discussing life and art with a group of friends, singing a song, just to name a few. Taking trips to find elements of beauty, to find themes of painting, to stimulate creative skills, is also very pleasant. In recent years, I retired from school, there is more time for me to integrate into the creation and travel. Traveling becomes indispensable in my life: touring thousands of miles to paint thousands of paintings, the utmost pleasure in life.

B6. 你說你喜歡旅行，近年來「旅行創作」是很多畫家喜歡的創作方式，你除了寫生之外，會將國外旅行中所見到的景色作為創作的題材嗎？

旅行是藝術家增廣見聞吸收藝術養分的歷程之一，將旅行中的感動轉化成藝術作品中外藝術家皆然，所以我經常在旅行中攜帶一個小畫箱，以最簡單輕便的速寫方式捕捉美景和異國情調，至於大幅的作品大多是在返回工作室內參考照片或速寫重新構思，有時候小品的速寫因時間和空間的侷限，反而下筆更俐落果決，用色也更簡潔大方，反而更具有趣味性，有一位畫家朋友就說：「出國旅行不畫就如入寶山空手而回，至少也要把旅費賺回來」。我當然不例外，不過在近年來，我大多以主題性的展覽來發表作品，還是以本土的風景題材為多。

B6. You mention that you like to travel. In recent years, "travel creation" is favored by plenty of artists. In addition to your sketching, would you include scenery abroad as a creative theme?

旅行時攜帶的小畫箱也是簡易的畫架

Traveling provide artists with benefits of broadening their horizons and absorbing multicultural nutrition. Transforming inspirations from trips into art is therefore frequent cases for Chinese and foreign artists. Oftentimes, I would carry a small cartoon to sketch in a simple and quick way to capture the beauty of exotic scenery. As for huge works, they would be re-conceived or completed after the trip in my studio with photos or sketches. Sometimes due to time and space limitations, small sketches are finished with neater and more decisive brushstrokes, and the color is more concise and fluent. It could be even more intriguing. A painter friend once said: " If you travel abroad and do not sketch or paint, it's as if you visit a treasure island and come back empty-handed. At least you should paint to balance the travel expense." Certainly, I am no exception. But in recent years, most of my exhibitions have surrounded particular themes, mostly centering on local landscapes in Taiwan.

B7. 你曾經以速寫的方式來培養自己對物象造型的敏感度，能不能說明你的做法？

我認為畫家在面對景物時必須有效的掌握造型、明暗、色彩、甚至能感受到情境中的氛圍，這才能精準的展現出藝術的精神跟涵養，這是可以訓練的，這也是寫生的意義，我曾經花很長的一段時間在野外寫生或速寫，即使在國外的旅行中也帶著小畫箱，往往 20 分鐘內逼著自己快速地進行觀察和描寫，景物如何去蕪存菁，簡化

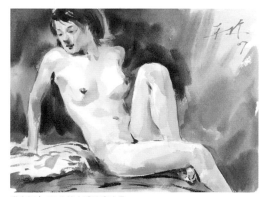

洪東標｜ 15 分鐘人體速寫小品

成結構性的比例關係，空間層次的誇張對比等，都是很棒的體會；90 年代起的十年間，我和一群新莊地區的畫家一起畫人體模特兒，我最喜歡的是 15 分鐘的速寫，

在微帶動感的姿態中隱藏著韻律的美感，有時是流暢的線條，有時是明暗的比例和節奏，有時是冷暖色調的和諧感，這些練習對我日後的創作更有助益。

B7. You have utilized sketching to develop your sensitivityof shape and image, can you explain your practice?

I suggest that when facing scenery, a painter must be efficient in grasping the shape, light and shade, color, and can even feel the atmosphere of that particular situation. Such accurately shows the spirit of art and conservation. This can be trained, and is also the meaning of sketching. I have spent a long time in the field to sketch from life or do a quick sketch. Even when traveling in foreign countries, I form a habit of carrying a small box. Oftentimes within twenty minutes, I force myself to quickly observe and depict to separate the wheat from the chaff. In this way, I simplify the scenes to a proportion of structures or exaggerate the space contrast and so on; they are indeed remarkable experiences. In the 90s, a group of painters in Xinzhuang area got together to draw human body models. My favorite was a fifteen-minute-sketch. The beauty of rhythm was hidden in the slightly dynamic posture. Sometimes there're smooth lines, or the proportion and tempo of light and shade, or the sense of harmony between cold and warm colors. These exercises are extremely beneficial to my future creation.

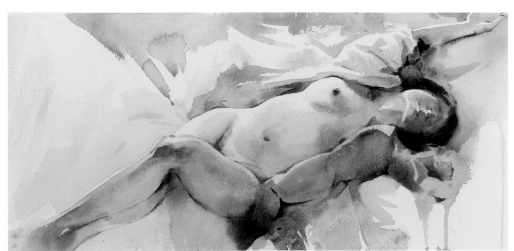

洪東標｜15 分鐘人體速寫小品

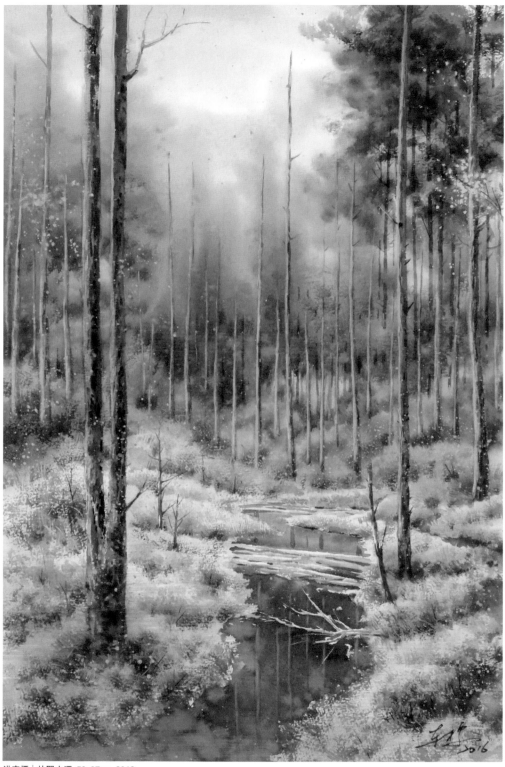

洪東標│林間水澤 58x37cm 2016

C

表現形式與特色

Forms and Characteristics

「...我一度喜歡「立體主義」的繪畫,但始終不覺得「美」,
讓當年剛從師大畢業帶著很重使命感的我想要尋找一個可
能,當年國際資訊不發達的年代裡,台灣水彩瀰漫著大渲
染的面貌裡,...」

「..I used to be fond of "Cubism" paintings, but never
felt "beauty" in them. As a consequence, graduating
from NTNU art division, I was endowed with a sense
of responsibility to find a possible way out. In the era
with underdeveloped international information, Taiwan
watercolor was filled with the aspect of big rendering.」

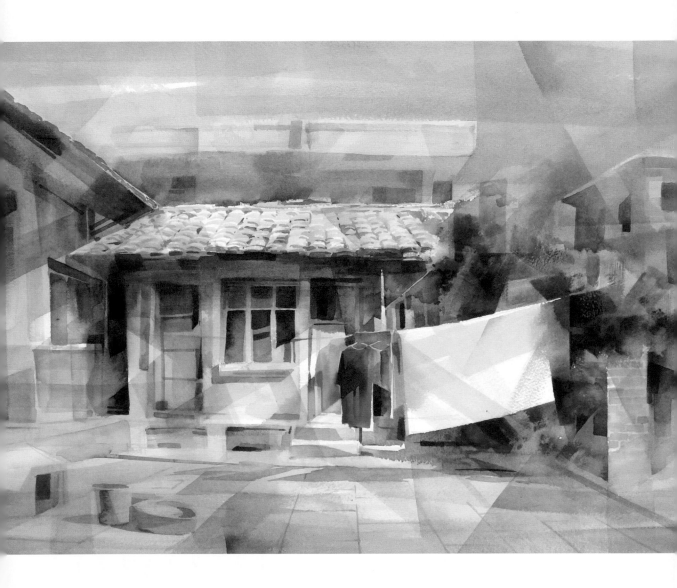

洪東標｜交錯時光的空間　38x55cm　2016

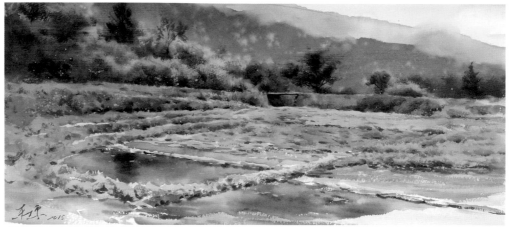

洪東標｜八煙之晨　24x56cm　2015

C1. 你經常出國旅遊，為甚麼你的作品大多還是以本土風景為題創作？

我是個土生土長的藝術創作者。我在這裡出生、在這裡長大、在這裡受教育，沒有出國去留學，在台灣唸大學與研究所，我就在這地方創作，我的創作都取材自這地方的景象，我把對這塊土地的熱愛轉化成繪畫的動力，透過繪畫表達我對這塊土地的熱愛。

C1. Since you often travel abroad, why do most of your works surround the local landscape?

I was born and raised in Taiwan. I grew up here, was educated here, and did not study abroad. Attending art university and institute in this country, I started to create works right here. My creation was therefore mostly drawn from this place. Ever since my first creation, I've transformed the love of this piece of land into the driving force of painting. Through watercolor, I sincerely express my enthusiasm and passion for this land.

C2. 你一直都以傳統寫實方式創作，對一個 21 世紀的畫家來説是不是過於陳舊？

近年來我一直堅持具象寫實的風格，用傳統的媒材─水彩來創作。就媒材來説沒

有所謂最現代最前衛的。我畫畫的時候，希望作品提供觀賞者非常輕鬆愉悅的感覺。因為我始終認為，藝術創作是很辛苦的，因為畫家要用心的思考創作，在作品上經營表現想表現的內容，精準的描寫物象結構、立體感，做出整體感、特殊的氛圍、營造氣勢…畫家要有創作經驗累積出的創作涵養去表現，這樣的畫讓欣賞者非常輕鬆愉悅，看畫時一目了然，可以慢慢品讀。這樣藝術才可以跟群眾結合在一起，而不是把自己鎖在象牙塔裡。

我認為繪畫不是很高深的學問，欣賞時不需要經過閱讀高深的文字解說才能夠理解；這是我一直很堅持的看法。我大三的油畫老師李石樵大師曾經講，：「現代藝術太強調個人感受，塗啊刷啊，很爽快，結果看畫的人都看不爽」。我們尊重現代藝術，但是不能忽略了傳統藝術這塊領域。我認為藝術的價值在於提昇人類生活的品質，藝術不能只是個人不滿情緒的發洩，對世俗批判的嘶吼，和無病呻吟；藝術要對人類有所貢獻，要提昇人類的生活品質。情緒上的不滿，發洩嘶吼，用鞭刑、暴力，都不是人類之福。許多前衛藝術家他們都是以反傳統為目的，爽了自己苦了別人。這難以理解的藝術會離民眾愈來愈遠，這絕不是藝術的本意。

我們應該是讓藝術可以走入群眾，群眾可以走入藝術，這樣藝術存在的 21 世紀，價值就會更高。這樣子社會主流中的大眾藝術，會大量的在民間流傳，透過畫廊和經紀制度提供一個為大眾所需求的空間，它提昇人類生活的價值也活絡了經濟，它絕對符合增進人類生活品質的崇高價值，當然它一樣面臨一個時代的考驗、競爭和優勝劣敗，何者將會勝出，勝出者必有其道理，甚麼樣的畫是好作品，不只是畫家必須要有的認知也是大眾必要的修養，作品是否具有「時代性」和「獨特性」幾乎是眾所週知的標準，它的標準絕無前衛藝術的讓人難以理解，亦絕無民俗藝術的千篇一律和媚俗。在藝術創作中，太容易獲得的東西，其藝術價值可能不會高；而難以獲得的，一旦獲得，其藝術價值必高。

C2. You have always created in the traditional realistic way, would it be sort of old-fashioned for a 21st century painter?

In recent years, I have always insisted on the realistic style, creating watercolor with the traditional media. There is no so-called most modern avant-garde in terms

of media. When I paint, I hope the works provide the viewer with a very pleasant feeling. And I always believe that it is very difficult to create art works. It's because painters have to plan carefully in their creation, working on the performance of the content, accurate description of the shape, or three-dimensional structure, and make a sense of the whole, a special atmosphere, and so forth. They must have creative experiences accumulated to showcase their cultivated appreciation of art. So much so that their painting is very easy to enjoy and appreciated. The audiences view the painting at a glance, and can taste it slowly. In this way, art can be combined with the masses together, rather than artists locking themselves in "the ivory tower".

I'm convinced that the audiences do not need profound knowledge to appreciate paintings. They need not read through the complicated interpretation of the works to understand. This perspective is what I have always insisted on. Master Li Shichau, the oil painting instructor in my junior year, once said: "Modern art puts too much emphasis on personal feelings---a brush here and there, very straightforward. The results? People looking at the painting feel uncomfortable and annoyed." We respect modern art, but we cannot ignore the traditional art of this field. I firmly believe that the value of art is to improve the quality of human life. Art cannot just vent personal discontent, roar toward criticism of the secular world, or groan as if in disease; art should contribute to mankind, to enhance the quality of human life. Emotional dissatisfaction, roaring to vent, using flogging or violence, are not blessings for human civilization. Many avant-garde artists aim to be anti-traditional, putting their enjoyment on others' misery. Such art forms are difficult to understand and can further segregate people. This is absolutely not the intention of art.

We should hold the belief that art can enter the masses, the masses can enter the art, so that art in the 21st century will become more invaluable. This kind of social mainstream art will be popular with people in the folk. With the aid of the gallery and brokerage system, a room for the public demand would be provided. It promotes the value of human life and is also beneficial to economy. Such is absolutely consistent with the promotion of quality of life. Of course, it is facing a test of the

times, and competition as well. Some works can be viewed as victories; there must be convincing reasons. What kind of paintings are considered as good works? Not only painters but also people in general should develop certain knowledge and appreciation of art. Whether the work has "modernity" and "uniqueness" is almost a well-known standard. Its standard is definitely not unpredictable or difficult to understand like avant-garde art. There should be also no monotony and kitsch as in folk art. In artistic creation, if it is too easy to achieve something, its artistic value may not be high; and if it is difficult to obtain, once obtained, its artistic value will be comparatively high.

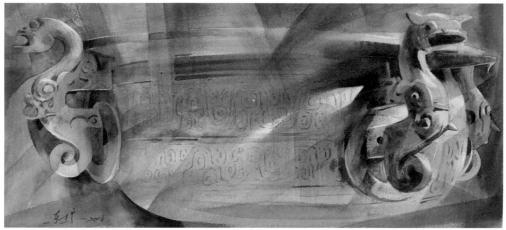

洪東標｜千年光影 25x54cm 2016

C3. 早年你是以分割表現形式的作品在水彩畫家中獨樹一幟，為何你做這樣的創作表現？

美術史的紀錄中，當代藝術的流派大多在美術眾多論述的理念中刻意的找到一個可以突破的理論作為標新立異之說，如印象派的色彩，新印象派的光譜分析，立體主義的造型重組，未來派的時間過程等，而我始終覺得，這樣的發展讓藝術有更寬廣的解釋，豐富了藝術的內容，但卻距離藝術追求「真、善、美」的核心價值越來越遠，我一度喜歡「立體主義」的繪畫，但始終不覺得「美」，讓當年剛從師大畢業帶著很重使命感的我想要尋找一個可能，在當年國際資訊不發達的年代裡，台灣水彩瀰漫著大渲染的面貌裡，我至少知道沒有人想要這樣做，我就來尋求一個可能，以為藝壇創造一個新的面貌自許。

C3. In the early years, you were distinguished among watercolorists with unique "split forms"; what factors affected you to create such innovative works?

In the art history, most genres of contemporary art deliberately seek a breakthrough theory as a symbol of innovation, such as colors used by Impressionists, the spectral analysis of New Impressionism, the reorganization of Cubism, the process of time in Futurism, and so forth. And I always feel that such a development allows art to be depicted with broader interpretation. It indeed enriches art content, but shies away from the core value of art--- "truth, kindness, beauty," further and further. I used to be fond of "Cubism" paintings, but never felt "beauty" in them. As a consequence, graduating from NTNU art division, I was endowed with a sense of responsibility to find a possible way out. In the era with underdeveloped international information, Taiwan watercolor was filled with the aspect of big rendering. At least I realized that at that time, no one wanted to try split forms, so I would like to seek a possibility to create a new look in the art world.

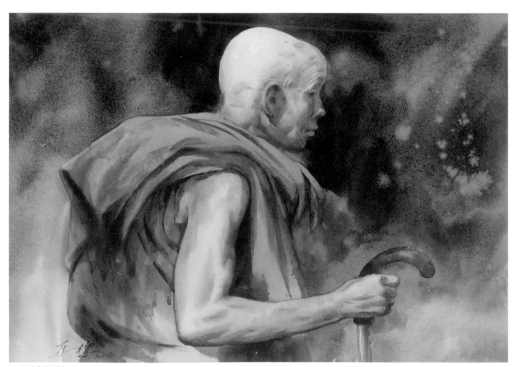

洪東標｜佛國的使者 37x54cm 2016

C4. 你曾經説你早期的分割表現形式有別於「立體主義」，能否請你説明？

多年前我以透過變形、分割與造形重組的形式，將光影的層次做理性的分析，在形式與技法上類似於立體派及未來主義中的理念，實際上我則拮取部份印象主義中對光作理性的詮釋，有條理的呈現光影的位移軌跡和明暗變化，再藉由水彩獨有的媒材特性，感性暨主觀的展現畫面中色彩層次的多變與律動，我喜歡大空間的描寫，保有三度空間的理想性表現，以畫面情境來讓觀賞者易於理解作者解釋光影現象的理念

二十多年間我作品中取材的範圍越來越廣，從早期透過以都市建築物的多面結構來表現光影，而後將風景、靜物、人物、花卉的類別漸漸引進入畫裡，取材改變了，內容增多了，變化的過程有其脈絡及軌跡可尋，為詮釋光影律動與層次美感的追求與努力依然。

C4. You once claimed that your early split form is different from the "Cubism", can you elaborate on the differences?

Many years ago, through the form of deformation, division and shape reorganization, I rationally analyzed layers of light and shadow in my watercolor works. The form and technique were similar to those in the Cubism and Futurism. In fact, I utilized part of the Impressionism to interpret light. Presenting light and shadow with displacement of the trajectory and shades of change in a rational way, I made use of unique characteristics of watercolor, emotionally and subjectively showcased changes and rhythm of color layers. Fond of depicting big space, I kept the concept of three-dimensional space to allow viewers to easily understand what was intended in the work regarding light and shadow.

More than 20 years passed, the range of my works has become broader and broader. From the early stage---the multi-faceted structure of urban architecture to express light and shadow, to the scenery, still life, people, and flowers, mixed subjects have been gradually introduced into the class. Materials changed, and the content

also increased. The process of change has its context and trajectories, but the interpretation of light and rhythm, and the pursuit of beauty in layers can still be found in those works.

C5. 在你進行畫面分割重疊的創作時，憑藉的是甚麼理念和依據？

在這個時期。我的創作是相當理性的，理性的是每一件作品都經過緊密的構思來構圖，如何創造出光線投影的方向，及其造成的明暗的層次變化，進行一層一層由淺入深的疊染，過程中冷靜地思考著每一筆要疊在何處，計算著每一個色塊的面積和律動的節奏趣味，後來我研究了國內外名家的作品，歸納出幾種形式，以建立更札實的論述基礎，但是創作時我反而不去理會這些形式，讓自己更自由自在地來畫，畢卡索何嘗不是如此

後來在研究所的論文中發表，也在不同場域演講時發表，竟然頗為叫好，我稱之為分割表現四個準則，一是切割後的起伏光影，二是分解後重組的錯位，三是局部的重複影像，四是曲面結構轉折，如下列附圖1~4，後來有一次有聽眾希望我以自己作品為例解說何處是應用四個準則中的第幾個準則，我哈哈大笑地請大家自行對照，因為我自己也不知道。

圖1：切割後重組形成錯位的效果。
圖2：將物像變形，曲線切成直線段組合。
圖3：滾動的過程造成的重複影像。
圖4：光影重疊造成的豐富的層次

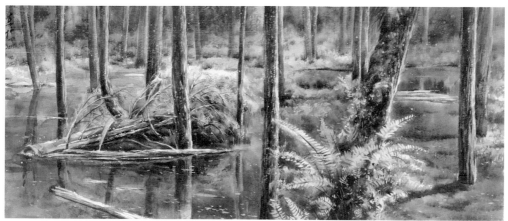

洪東標｜生與死之間，24x56cm，2014

C5. By virtue of what idea or what basis, were your split form and overlapping works created?

During that period, my creative process is quite rational. By "rational", I refer to the fact that each piece of work had been carefully conceived before the composition--- how to create light projection, and its resulting changes in the layers of light and shade. From shallow to deep stacking, the process of calmly thinking about where to stack, calculating the size of each color and fun of rhythm was pure ration. Later I studied celebrated works of domestic and foreign elite painters, and summed up several forms to build more solid theory bases. But when starting to paint, I did not care about these forms so that they were more liberal to come to my work. Isn't it the case with Picasso?

In later days, those paintings were published in the Art Institute paper, and also in different speeches and fields. They turned out quite applauded and acclaimed. There were four criteria for split forms: the first is the ups and downs of light and shadow split. The second is the dislocation after decomposition. The third is a partial duplication of the image. The fourth is the surface structure of the transition, as shown in the following Figures 1 to 4. There was once an audience expected me to use my own works as an example to explain my application of the four guidelines. Laughed loudly, I invited the audience to look for themselves since I did not know, either.

C6. 是什麼原因讓你決定放棄分割表現形式的創作？

將近二十年的時間裡，就如前所述，這樣的創作無法感性地畫自己想畫的畫，正逢家庭的責任壓力及孩子成長中最需要父愛的階段，創作的時間受到擠壓，作品量相對地少，又目睹一些前輩畫家駐足不前的窘境，感受到藝術家應尋求不斷的成長與轉換，創新是永無止境，我體會到分割表現形式的畫作是視覺表象的感受，無法更深沉的在感情部分營造視覺表象的感受，無法在感情部分營造更深沉的厚度，加上恢復熱愛寫生後重燃對台灣自然鄉土的情感關懷，於是我決定讓創作之路更寬廣，不侷限在一種面向裡。

C6. What is the reason for your decision to abandon the split form of expression?

For nearly two decades, as mentioned earlier, such creation fails to allow painters to emotionally express what they really intend to reveal. Coincided with the pressure of family and the stage in which my children needed to grow with a father's love, the time of creation was squeezed. The number of works became relatively small, and I also witnessed some predecessors' painstaking dilemma. I then felt artists should seek constant growth and transformation. Innovation is endless. I came to realize that the division form was a visual representation of feelings, failing to more deeply express emotional thickness. Coupled with the love after rejuvenation of sketching Taiwan's rural scenery, I decided to make the creating road broader, without the limitation of only one aspect.

C7. 你如何在畫面中同時表現出水彩的輕巧透明性和油畫的厚實感？

夕陽下的官芒花（局部）

我認為「水能載舟也能覆舟」，水彩因為水性的特殊性質跟中國水墨非常接近，所以以往有一些前輩畫家過度的注重水分的趣味而忽略

西方繪畫中非常重視的素描，和繪畫內容中應有的結構性和空間性，水墨形式的水彩畫被譽為是「中國式的水彩」，更是「東西藝術的融合」，我認為這是形式和技術的表象融合，卻讓社會大眾誤認為水彩就是一種具有中國水墨趣味，玩玩水分的小技巧和小趣味的繪畫方式。

其實我們曾經看過十九世紀一些傑出的英國水彩畫家的作品，根本和油畫沒兩樣，水彩也是一種繪畫的媒材，所能表現和追求的繪畫結果還是一樣；我的創作一直期望做到的不只有水彩的水份的趣味等，它還可以有油畫的肌理和厚實的層次，可以與油畫抗衡的。但這都是透明的畫法，不是用不透明的顏料來推疊，依靠的是素描基本功夫和表現技巧。

C7. How do you show the lightness and transparency of watercolor plus the thick sense of oil painting in your watercolor works?

I believe in the proverb: "Water can carry a boat, but the boat can also be overturned by water". Because the special nature of watercolor is close to Chinese ink, some senior painters over- emphasize the fun of water flowing and ignore the sketch, structure, and space in Western paintings. They hold a belief that watercolor in the form of ink and water is known as the "Chinese-style watercolor"; it is "the integration of Eastern and Western art". Nevertheless, I think this is appearance of integration of form and technology, which causes the misunderstanding of the public. They mistake watercolor for a kind of Chinese ink with fun, playing with water and small tricks in the painting,

In fact, we have seen some outstanding works of British watercolor painters in the 19th century. There is almost no difference between their watercolor works and oil paintings. Watercolor is also a medium that can showcase the pursuit of beauty and results of paintings. My creation has been expected to include not only the fun part of water, but also the texture and thick layers to compete with oil painting. But I paint mostly with transparent watercolor, not with opaque pigments to stack, relying on the basic sketch skills and performance.

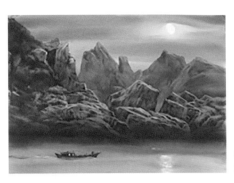

洪東標｜銀色月光照東引 Silver moonlight in Dongyin
55x75cm 2008

C8. 什麼動機促使你開始在 2007 年開始創作「夜景系列」？

2007 年在馬祖服兵役的兒子說，他在東引島站夜哨的時候，看到月亮從東方海平面上升起，銀色月光灑在平靜的海面上很美。他的描述引發了我去馬祖的動機。前後兩次我去東引，東引的夜色的確很美，令我感動，尤其是它的海岸線。於是我試著畫的第一張夜景就是東引海岸〈銀色月光照東引〉，當時我面對一張白天從海上拍到的海岸照片，思考了很久，才決定畫成晚上月光下的海岸，我最喜歡那種寧靜的感覺，被我畫出來了，我自己相當滿意。於是我就繼續畫了一系列的月夜的作品，前後三年之間將近 30 幾件，都是將日景的照片畫成夜景，當然裡面有很多的生活體驗和想像。

C8. What motivates you to start creating "Night Series" in 2007?

In 2007, my son doing his military service in Matsu said that when he was standing guard at Dongyin, he would watch the moon rising from the east sea level. The silver moonlight sprinkling on the calm sea was impressively beautiful. His description motivated me to go to Matsu. I went to Dongyin twice; the night there was indeed very beautiful. Therefore, I was moved, especially by its coastline. I tried, therefore, to paint the first night view. I faced a photo taken during daytime, pondering for a long time before deciding to draw the moon night. I like the kind of peaceful feeling the most, and I succeeded in painting the serenity. Satisfied and content, I continued to create a series of moonlight works. During three years, nearly 30 pieces were finished with pictures of the daytime. Certainly, they are enriched with a great deal of life experiences and imagination.

C9. 你能不能以實際的作品來做說明，如何將白天的照片畫成夜景？

以我的相機設備和技術其實很難拍出真正的夜景照片，尤其是在沒有任何燈光的環境裡，一片漆黑，所以只能想像，我以〈東引的夜釣客〉為例，東引在西引島的最北端有一個小海灣，上面有「國之北疆」的石碑，當我決定把它畫成夜景，我把明暗反差做大了之後，月光的亮度出來了。平直的海岸沙灘改成彎的，因為在這些堅硬的稜角岩石間，呈現一個圓弧的海岸，是會更美的。在海灣裡有一個月亮倒影，顯得非常的平靜，沒有什麼浪，加一個釣魚的人，拿著燈在沙灘上走，燈光會在沙灘上拉出一個人的影子。這是用繪畫的經驗去想像，畫出人拿著燈的動作，背著東西和一個釣竿，所以叫做〈東引的夜釣客〉；其實我根本不知道在那個軍營的區域裡是不是可以夜釣，這就是畫家創作的自由了。

東引海灣實景 The real gulf in Dongyin

洪東標｜東引夜釣客 Night fishing in Dongyin 55x75cm 2008

多一個例子是，2007 年我去福建土樓的途中經過這個小鎮，很多觀光客會在這裏停下來，它有一條小路經過，旁邊有一條小溪。我覺得這條路用水泥板鋪的這麼平，顯得太硬，不夠樸拙。所以在經營畫面的時候，我就思考怎麼改變，結果是這樣的：月光照在屋頂上和左邊的這面牆上，這個牆面的透視很重要，我需要它形成一個畫面的深度。其實從照片中看不到這面牆，我必須讓月光在這牆面上亮起來。加上屋簷、屋頂的投影，就有月光了，然後再加上走在草坡地上這個人，他走在土路上，不是水泥地了。這個溪流中有石頭，石頭上也有光、有影子，石頭上圓弧形的光是設想出來的，同時有投影。

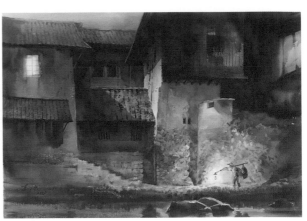

小鎮溪徑實景 Real scene of town creek road　　　洪東標｜夜行者 Night walker 55x75cm 2009

C9. Can you make a description of the actual work; how do you paint night scenes with the daytime photo?

As a matter of fact, it is difficult to shoot a real night view with my camera equipment and technology, especially in the absence of any light. It was pitch- dark, so I could only imagine. Take <Night fishing at Dongyin> for an example. There is a small bay in the northernmost part of the west of the island. A stone tablet is inscribed with "northern part of the country". When I decided to paint it as a night scene, I made the brightness of the moon emerge out of the contrast. The straight coast of the beach was changed to a bent one because in these hard edges and corners of the rocks, showing a rounded coast would be more appealing. There are no waves but a moon refection in the bay; it is very calm. Plus, a fishing man was holding a lamp on the beach, and the light would reveal on the beach a person's shadow. This is the experience of painting out of imagination. I painted that man holding a lamp, carrying stuff and a fishing rod, so it was called <Night Fishing at Dongyin >. In fact, I do not know whether night fishing is allowed in that area of military field. Such is the freedom of the artist's creation.

One more example is that in 2007, I went to visit Fujian Tulou (Earthen). On the way I passed a small town, where many tourists frequently stop to take a trip. There was

a path next to a stream. I felt that road with cement board so flat was too hard, not rural. So when I worked on the picture, I thought about how to make changes. The result follows: the moonlight shines upon the roof and the left side of the wall, so the perspective here is very important. I need it to form a picture depth. In fact, from the photo, we cannot see this wall; I must make the moonlight brighten up on this wall. I add the eaves, and the projection of the roof, then there appears the moonlight. And then the man walking on the grass slope is added; he walks on the dirt road, not a concrete. There are stones in the stream, and there are light and shadow on those stones. The arc on the stone with projection is imagined and created.

C10. 在觀賞你的「夜景系列」的作品中，可以感受到一股寧靜祥和的氛圍，你是想藉此表達什麼意境嗎？

我為什麼要畫寧靜的夜？是因為我真的有所感觸。我希望藉由作品中所傳達一種寧靜的氛圍，能夠營造出一股動人的力量。我在畫面中都有一個小小的人，不管畫中的他是要回家，還是坐著在看海，都是孤獨寧靜的，試想，我們就是這個畫中人物，在那樣的氛圍裡沉澱心中的喧囂、雜念，得到祥和之後再仔細地去思考。

我是常常獨自地思考我要怎麼創作？這條路怎麼繼續走下去？尤其在水彩這個領域，不受重視，市場又小，思考自己的創作；自己的角色是一個畫家以外，也是一個水彩老師，當時我還是一個水彩協會的理事長。所以只有在孤獨的時候、沉澱自己的時候，才能夠找到自己的方向。 特別是處在台灣這種喧囂不安的現況，那種被激化出浮躁的民心的時候，更需要大家能夠體驗孤獨和寧靜的這種氛圍，看看畫能否讓大家能夠平心靜氣地來促進這個社會的平和，來享受台灣這個寶島生活，營造一種平和的幸福！

這不是什麼大道理。其實我很卑微地滿足於畫畫的理想，希望這樣的作品能夠帶給大家一點正面的啟發，追求「藝術的價值在提升人類生活的品質」的理想，也只有這樣，藝術存在的價值才是崇高的，藝術家才值得尊重。

C10. In watching your "Night Series" works, the audience can feel a quiet and peaceful atmosphere. Do you want to express a particular mood?

Why would I paint a serene night? It's because I really feel. I hope that through the works I can convey a quiet atmosphere, and a moving force. There is a small person in the picture, whether he's going home, or sitting by the sea, is lonely and quiet. Try to imagine that we are the characters in the painting: in that atmosphere and in the precipitation, to get rid of noises and clamor, distractions⋯. We obtain peace prior to thinking carefully.

I often ponder about how to create my own works? How does this road go on? Especially in the field of watercolor, not being paid attention to, and the market is small, I think about my own creation. Besides the role of a painter, I am a watercolor teacher. At that time, I was also a watercolor association director. Hence, only in the lonely time, and the precipitation of my own, would I be able to find my own direction. In particular, in the hustle and bustle of Taiwan, people feeling impetuous, we need to be able to experience the kind of loneliness, quiet atmosphere---to see if we can calmly promote peace in this society, to enjoy such a Taiwan island life, to create peaceful joy!

This is not self-righteous truth. In fact, I am very humble to be satisfied with the ideal of painting. Sincerely I hope that such works can bring forth a little positive inspiration, and the pursuit of "the value of art in the promotion of quality human life". And only by doing so, will art become invaluable, and artists worthy of respect.

C11. 近來你的風景畫有很大的改變，你期望在的風景畫裡表現出何種特色？

水彩是來自西方的媒材，在學習過程中我們經常受到西方美學的影響，以西方的標準來評估作品的好壞，但是我是一個東方的水彩畫家，如何融入中國人的生活美學，畫出具有東方特色或是中國特色的水彩畫，甚至於是具有台灣特色的水彩畫，這才是我們當代畫家的一大課題，雖然我們的骨子裡流著東方的血液，畫出

來的卻是西方的畫，所以早期的前輩畫家大舉東西文化美學融合的大旗，開始用西方材料畫中國傳統的水墨畫，融合水墨畫的大渲染，成了一時水彩的表徵，其實那只是材料被廣泛的應用和技巧的拓展，跟東方精神完全無關，更與傳統美學搭不上關係。

我認為過度地強調水彩的特點或優點，就成了缺點，總會讓畫面單薄，不夠厚實，肌理不夠，層次不足…，所以我用技法來補足這些問題。例如近景的草地部分我用乾筆刷出痕跡，再去重疊，希望能做出雜草的質感。這些東西，比較類似油畫的技法，我還是用透明的畫法來表現，而不是用不透明的畫法來表現。我的水彩畫要跟別人不同，表現水份淋漓、輕鬆輕巧的特點部分要保存，也同時要有嚴謹、厚實的部份來呈現畫面。

C11. **Recently your landscape paintings have changed a great deal, what kind of characteristics do you expect to include in them?**

Watercolor is a medium from the West. In the course of learning, we are often influenced by Western aesthetics, using Western standards to assess art works. As an oriental painter, how to integrate into Chinese people's life aesthetics, painting a watercolor with oriental or Chinese characteristics, and even with Taiwanese characteristics is a major topic for our contemporary painters. Although we are born with oriental thoughts and aesthetics, our works are painted in the Western way. In early days, the painters calling for large-scale cultural and aesthetic fusion of East and West, began to use Western materials to draw traditional Chinese ink painting. The fusion of ink painting suddenly became a fad of watercolor characterization. In fact, it is only a wide range of materials and skills expanded, completely irrelevant with the East Spirit. It is also not related to the traditional aesthetics.

I think that excessive emphasis on the characteristics or advantages of watercolor can become a disadvantage. It always makes the picture "thin, not thick", without enough texture, lack of layers so I use certain techniques to compensate for these problems. For instance, I often use dry brush strokes to paint a meadow in the front.

And then I overlap the strokes, hoping to make weed texture. These techniques are similar to those in the oil painting. I still use a transparent painting to express, rather than opaque colors for my performance. My watercolor painting is to be differentiated from others --- the performance of water dripping, easy and lightweight features to be preserved, but also rigorous, thick parts of the picture.

C12. 請你列舉你認為創作生涯中最成功的代表作品？

伍迪艾倫說：「邁向偉大，最大的障礙就是自己」，對一個藝術家來講，創作是永無止盡的追求最美的作品，到目前為止我仍然在堅持創作更好的作品，我總相信下一張會更好．

C12. Would you like to list the most successful representative work you in your career?

The American author and director, Woody Allen, contended: "Towards the great, the biggest hurdle is ourselves". For an artist, creation is the never-ending pursuit of the most beautiful works. So far I've still insisted on creating better works. I'm always convinced that the next work will be better.

洪東標｜寂靜茶園 21x44.5cm 2014

C13. 能具體地來說明，你的理想是如何表現屬於具有中國思想的作品特色嗎？

就內涵來說，我希望在作品中呈現一種屬於中國傳統哲學中天人合一的思想概念，就如我畫台灣，我是一個生活在這塊土地上的人，體驗未必深刻，但是當你去描繪它的時候，情況完全不一樣，我熱愛寫生，當我坐在堅硬的石頭上，感受帶有海味的風和溫度，聽著樹葉在風中的呢喃，路人的閒言雜語和狗吠雞啼，看得仔細、望得頻繁地一筆一筆畫下這塊土地上的線條和色彩，我企圖將自己置身於畫中，融入在那一個畫中探索這塊土地的人身上，循著步道走入畫中，去體驗融入自然中的一種孤獨，

藝術家何懷碩在 2010 年為菲利浦科克 (Philip Koch) 著作「孤獨」序文中提到：「孤獨是人生的本質，是生命的真相，每個人的生命都像大海中孤獨的小舟，不論王公將相、平民百姓都逃不了孤獨的暗影。」他覺得孤獨是一場惡夢，眾人唯恐避之不及，往往孤獨會變得尖酸、敏感、病態、可悲、脆弱、自怨自哀、憤世嫉俗，甚至歇斯底里。但是我認為在喧囂的台灣社會裡，孤獨者的末梢神經容易體察到的悲傷、溫柔、喜悅，使活著的感受更為迫切，這「迫切的感受」能激發天馬行空的大塊靈感，甚至讓人「醒著做夢」，來場「既免費又不傷身」的酒精效應。其實在古代的中國，孤獨是文人生活中不可多得的奢侈，古代畫家縱情於山水，即是借景抒情，滿足了觀賞者脫離喧囂、享受寧靜，不被干擾的孤獨，在中國的美學中「孤獨」的藝術表現，如唐朝柳宗元的詩「江雪」：

「千山鳥飛絕，萬徑人蹤滅，孤舟簑笠翁，獨釣寒江雪。」

詩作〈漁翁〉描寫孤獨的「陶醉於山水」：

「漁翁夜傍西岩宿，曉汲清湘燃楚竹。煙銷日出不見人，欸乃一聲山水綠。」

孤獨就是一種藝術的源頭，往往就能產生藝術，孤獨成了醞釀精神美酒不能缺少的「酒麴」。

就表現形式上，我認為水彩一直被過度的重視表現技巧和水分的趣味，在藝術表

現中，略嫌本末倒置，澳洲水彩協會會長布萊恩 Bryan 曾說：「不要畫水彩畫，要以水彩來畫畫。」這句話的精神就在於強調，我們必須捨去水彩固有的形式，把水彩當作是一種純粹的工具材料，去創作一幅與油畫或其他媒材無分軒輊的藝術作品，因此在我作品裡，水彩所能呈現的乾濕趣味，必須圍繞在物象形體的素描概念裡，有堅實的結構性和空間性，畫面既有水彩的水分流動性趣味，又兼具厚實的肌理和層次。

C13. Can you specifically explain your ideal concerning expressing characteristics of works with Chinese thoughts?

In terms of content and connotation, I hope that there is a concept or thought belonging to the unity of man and nature in Chinese traditional philosophy. This is nearly the same with my painting Taiwan. As a person living on this land, my experiences may not be profound. But whenever I depict this island, the situation is completely different. I love painting sketches. When I sit on a hard stone, feel the wind and temperature of the sea, listen to leaves in the wind whisper, passers-by gossip or dogs barking, cocks crowing, and then I watch closely and frequently to paint stroke by stroke. Trying to put myself in the picture, I follow the person who explores the land. I also walk through the trails. Wandering into the painting, I try to experience the integration of loneliness in nature.

Artist Hur Huaishuo stated in the preface of "Solitude" written by Philip Koch: "Solitude is the essence of life; it is the truth of life. Everyone's life is like a lonely boat in the sea; whether endowed with royal backgrounds or civilian population, all cannot escape the lonely shadow. "He felt that being lonely is a nightmare that everyone evades to avoid. Oftentimes lonely people become sarcastic, sensitive, sick, pathetic, fragile, self-pitiful, cynical, and even hysterical. But I think that in the hustle and bustle of Taiwan society, lonely people whose peripheral nerve easily perceive sadness, tenderness, and joy, so that the feeling of living is more urgent. This "urgent feeling" can inspire a great amount of inspiration, and even cause people to "awake to dream", intoxicated in the free and harmless "la la land". In ancient

China, loneliness was not rare for refined scholars; the ancient painters indulged in such loneliness in the landscape. That is, with lyric scenes, they led viewers to escape from the noise and clamor, enjoy the quiet, and not disturbed loneliness. In Chinese aesthetics, " Lonely "artistic expression, is presented in Liu Zongyuan's poem" Jiang Xue (The Snow-covered River)" in Tang Dynasty:

Not a bird from thousands of mountains flew away,

Not a soul nor trace of footprint on any way.

An elderly man on a raft dressed in coir raincoat,

Alone is fishing in the frosty river's snow.

In the poem "Fisherman", he also describes being lonely and intoxicated in the landscape:

In dusk, a fisherman rests his boat near West Rock.

Morning has broken; he draws water from Xian river, burns Chu bamboo.

The sun rises with no smoke. Disappears who?

Humming and rowing, he turns and views water green, mountains blue.

Loneliness is the source of art, often leading artists to produce art. Thus, loneliness has become the "wine yeast" of brewing the wine of spirit.

In the form of expression, I think watercolor has been over-emphasized on performance skills and moisture of the media. In the artistic performance, this is slightly overturned. Australian Watercolor Association President Bryan said: "Do not paint watercolor, but paint with it". The spirit of this sentence is to emphasize that we must abandon the form of watercolor, treating it as a purely instrumental material to create a piece of art that can compete with oil paintings or other media. In my work, watercolor can be revealed with taste and texture of dry and wet pens, centering on the sketch concept of objects. There is a solid structure and space; the picture is filled with the fun of water flowing, but also thick texture and layers.

C14. 你曾經創下一個紀錄，是第一個畫家以機車環島寫生方式，完成台灣海岸百景的寫生紀錄，能請你述說當年從事海岸百景的動機嗎？

2011 年的某一天，我和一群同事聊天，有地理老師和歷史老師，剛好聊到「福爾摩沙」這個名詞，我確認了這是十六世紀葡萄牙人航海經過台灣時，驚見台灣美麗的海岸美景，於是驚呼：「福爾摩沙」；這樣的讚美已經流傳了五百年，卻從沒有一位藝術家為她留下完整的記錄。

剛好當時電視上的一個廣告，有一群八十餘歲的老人家騎機車環島，終於圓夢了，令人感動，我回想自己三十幾年前也曾經有過以機車環島的夢想，可是從未實現，現在我如果能以自己粹煉三十年的繪畫表現能力，循著台灣海岸線進行環島寫生，為自己所珍愛的這塊土地留下完整的海岸之美繪畫作品做為紀錄，呈現新世紀的「福爾摩沙」面相。再藉由展出喚起島民更珍惜台灣之美，更惜福知足、共同守護這一塊美麗之島「福爾摩沙」。這不是太美好了嗎？所以有了這個計畫。

C14. You have set a record---the first painter that motorcycles around the island to sketch and complete 100 Taiwan coast paintings. Can you elaborate on the motive to finish "the coastal hundred" in that year?

One day in 2011, I chatted with a group of colleagues. A geography teacher and a history teacher happened to talk about the term "Formosa". I confirmed that in the 16th century when Portuguese sailed by Taiwan, they were so amazed at the beauty of the coast that they exclaimed: "Formosa"! This praise has been circulating for five hundred years, but never did an artist leave a complete record for her.

At that time, there happened to be an ad on TV --- a group of eighty-year-old seniors riding motorcycles to travel around the island, and finally they achieved their dream. It was indeed very moving. I recalled that 30 years ago, I also had had a dream to circle around the island, but it was never achieved. I wondered that if equipped with more than three decades of watercolor experiences, could I follow the coastline of Taiwan to sketch, for my own love for this piece of land, leaving a complete

洪東標｜日光浴 29x45cm 2016

impressive coastal works as a record, showing the new century " Formosa"? And then probably I could utilize the showcase to evoke the islanders to cherish more the beauty of Taiwan, and also feel satisfied and blessed to become common guardians of this beautiful island "Formosa." Isn't that too good to be true? Subsequently, I conceived such a plan.

C15. 當年你是以多少時間完成這項計畫的？計畫中還完成了什麼相關活動嗎？

我是以兩個月共 56 天的時間，騎乘機車沿著海岸線進行三千多公里的環島寫生，完成一百多件以上作品，事後再經過半年的整理，最後以 118 件作品在 2012 年的十月二十四日起在中正紀念堂正式展出。當時為了讓更多的朋友參與關懷海岸的活動，我透過網路邀請各地熱愛藝術的朋友一起來畫我們的海岸，每一個縣市一個半天，可惜當時訊息傳播不是很充分，反應不太熱烈。

C15. How much time did you spend on finishing the project? What related activities have been done in the program?

It took me approximately two months, a total of 56 days to ride a motorcycle traveling along the coastline for more than 3000 kilometers of the island. During that period, I sketched on the way and completed more than 100 pieces of watercolor. Six months after the journey, I finally officially exhibited 118 works on October 24, 2012 at Chiang Kai-shek Memorial Hall. At that time, in order to allow more friends to participate in caring about activities of the coast, I invited all friends who love art to paint our coast through the Internet. I planned to save half a day for each city or county. Unfortunately, the message was not fully transmitted; that event was not so warmly welcome as expected.

洪東標│浪拍岸 55x75cm 2015

C16. 這次的環島寫生之旅，你在畫冊上區分為桃竹苗海岸、中彰海岸、雲嘉南海岸、高屏海岸、墾丁半島海岸、花東海岸、蘇花海岸、蘭陽海岸、東北角海岸及北海岸等 10 個區域。面對各個海岸也許雷同的風景，你是如何在畫面中表現其多樣性的？

台灣是一個地質和地貌非常豐富多元的島嶼；台灣西部多平原，渡海移民開發較早，我主觀的將此區域依據產業特徵、自然面貌、及行政區來區隔、強調天人合一的景觀特色、 如捕捉鰻苗架設的漁網、沙洲、火力發電廠、風力發電機、造林防風的圍籬、漁港設施、岸外工業區等；而南部海岸就以椰林、珊瑚礁等極具熱帶風情的題材為主；東部多山，山海交界造成岩岸地形特徵非常明顯，壯闊的太平洋沿岸保有原始的自然生態和樸實的農業風情，岬灣交錯的北部海岸則多火山地形和東北季風千百萬年共同雕琢的奇岩怪石，寫生的過程，我理性的探索、觀察，再以感性的體會來進行描寫，雖然都是海岸，但因天氣的變化、時間的更迭、季節的變換，在在都能展現多采多姿的台灣海岸美景。

C16. In this book of island sketch, you basically make a distinction of 10 areas: Taoyuan, Hsinchu, Miaoli coast, Taichung, Changhua coast, Yunjia South Coast, Kaopin coast, Kenting Peninsula coast, Hualien East coast, Suhua coast, Lanyang coast, northeast corner, and north coast. With similar coast scenery, how do you present diversity in your painting?

Taiwan boasts very rich geology and geomorphology. There are more plains in the western area; early immigrants crossed the sea to explore. I subjectively distinguish this area based on industrial characteristics, natural appearance, and administrative regions, emphasizing landscapes of nature and human. For instance, there're fishing nets set up to capture eels, sandbar, thermal power plants, wind turbines, fencing of afforestation, fishing port facilities, offshore industrial areas, etc. And the southern coast mainly includes coconut groves, coral reefs and other tropical themes. On the eastern mountainous area, characteristics of the sea boundary caused by rocky terrains are very obvious. The magnificent Pacific coast retains the original ecological and simple agricultural style. Northern coast is crisscrossed with the cape bay; the volcanic terrain and northeast monsoon in millions of years have carved strange rocks and stones. In my sketching process, I rationally explored, observed, and then depicted with my emotional experiences. Despite similarities of the coasts, the changing weather, the passing of time, the transformation of seasons, all help to showcase the colorful scenery around.

C17. 畫作的內涵是你創作時最優先考慮的因素？還是展現水彩創作過程的繪畫性趣味和效果？

我認為，畫作的內涵也稱作是深度，這不是水彩描寫過程能自然產生結果，是要刻意追求經營的，不能讓位於自然過程出現的某些偶然的漂亮肌理效果。漂亮的效果是畫家使用的手段，深刻內涵才是表現的目的。繪畫性趣味和效果絕對是繪畫中不可或缺的一部分，但是過於重視除了本末倒置，也可能成為制式的表象。

C17. What is the priority of your creation? The content first or the fun and effect shown in the process of your painting?

I believe that content and connotation of a painting, also called the depth, is not produced naturally in the creation. It is to be deliberately pursued or worked on. It cannot give in to some occasional beautiful texture effect in the natural process. Beautiful texture effect is one of the means utilized by artists whereas profound content is the purpose of performance. Painting interest and effect is absolutely an indispensable part of the painting, but too much attention paid is to put the cart before the horse. It may become a standard appearance.

C18. 你的水彩畫既是傳統的媒材又是寫實的表現形式，在 21 世紀這樣多元的藝術表現領域裡，你認為還會有喜歡的觀賞者嗎？

在我們的藝術創作的領域裡，就好像是廚師，憑藉每位藝術家的素質與修養，烹調出不同口味的佳餚，提供不同愛好的顧客選擇。其實在短暫的時間裡我們會認定哪種最好吃，有些嘗鮮的新料理認為很好吃，但是我們不會戒掉已吃多年仍然愛吃的傳統菜餚。藝術的表現讓餐桌上的好吃的菜肴豐富起來，滿足不同胃口的人們多方位的選擇或不同時間上的需要，喜歡傳統水彩的人還是不會忘記的吧？

C18. In the 21st century with such a diverse field of artistic expression, your watercolor is with both traditional media and realistic expression. Do you think there will still be certain viewers who like it?

In the field of artistic creation, painters work somewhat like a chef. With each artist's qualities and cultivation, cooking various tastes of dishes, we provide different culinary options for customers to choose. In fact, in a short period of time, we will identify which is best to taste. Some adopters of the new cuisine may taste it deliciously, but we will not quit eating tradition dishes that have accompanied us for many years as well. The performance of art makes delicious dishes on the table rich in different times---to meet various appetite of people with multi- needs. Those who prefer the traditional watercolor would certainly not forget it?!

C19. 在生活中，你如何找到創作的元素？

藝術原本就來自於生活，繪畫是絕對的視覺藝術，從生活視覺的體驗中就有無限寬廣的資訊可供畫家取之不盡用之不絕。在自己的感動中，我選擇以「對比」為原則來尋求題材，畫面中的「空間對比」、「色相對比」、「明度對比」、「比例對比」、「造型對比」，經常在閒暇時，漫步在生活環境中以此為原則尋求題材，或在旅行中搜尋創作元素，不論是現場寫生或是拍照進入畫室創作，當你架起畫架寫生或拿起相機取景，在生活的周遭選擇取景你就已經進入創作的情境中了。

C19. How do you find the elements of creation in life?

Originally and naturally, art comes from life. Painting is absolutely visual art: from visual experiences in life, painters find infinite and inexhaustible information. I like to use the "contrast" principle to seek the theme--- "space contrast", "color contrast", "light contrast", "proportional contrast", "modeling contrast", and so forth. In my leisure time, when walking in various surroundings, or in search of creative elements in travel, I hold such a principle to seek the subject matter. Whether it is sketching or taking pictures to paint in a studio, when I set up an easel or pick up the camera to shoot, I am already in the process of creation.

D

工具與色彩
Tools and Materials

「... 在我的調色盤中，綠色只有胡克綠，透過調色可以呈現出非常豐富的綠色世界，暖色系的綠色表現近景及受光的樹林，在冷色系的綠色調中用鮮藍，再分別調色，...」

「...In my palette, there is only one green color---HOOKER'S GREEN LIGHT. But by using it alone or blending this color with others, I can showcase a very rich green world---warm green appearance in close scenes and light - receiving woods; if the cold color with the green tone INTENSE BLUE is added, and then respectively, ...」

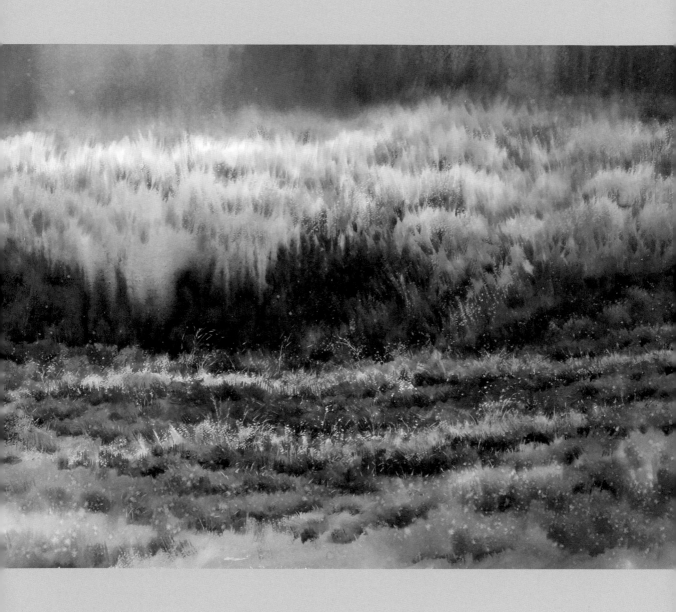

洪東標｜夕陽下的官芒花　55x75cm　2016

D1. 你能說明你的慣用色彩嗎？

我所知道的水彩繪畫大師們的調色盤上顏色種類都是很少的，但沒有人敢說他們不是偉大的色彩家。我的調色盤在沒有特殊色彩需求的情況下，只有10來種顏色，這個調色盤無論畫風景或者是靜物甚至人物，都是足夠的。主要有：

玫瑰紅 ROSE PERMANENT

鎘朱 CADMIUM RED HUE

鎘黃 CADMIUM YELLOW

黃赭 RAW SIENNA

岱赭 BURNT SIENNA

凡岱克棕 VANDYKE BROWN

焦茶 SEPIA

胡克綠 HOOKER'S GREEN LIGHT

鮮藍 INTENSE BLUE

鈷藍 COBALT BLUE

群青 ULTRAMARINE

藍紫 DIOXAZINE VIOLET

有時候在面對特殊色彩需求的時候，也會加上其他色彩如石綠和銅藍等顏料。

D1. Can you explain your color usage?

As far as I know, color types on the watercolor masters' palettes are very few, but no one dares to say they are not great colorists. If without special color needs, there are only around 10 colors on my palette. Whether painting scenery or still life, and even portraits or figures, the colors are enough for me. They are mainly ROSE PERMANENT, CADMIUM RED HUE, CADMIUM YELLOW, RAW SIENNA, BURNT SIENNA, VANDYKE BROWN, SEPIA, HOOKER'S GREEN LIGHT, INTENSE BLUE, COBALT BLUE, ULTRAMARINE, DIOXAZINE VIOLET. Sometimes if in the face of special color needs, other colors of paint will be added.

D2. 你能展示你的工具和材料嗎？

這裡我以兩張照片來展示我的工具和材料，我的雜牌軍顏料，雜牌軍的筆，和三種品牌的紙張等，比較特殊的是應該是顏料盒和調色盤。（如上照片）

D2. Can you display your tools and materials?

Here I present two photos to show my tools and materials: my miscellaneous pigments, miscellaneous pens, and three brands of paper, etc. The special part is the paint box and palette. (photo)

D3. 2008 年畫家鄧國強稱你是綠色王國的國王，在四季如春的台灣，你如何表現各種綠色的植物？

台灣四季如春，綠色幾乎是台灣自然風景中主要的色彩，對於喜歡描繪本土風景的創作取材來說，綠色是我最重要的課題之一，寫生的時候我經常面對一大片單純的綠色的森林，仔細地觀察，發覺森林中隱藏著不同的樹種，呈現出不同的色調，在單純中有很細微的變化，加上空間距離和濕度也改變著色溫，即使在四季如春的台灣，色彩和內容也都非常豐富，體驗讓自己更深刻的認識自然的色彩。

在我的調色盤中，綠色只有一個顏色胡克綠，但是透過調色可以呈現出非常豐富的綠色世界，暖色系的綠色表現近景及受光的樹林，在冷色系的綠色調中用鮮藍，再分別調色，來形成不同明度的冷綠調表現遠處及暗處的樹林，即使在雨霧的季節裡，也都是以這些色彩依比例的不同，去營造屬於台灣本島季節性的色彩。

D3. In 2008, painter Deng Guoqiang praised that you are the king of the green kingdom. In Taiwan, where the weather is like an eternal spring, how do you present a variety of green plants and scenes?

Taiwan is nearly spring-like in four seasons, so naturally green is almost the most important color in the creation of native landscapes. Green is one of my most critical topics. When sketching, I often face a large green forest. Carefully observed, the forest is hidden in different species, showing different tones. In simplicity, there are very subtle changes. Besides, space, distance and humidity also change the color temperature. Even in the four spring-like seasons of Taiwan, the colors and content are also very rich. Try to experience and make your own profound understanding of the natural colors.

In my palette, there is only one green color--- HOOKER'S GREEN LIGHT. But by using it alone or blending this color with others, I can showcase a very rich green world---warm green appearance in close scenes and light - receiving woods; if the cold color with the green tone INTENSE BLUE is added, and then respectively, it forms different light of the cold green in the distant and dark woods. Even in rainy or foggy seasons, I also use these colors in accordance with the proportion to create seasonal colors in this island.

D4. 能請你詳加說明，是如何調出「暖色調的綠」和「冷色調的綠」來表現台灣的森林？

我慣用的綠色只有一個顏色胡克綠，但是透過調色可以呈現出非常豐富的綠色世界，其中，我喜歡在暖色系的綠色裡面分別調和黃赭、岱赭、凡岱克棕、焦茶呈現出由亮到暗的暖綠調，在冷色系的綠色調中，我喜歡用鮮藍，再分別調入上述中的各棕色系來形成不同明度的冷綠調，即使在秋冬的季節裡，也都是以這些色彩依比例的不同，去營造屬於台灣本島季節性的色彩。（附圖照片）

每列之中段色彩即是以兩色調出的冷色調的綠色　　　　　每列之中段色彩即是以兩色調出的暖色調的綠色

D4. How do you use "warm green" and "cold green" to express Taiwan's forests?

The green color I often use is HOOKER'S GREEN LIGHT, but through the color-blending I can show a very rich green world. I like to blend in the warm green with RAW SIENNA, BURNT SIENNA, VANDYKE BROWN, or SEPIA. As for the green tone in the cold color, I like to use INTENSE BLUE mixed with the above-mentioned brown colors, to transfer to different lightness of the cold green tone. Even in autumn and winter seasons, I also tend to create a seasonal color of Taiwan based on the proportion of these colors. (Photo)

D5. 你還是會告訴你的學生「黑色」和「白色」在一般水彩繪畫裡，不要使用嗎？

正確地說，是儘量不要使用，因為在傳統的寫實繪畫中直接使用「黑色」和「白色」沒有其必要性，調色又容易讓色彩混濁，以透明水彩的概念哩，白色就是紙張的白，只有在細緻的暗處需要用不透明的方式來表現，或進行補救時才用到白色；而在大自然中，很少有真正的黑色，即使是在描寫真正黑色物件時，也會因為空氣感和幅射光讓黑處不黑，黑色在畫面裡也容易不穩定的跳脫出畫面的空間層次，我一向以補色來調出的暗色來代替真的黑色。

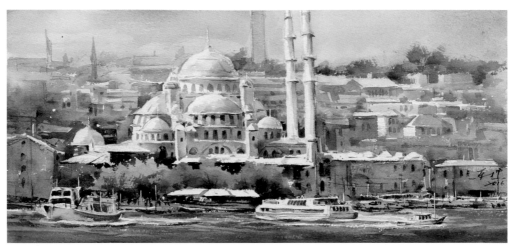

洪東標｜伊斯坦堡的陽光 19x44cm 2016

D5. Will you generally suggest your students not to use "black" and "white" in watercolor painting?

To be honest, try not to use them if possible. The reason is that in traditional realistic painting, directly using "black" and "white" is not necessary; it's easy for painters to make color opacity. With transparent watercolor concept in mind, we consider "white" as the white paper. We may need to use an opaque way to show it in the details of darkness, or use the white for remedy. And in nature, there is little real black; even in the description of real black objects, because of air and radiation, black is not black. It is also easy for black to jump out of the picture and space. I have always mixed complementary colors to replace the real black.

D6. 應如何避免顏色「髒」的感覺，如果已經覺得髒了，該如何補救？

每一個人對色彩「髒」的定義標準不同，我的經驗告訴我，除掉白色和黑色之後，畫面的顏色髒了，多半是重疊太多層次的色彩造成，尤其在畫面將乾未乾時重疊色彩最容易髒；這時候我會建議兩個方法，第一是「洗」，先用多量的水溶解這個區域紙面上的色彩，如果是結構堅實的專業水彩紙，還可以用硬毛筆輕輕地刷除紙上的色彩，再用乾淨的吸水布將該處的水分吸除，待乾，再重新上色。有時候我會使用第二個方法，我會加重色彩的濃度和暗色，在「髒」處的周圍，因為

對比的效果，可能讓「髒」處反而變得明亮一些，感覺會緩和許多。

Everyone defines "dirty color" with different standards. My experiences taught me that after removing white and black, if the color of the picture becomes dirty, it is mostly overlapped with too many layers. In particular, when the painting part is becoming dry, overlapping strokes would most likely cause the "dirty" phenomenon.

For this, I will recommend two methods: the first one is "wash", using plenty of water to dissolve the color of that region on the paper. If it is solid professional watercolor paper, you can also use a brush to get rid of the color. And then, use absorbent cloth to clean that part. Wait for it to become dry, and then re-color. Sometimes I would use the second method: I would increase concentration and darkness surrounding the "dirty" part, because the contrast effect may make "dirty" colors become bright, thus result in a comparatively "clean" feeling.

我總覺得在我的作品中，技巧的實驗性是最匱乏的，或許有人認為沒有創意，不是我沒有想法或好點子，因為我經常在教學中提到的，每一種新的技巧應用或另類的材料加入，我會考量到它對紙張或顏料的破壞性，我的化學素養不夠好，也沒時間去研究材料的化學性變化，我重視的是作品的單純性和長久保存性，所以我總是建議學生不要在畫面裡使用不被證實可以使用的材料，你或許會說缺乏實驗是不是就缺少創新，不！我認為創新不在於特殊技法，是創作理念，但是我認為藝術仍有許多可以創新的空間，即使是表現同一個題材，都有無限的可能。

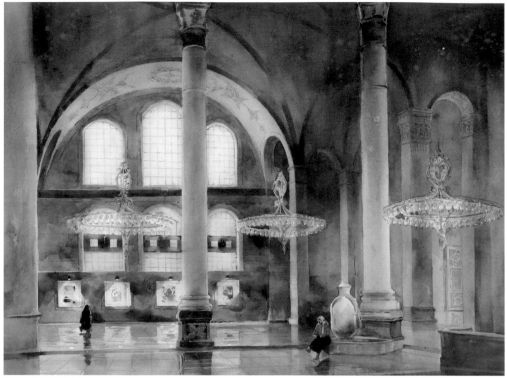

洪東標｜聖殿 55x75cm 2016

I always feel that in my works, the experiment of skills is the most deprived of, and perhaps some people think that innovation is thus needed. It's not the case that I have no ideas or good ideas. As I often mentioned in my teaching---each new skill application or alternative materials should always be considered with its destructive influence on paper or paint. My chemical literacy is not good enough, and there's no time for me to study chemical changes in materials. I therefore attach importance to simple and long-term preservation of works. So I always recommend my students not to use the material that wasn't proven harmless. You may say that the lack of experimentation isn't the lack of innovation? No, I contend that innovation does not lie in special techniques, but creative ideas. I also believe, however, there is still a great deal of innovative space in art; even with the performance of the same subject, there are infinite possibilities.

D8. 觀察你的創作過程，發現你常使用中國毛筆，能說明它的優點和特性嗎？

我是喜歡用狼毫的「中蘭竹」作畫，比較水彩筆中的圓筆和中國毛筆中的「蘭竹筆」，你會發現中國筆的筆鋒較尖也較長，也能兼具扁筆和圓筆的效果，而狼毫的彈性和貂毛的彈性相若，含水性則以貂毛略勝一籌。但畫筆是屬於消耗品，不斷地在粗紋紙上磨擦，耗損很快，所以價差很多的情況下，我選擇以貂毛水彩筆描繪線條或細節，以中國蘭竹筆製作肌理重疊乾刷的趣味。（照片）

D8. When observing your creative process, we find that you frequently use Chinese brushes. Can you explain their advantages and characteristics?

I indeed like to use "wolf pens", Chinese brushes made of weasel bristle, with middle-size orchid bamboos. Comparing watercolor round pens and Chinese orchid bamboos, you will find the tip of a Chinese brush is sharp-pointed and longer, and it has effects of both flat pens and round pens. The flexibilities of wolf pens and mink hair are similar, but the water content of mink pens is slightly better. Pens and brushes are consumables, constantly rubbed on coarse paper. So they tend to wear very fast. With distinct prices, I choose mink watercolor pens to paint lines or details, and use Chinese brushes for the production of texture or fun of overlapping dry pen strokes. (photo)

E

創作技法

Expression forms and characteristics

「... 我在畫面中的處理時大多是把視覺的焦點和畫面中的
明亮處表現為「實」；而將背景，遠處或是暗處作為「虛」。
一幅好畫一定是需要虛實相互輝映的，...」

「...Mostly I deal with the visual focus and bright parts
preforming the "real", and the background, distant or dark
parts as "virtual". ...」

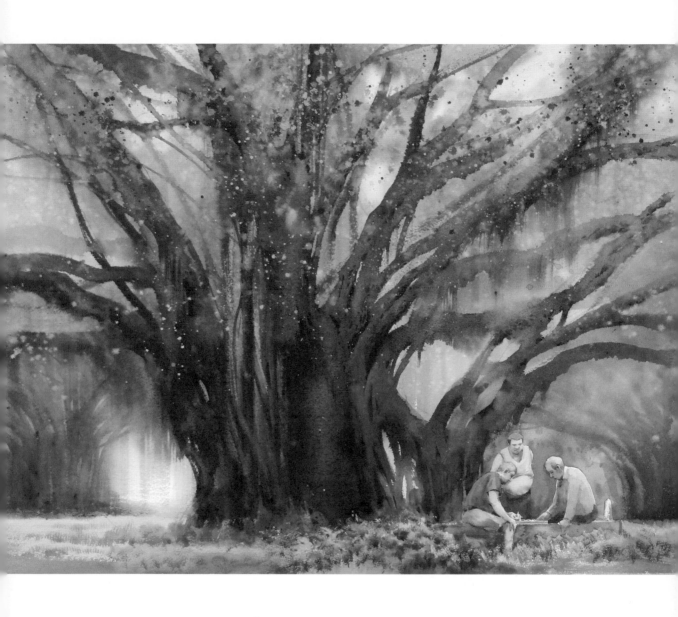

洪東標│榕樹下的午後　55x75cm　2015

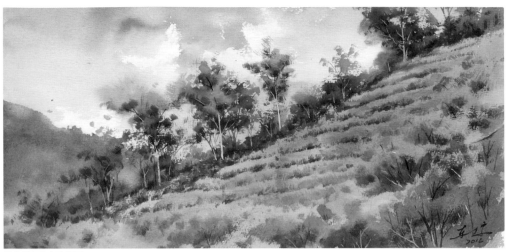

洪東標｜山上的茶園 22x45cm 2016

E1. 你認為可以透過取得授權用別人的照片來創作嗎？

我覺得一張畫要感動別人，一定是要先感動自己，才能夠感動別人，複製別人的感動是很虛偽的，原創就是將自己的體驗分享給他人的創作態度，就算是時地不宜的情況，都必須堅持不使用他人照片；十多年來我一直自我要求，我畫的每一張照片都是我拍的，除了教學示範使用學生提供的圖片外，我的創作絕對不借用他人照片：第一，那不是你的「原創」；第二，那是別人的感動，跟你無關，所以我期望所有的畫家們用自己的感動來創作，自己照片拍不好就用自己的創意和美感素養來彌補。當我們面對美景，從相機的取景框裡觀察自然，到按下快門時，我們的創作已經開始了，取得授權是免除和規避法律上的瞟竊，還是免除不了道德上瑕疵。

E1. Do you think artists can create works by obtaining someone else's photo authorization?

As mentioned before, if artists intend to move others with their painting, they must first move themselves with that certain picture. Copying someone else's being moved is very hypocritical; originality is the creative attitude to share their experience with others. Even when time and space is not appropriate, the principle must be insisted

on not using other people's photos. More than a decade I have been self-demanding; I painted every photo I took except for teaching demonstration in which I might use pictures provided by students. As for my creation, I definitely did not borrow photos from other people. First, it is not your "original"; second, it is someone else's inspiration, nothing related to you. Hence, I expect all painters create their own works out of their own inspiration. If they fail to take good photos, they can compensate for this part with their innovativeness and sense of beauty. When we face beautiful scenery, observe nature from a camera viewfinder, and press the shutter, our creation has begun. To obtain authorization is to avoid the law of plagiarism, but one cannot escape the moral flaws.

E2. 你的創作中，以「組合照片」方式來創作時，你會注意哪些重點？

不管你決定用幾張照片來組合成一張作品，相互間的「協調性」絕對是組合最重要的考慮要素，須注意到不同照片中的視角（透視中視平線高度），光源，是否一致，當然也包含物件間的大小比例，空間關係，季節與自然的條件等，這些都可以透過不斷的練習和觀察，找出失誤的地方。我在組合時一定會先畫一張素描稿，在稿子裡不斷地修正調整到滿意，才進行作品的創作。

E2. In your creation, there is a "combination of photos" way to create; what attention needs to be paid in combined photos?

No matter how many photos you decide to combine into a piece of work, the "coordination" of each other is definitely the most critical consideration. It should be noted that the angle of view in different photographs (the height of the horizon in the perspective) and that whether light sources are consistent. Certainly, you should also consider the size of the ratio between objects, space relations, seasonal and natural conditions, etc., which can be detected with mistakes through continuous practice and observation. Before the creation, I would first draw a sketch in the manuscript of combination and make several amendments to adjust till satisfied.

E3. 你能以一件作品創作實例來解説如何「組合」嗎？

2008 年大幅作品〈航向光明〉，靈感來自於東引的東湧燈塔，我稱之為「台灣最漂亮的燈塔」。它座落在一個很高的岩岸上，我沒有機會從海面上看它，我從自己拍的照片去設想，我想從海上畫它，加上一些東引海岸的岩石，把畫面理想化，於是我開始大膽嘗試。初步的鉛筆稿上，我讓畫面有一個大大的 Z 字結構，這個形狀從這山頭、步道，走近到燈塔，然後跟著這個岩石的稜線，這樣下來，就形成一個 Z 字型，中間的大三角形正好穩定了這個畫面。然後加上一艘船，這艘船是另一張從南竿拍到的照片，它被我開到這邊來了。

燈塔實景　Lighthouse real scene

設計好鉛筆稿後，我在少數地方塗留白膠好保留受光的亮面，刷水後把亮的暖光先刷上去，包括它會照到的地面。

燈塔鉛筆稿　Lighthouse pencil manuscript

岩石的暗處，在沒有乾的時候就開始做一點色調的變化和重疊。岩石最重要是表現結構的基底和明暗。我刻意地把這個岩石表現得稜角分明，稜角分明的結構讓岩石堅硬質感更逼真。這是素描的概念，透過想像，來畫岩石，哪裡暗、哪裡亮，表現出它的結構空間。

燈塔打底　ghthouse base

海岸邊有一些海浪在暗處拍打到石頭，浪不是很大，是一種比較平和寧靜的感覺。

常有朋友面對我的作品問：「你要花多少時

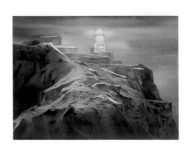

岩石初步處理 Preliminary treatment of rocks

岩石細部處理 Rock detail treatment

岩石近景 Close-up for Rocks

洪東標｜航向光明 Heading Light
100x150cm　2008

間？」其實很難計算，有時候一幅作品開始動筆兩天就解決了。可是構思的醞釀期卻要花很長一段時間，腦子裡思索著月光從哪裡來？燈光如何投射在岩石上？開始打鉛筆稿，畫草圖，一面思考如何進行，到最後我在畫紙上完成鉛筆稿，已經是一個星期了，所以時間無法計算。

E3. Can you offer an example of your work and share the process with readers?

<Heading Light>, a large work in 2008, was inspired Dongyong lighthouse in Dongyin, which I praise as "Taiwan's most beautiful lighthouse." It is located on a very high rocky shore. As I did not have an opportunity to look at the lighthouse from the sea, I tried to imagine with pictures I took. Intending to draw it on the sea, add some rocks near the coast, and idealize the picture, I started trying boldly. On the initial pencil drawing, I made a large Z-shaped structure. This shape started from the hills, trails, approached the lighthouse, and then followed the rock ridge to form a Z-shape. A middle triangle just stabilized the picture. Then I added a boat; this ship was taken from another picture of the South Pole. It was steered to this side by me.

After a pencil manuscript, I painted a small amount of white glue in a few places to keep the bright light. First, I brushed water over, and painted warm light of the bright area, including

the ground it brightened up.

A little tone changes and overlapping was made in the darkness of the rocks before that part dried. In presenting rocks, the most important is to show the base and shades of their structure. I deliberately painted the rocks angular so that the hard texture became more realistic. This is the concept of sketches. Through imagination, I started to paint the rocks, deciding where the dark part was, where brightness was, to reveal their structural space.

There were some waves beating stones on the coast in the dark. The waves were not big, presenting a relatively peaceful and tranquil feeling.

Oftentimes friends faced my work and asked: "How much time did you spend on finishing this work?" In fact, it is difficult to calculate the time. Sometimes I finished a work in just two days but the brewing period of ideas was quite long. For this painting, my mind pondered about "Where the moon was from?" "How was moonlight projected on the rocks?" Starting with pencils, drawing sketches, thinking about how to proceed, and in the end I finished drawing the pencil manuscript on arches paper; it was already a week. So I would reply: The time cannot be calculated.

E4. 你的最大幅作品「白色初秋」也是使用多張照片進行組合，能具體的來説明構思的過程嗎？

本件作品首次發表於 2012 年四月，是中華亞太水彩藝術協所舉辦的《壯闊交響－巨幅水彩創作展》中的作品，引起很多觀眾的關注與回響。我以浪漫寫實風格來描寫我所看到的台灣意象，初秋的台灣，河川高灘地長滿蘆葦，雪白的蘆花映著陽光閃耀著光芒，數大是美，大幅的畫作中，輕柔搖曳的白浪遍地蔓延到整幅畫作，映入觀賞者的眼簾，展現著輕柔且壯闊的季節之美。以下解說我的創作過程。

多年來的每一個星期四，我一直都在新竹地區上課，每一次清晨驅車南下時隨著季節和天候的變化，總可以一邊聽著廣播音樂一邊欣賞高速高路兩旁的不同景緻，

附圖一：十六開速寫於新竹頭前溪畔 Figure 1: 16K sketch near Touqian River in Hsinchu

附圖二：頭前溪岸照片一 Figure 2: photo one of the river

附圖三：頭前溪岸照片二 Figure 3: photo two of the river

附圖四：四開的用鉛筆素描稿 Figure 4: 4K with a pencil sketch

尤其在秋季，初秋的農田剛結穗的稻子會由蒼翠的綠色慢慢轉黃，路旁的台灣欒樹會開出鮮黃色的花朵，隨著時序慢慢轉變成橘紅色再轉成褐色，橋下溪流的高灘地原本翠綠的蘆葦抽出細長的白穗，再綻放出一叢叢奔放的白花，拓展成無邊無垠的白色大地，這是一個絕對台式的風景，也是許多人的記憶，2011 年的秋天，當中華亞太水彩協會決定舉辦一次巨幅水彩畫的創作展之後，我立刻聯想到這就是我要的題目了。

原本我就曾經在頭前溪畔畫過一張 16 開的水彩速寫〈附圖一〉，手上也有幾張拍自新竹頭前溪畔的照片，經過篩選，先做小幅四開作品的練習，嘗試著以不同技法來表現；最後決定精選出兩張照片來組合〈附圖照片二三〉，調整構圖延伸遠處的樹林布滿畫面，我先以四開的規格用鉛筆稿，約略畫出草圖和明暗的色階〈附圖四〉，確認構圖後我將 arches 的 300g/m2 的整捲畫紙攤開，裁切出一張 114*180cm 大紙，將草圖按大約的比例放大，完成鉛筆稿。

E4. <White Early Autumn>, your hugest work, is created with multiple photos. Can you specifically describe your forethought and composition?

This work was first exhibited in April 2012 at Chiang Kai-shek Memorial Hall by the China Asia-Pacific Watercolor Association. It was included in "magnificent symphony - a huge watercolor creation exhibition", causing a great deal of attention and response. I utilized a romantic realistic style to describe images of Taiwan. In early autumn, the bank of river is covered with tall reeds; white phragmites reflect the shining light of the sun. Generally speaking, Chinese believe huge quantity forms beauty. In this large painting, gently swaying white waves spread to the whole picture, and jump into the viewer's eyes, revealing such gentle and magnificent season of beauty. The following explains my creative process.

In recent years, every Thursday, I have been teaching in Hsinchu area. On every Thursday morning, driving southbound when the season and weather change, I could listen to the radio and enjoy different views on both sides of the freeway. In particular, rice spikes on early autumn farmland would slowly turn yellow from green. Taiwan koelreuteria on roadsides blossomed with bright yellow flowers, gradually turned into orange and then turned into brown. The river on high land under a bridge was filled with tall reeds. Originally green reeds grew with a slender white spike, and then bloomed out of a cluster of unrestrained white flowers, expanding into boundless white earth. Such is absolutely Taiwanese scenery, and also many local people's memory. In the fall of 2011, when the China Asia-Pacific Watercolor Association decided to hold a huge watercolor painting exhibition, I immediately associated this with my subject.

Previously, I had sketched a 16K watercolor [Figure 1] near Touqian River and a few photos of that river on hand. After screening, I first painted a 4K work, trying to use different techniques to express. Finally, I decided to select two photos for the combination <photo two, three>. Adjusting the composition with the extension of distant trees to fill the picture, I drew a pencil manuscript on 4K. Roughly, I sketched

an outline with light and dark parts --- the color scale. <Figure 4> After confirming the composition, I spread out the whole roll paper of arches 300g ╱ m2, cut out a 114 x180cm large paper; the sketch will then be enlarged in proportion to complete my pencil manuscript.

過程圖一：先將畫面鋪水，大渲染出淡淡的灰紫色，以乾筆輕輕的掃出蘆葦的暗色，加入綠色系描寫蘆葦底部綠色的莖葉，隱約可見到畫面左邊原本預留一個划船的人影。

Step 1: First, brush water on the paper, offer a big rendering of gray purple, gently use a dry pen to brush out the dark reeds, and add green to describe the bottom of green stems and leaves. Vaguely visible is the left part originally reserved for a rowing silhouette.

過程圖二：繼續加深色彩，當綠色的莖葉畫的越多，芒花就越少，當莖葉畫的越深，芒花就越白，色彩的明度對比的重要性在此更顯著。

Step 2: continue to deepen the color. When the green stems and leaves are painted more, the fewer white flowers are revealed. When darker colors are used to paint stems and leaves, the flowers become even whiter; the importance of color contrast is more significant here.

過程圖三：以灰藍綠色來畫出水流，橫筆上下微微起伏地畫出流動的波紋。

Step 3: draw the water flow with gray, blue, and green; use a horizontal pen slightly painting up and down to present the flow of ripples.

過程圖四：以渲染法畫背景中的木麻黃樹林，用岱赭和鮮藍調出暗調子的灰藍綠色畫出空間較深遠的樹林。
Step 4: render Casuarina trees in the background. Mix BURNT SIENNA with INTENSE BLUE, the dark tone of the gray and blue green, to draw more distant woods.

過程圖五：以不透明的白色點，畫芒花的亮處，加入飛翔於芒花上，晚歸中的鷺鷥鳥，隱約中充滿生氣和律動，完成作品。
Step 5: use opaque white to draw light parts of the flowers. Add egrets that fly home late, vaguely full of vigor and rhythm, to complete the work.

洪東標｜白色初秋 White Early Autumn
114x180cm 2012

E5. 你能說明你對抽象與具象藝術的觀感嗎？

我用數字來比喻說明，當我用 100 筆畫出一個美麗的蘋果，這 100 筆的每一筆都是客觀地描寫蘋果的結構，色彩，明暗和質感細節等，這個蘋果必然非常逼真，這不但是具象而且是相當的寫實，假如我以 50% 的客觀描寫，50% 是主觀的繪畫性描繪，這個蘋果還是會被正確地觀看出來，它還是具象的，如果我加大主觀描寫比例到 70% 時，大家可能只是隱約地看到一點點蘋果的特徵，觀賞者會猜測到我畫的是一顆蘋果，這時候的作品就相當的寫意，當我以 100% 是虛擬的主觀來畫，根本不在乎蘋果的外在形象，那有可能所有的觀賞者已經無法判讀作品是在畫些什麼，這就可以就稱之為「抽象畫」了。

西方藝術在歷史上有很多的變革，許多藝術家都在尋求創新，過程中沒有一項主張可以全面地否定以往藝術的成就，但是到了二十世紀初，甚至以革命式的激烈

手段來否定前者，我認為最激烈的莫過於抽象繪畫，其實從事具象或抽象的畫家各有其道理，更有其缺點，我相當認同中國水彩大師關維興說：「具象繪畫的危險在於形象太具體，不能給觀眾留有充分的虛擬的想像的空間，將自己具體的一切強加給觀眾，迫使觀眾接受；抽象的潛在危險在於不易形成形象感，甚至連虛擬的形象也形不成，會因其沒有內涵，虛張聲勢，失掉觀眾」。

E5. Can you explain your perception towards abstract and concrete art?

I use figures to describe the metaphor. When I use 100 brushstrokes to draw a beautiful apple, if each of the 100 strokes is an objective description of the structure, color, light and texture details, the apple must be very realistic. This is not only concrete but also quite realistic. If I use 50% of the objective description, 50% subjective painting depiction, the apple will still be recognized. It is still concrete. If I increase the proportion of subjective description to 70%, we may only vaguely see a little bit of characteristics of the apple. The viewer will guess I paint an apple; this time the work is quite freehand. When I paint 100% with the virtual subjective and do not care about the apple's external image, it is possible that all the viewers have been unable to interpret the work which can be called "abstract painting".

Western art experiences a great deal of changes in history and many artists constantly seek innovation. In the process, there is not any proposition to completely deny achievements of the past art. Nevertheless, by the beginning of the twentieth century, there are even revolutionary means to deny the former. I feel abstract painting is the most intense in art history. In fact, engaging in concrete or abstract painting has certain reasons and shortcomings. Personally, I quite agree with what Chinese watercolor master Guan Weixing states: "The risk of concrete painting is that there're too specific images. It can't offer the audience space of full virtual imagination, but artists' specific images, forcing the audience to accept all. On the other hand, the potential danger of abstract painting is that it's not easy to form a sense of image, and even the virtual image is also not formed. Because it has no content, only bluff, it will eventually lose the audience ".

E6. 風景畫中的水是非常重要的元素，你認為要如何表現得更生動？

水在風景畫中是一個非常重要的元素，如果畫中的主題是「水」，大多是動態的，包括：海浪、瀑布、激流等，衝擊中的水融入了大量的空氣，在水彩表現時，適合用透明的乾筆畫法來表現，或以渲染法來表現被風吹起的水氣，流動的波紋適合用重疊；靜態的水面大多是主題的配景，像寧靜的湖面，這時候波光、倒影就很重要，元素越豐富越是迷人，觀察實景不容易理出頭緒，可以拍下照片來觀察，不是有句話說：「科技始終來自於人性」，藉由攝影的輔助就能更深入觀察；畫「水」的內容應包含下面幾個層次 1. 水面的顏色 2. 水面的波光 3. 水中的倒影 4. 水底下的景物等，按照這個順序，描寫越多層次就越困難，但也就越生動。

E6. In landscapes, water is an essential element. How to paint it vividly?

Water in the landscape is extremely critical. If water is the theme of the painting, mostly it includes dynamic water: waves, waterfalls, torrents, and so on. The water flow is mixed with a large amount of air. In the performance, transparent watercolor with dry strokes or rendering methods to show moisture from the wind are suitable to express water. Overlapping is suitable for the flow of ripples; static water is mostly a matched scene of the theme. For a tranquil lake, for example, dancing waves and the reflection are particularly important elements. The more enriched content, the more appealing it is. Observing the real scenery is not easy for painters to catch a clue, thus you can take a photo to observe later. Well goes a saying: "Technology always comes from human nature". With the support of photography, we can have more in-depth observation. The contents of painting water should include the following aspects: 1. Water surface color 2. the surface of the wave 3. the water reflection 4. the scenery under the water, etc. In accordance with this order, the more layers to describe, the more difficult it becomes, but it's also the more vivid depiction of water.

E7. 你認為水彩畫面上的「收」與「放」如何掌握效果呢？

其實所謂的「像」就是在畫面中描寫對象時要求要有準確的造型、真實的色彩、

洪東標｜仲夏的野溪 17.5x37.5cm 2014

完整的展現時空的瞬間性、符合焦點透視原則，這些都是畫面中的「實」，相對應的就是「虛」。

我在畫面中的處理時大多是把視覺的焦點和畫面中的明亮處表現為「實」；而將背景，遠處或是暗處作為「虛」。一幅好畫一定是需要虛實相互輝映的，然而在初學者的眼裡，畫面何處是「實」，何處是「虛」很難拿捏，畫中 70% 是客觀的描寫在「實」，30% 是主觀的在「虛」。往往一幅水彩畫，大都是在「虛」的地方表現出水分媒材特有的精彩效果而更加迷人。

E7. In what way can you control the effect of "drawing back" and "putting forward" of the watercolor pictures?

In fact, the so-called "being alike" is in the description of an object. When asked to have accurate shapes, and true color, or to complete the time and space at the moment, in line with the principle of focus and perspective, we contend that these are the "real", the corresponding is "virtual".

Mostly I deal with the visual focus and bright parts preforming the "real", and the background, distant or dark parts as "virtual". However, in the eyes of beginners, where "real" is, or where "virtual" is, is difficult to detect or deal with. I would

therefore suggest that 70% of a painting is an objective description with the "real", 30% are subjective in "virtual". Oftentimes, it is in the "virtual" depiction that impressive characteristics of watercolor reveal their enchanting charm.

E8. 當你拿到一張照片，應如何確定何處是畫面的焦點呢？

如何在參考照片創作時，順利地尋找視覺焦點？這個問題從不發生在我的創作裡，因為我的參考資料都是我親自拍的照片，在當初我拍照的當下我已經確認了主題在畫面中的正確位置；但是如果我們應用他人的照片，往往視覺的焦點容易存在於畫面中的中景的光亮處，如在自然的風景中，動物最具有吸睛力，在街景中活動中的物件或造型奇特的廣告招牌都有吸睛力，但是就藝術創作來說，焦點在何處應該是創作者以主觀的意識來設定，在經過構圖調整，光線明暗的設計，焦點就自然成形了。

E8. When you get a picture, how would you determine where the focus is?

How do you find the visual focus when you are working on a reference photo? This situation never really occurred in my creation because I only used photos I took as a reference. At the moment I took pictures, I had already confirmed the theme in the correct position. But if we use other people's photos, often the focus tends to be in the light area in the middle. For instance, in natural scenery, animals are the most eye-catching; in the streets, moving objects or peculiar advertising signs particularly appeal to the audience. But in terms of artistic creation, where the focus should be depends on the creator's subjective choice. After a composition adjustment, design of light and darkness, the focus is naturally formed.

E9. 畫面中的視覺焦點只能有一個嗎？兩個（或以上）又會如何？

當然，一個畫面是可以有多個視點，這是繪畫領域裡由傳統到現代的一大變革，但這卻不是現代人的發明，它早在和焦點透視理論創立之前就存在於世了，早在一千年前，中國傳統的繪畫裡就已經有多視點的設計了，最有名的當屬張擇端的

清明上河圖了，中國的敦煌壁畫和漢墓壁繪畫也都存在，反而在西方的繪畫中講求瞬間時空中一定的空間關係，一幅畫就只能有一條視平線，以一個空間的概念來完成作品，我們知道傳統繪畫有四大特徵：準確的造型、真實的色彩、時空的瞬間性、焦點透視。它所描繪的事物，我們可以簡稱為「一個視點」。

而現代繪畫打破了這四項的束縛：原來眼睛所看到的造型，用主觀意識重新組裝，甚至被簡化成符號；以純主觀情感支配色彩；主觀地延伸時空，把瞬間性變成為時間過程或音樂律動，拓展了深度和廣度；為表現瞬間性，所必用的焦點透視被主觀地改變為「多點」或「散點」透視的組合，從而，突破了「一個視點」，成為融合了不同角度同時可以看到的「多個視點」。相對於傳統繪畫來說，這是一種新的理念、新的思維模式，是時代發展的產物。不過在單一的畫面中要同時呈現多個視點或是多重透視的概念，比較適合大尺幅的畫面，因為當畫幅超越眼睛視線的寬度極限後，觀看時會自然地將畫面分區段觀賞，多視點就不會混淆視覺的感受，而在小尺幅的畫面空間內就無法顯現效果。

E9. Is there only one visual focus in a picture? What about two (or more)?

Certainly, there can be multiple viewpoints in a picture, which is a major change in the field of painting from tradition to modernity. But this is not the invention of modern people. It had existed before the focus perspective theory. A thousand years ago, traditional Chinese paintings had a multi-point of view, the most famous of which is the Qingming River painted by Zhang Churduan, Dunhuang murals and Han tombs paintings. On the contrary, Western paintings emphasize a certain spatial relationship in the moment of time and space. A painting can only have a horizontal line, and be completed with a space concept. As we know, traditional paintings have four characteristics: accurate shape, the real color, time and space, the focus of perspective. What it describes is what we call "a point of view".

Nonetheless, modern painting broke the shackles of these four: the shape originally seen with eyes is re-assembled subjectively, or even to be simplified into symbols; pure subjective emotions dominate color; subjective depth of time, or the moment

is time process or music rhythm, to expand the depth and breadth; the focus is to be subjectively changed to "multi-point" or "scattered" perspectives, thus breaking the "one point of view" and become a fusion--- "Multiple viewpoints" that can be seen at different angles. Compared to traditional painting, this is a new concept, a new mode of thinking, and the product of times. But in a single picture, it's difficult to present multiple viewpoints or multiple perspectives at the same time. The concept is more suitable for large size paintings. Because when the frame is beyond the width of eye sight, viewers will naturally view section by section, multi-viewpoints will not confuse the visual experience. But in small size pictures, the effect can't be revealed within limited space.

E10. 風景畫中的透視一直是初學者最困擾的問題，可以請你提醒大家應該注意的部份嗎？

一般來說，水彩的畫幅都不會很大，就如我在前一個問題中的回答，小尺幅的作品以一個視點表現較為洽當，這就是透視空間的營造，在風景畫裡這是不能迴避的問題，我都建議學生觀察一張參考資料的圖片時，一定先找到視平線，然後找到圖中透視的消失點，再以消失點來延伸畫出結構上的相關線條，就以下圖為例。

E10. The perspective concept in a landscape composition has been the most troublesome for beginners. Can you remind them of certain aspects?

In general, their watercolor frames are of small size. As I answered in the previous question, it is more appropriate to utilize a point of view. This is the perspective of space for creation, and the issue cannot be avoided in landscapes. I suggest that students observe a reference picture beforehand. We must first find the horizon line, and then find the vanishing point. Extend with the vanishing point to draw relevant lines of the structure. The following figure shows an example.

E11. 謝明錩大師曾形容你的表現技法中的「飛刷洗水」，在畫面中形成許多平行的細紋，你能具體的說明如何產生的嗎？在畫面上產生何種效果？

我喜歡畫面水分融合的輕柔感覺，所以我會在作品完成後用一隻軟毛的尼龍排刷沾水，輕輕地在畫面上以水平的方向刷過，含水的毛尖會將畫面的顏色微微的溶解，就會出現較淺色的細條紋，深色顏色會被帶到淺色的區域，也會出現較為暗調子的條紋，畫面的亮和暗會自然的綜合出柔和的色調。

工具：尼龍刷

（左圖）飛刷洗水示範

E11. Watercolor master Xie Mingchan has described the "flying brush over water" in your performance techniques to form a number of parallel lines in the picture. Can you specify how to paint with such a technique? What effect does the painting produce?

I like the soft feeling of water fusion in the picture, so I render a nylon pen with soft

hair to brush gently on the paper in a horizontal direction. The tip of the brush will slightly dissolve the color. There will be more light-colored stripes; dark colors will be brought to light-colored areas, and there will be more dark tone of the stripes. The picture will eventually be presented with a soft tone, bright and dark naturally blended.

E12. 在你的學生中傳說的「雞蛋原理」你能進一步的具體說明嗎？

我們先來看一張照片，這是台灣民間商店的雞蛋箱，每一顆堆疊的雞蛋都是同樣的顏色，在光線下明暗分明，剛好雞蛋和雞蛋之間都是以明暗互相襯托來呈現前後的空間關係，大自然有許多這樣的現象，我在教學上，都請學生在觀察大自然時描寫大自然時用來對照，不管是雲海、山巒、海邊的石頭、樹叢 這樣的現象無所不在。理解這個概念就幾乎可以畫出所有大自然中的物件了。

下面是上課示範作品中的例子。The following are examples of works in class.

上課示範一：樹

上課示範二：岩石

E12. There is a legendary "egg principle" among your students. Can you further elaborate on that principle?

We can first look at a photo, which is an egg box in a traditional Taiwanese grocery store. Eggs in each stack are with the same color; bright and dark areas are clearly differentiated under the light. Eggs are set off with each other to display the relationship of space. In our Mother Nature, there are many such phenomena. In my instruction, I would ask students to observe nature for the comparison. Whether it is the sea of clouds, mountains, seaside stones, trees, and so forth, such a phenomenon is ubiquitous. Understanding the concept of nature nearly enables you to paint all objects in nature.

E13. 在「樹」的描寫上你獨樹一幟，你能否進一步地解說你的表現方法和重點？

我喜歡畫樹，因為身處在年雨量超過 2500 公厘的台灣，森林處處可見，我長時間地觀察，下工夫地研究畫樹，我認為，畫樹表現的不只是樹的型和色，它的立體空間才是最重要的內容，我往往先確定它的型態和色調，先畫樹葉，最後再勾畫樹枝和樹幹，樹葉先從亮處淺色先鋪色，在沒乾的時候加深樹叢的暗處，觀察樹形讓葉叢有大有小，再加深一層顏色在第二層顏色的下方，這樣重複第三層和第四層暗綠的色調後，等畫面乾後在樹叢的暗處和透空的位置勾畫樹枝和樹幹，這樣就會形成厚度和前後空間了。

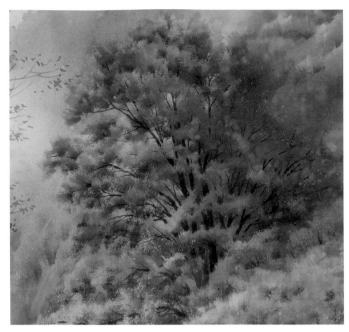

霧鎖溪谷 (局部)

E13. You are particularly unique in your depiction of "trees". Can you further explain painting methods and major points in your performance?

I like to paint trees. Because there's an annual rainfall of more than 2000 mm in Taiwan, forests can be seen nearly everywhere. I've long observed trees and worked on painting them. In my opinion, besides tree types and colors, the three-dimensional space is the most important content in painting trees. When portraying a tree, I often first determine its type and color, draw leaves, and finally add branches and trunks. For leaves, I start from the light part, and then deepen a layer of color below while it is still wet. I also observe the tree so that the leaves are painted big and small. Then the third layer and the fourth layer of dark green tones are added. After the paper becomes dry, branches and trunks are placed in the dark parts and empty location. Thus, it will form the thickness and space in the painting.

E14. 你的創作曾遇到瓶頸嗎？遇到創作的瓶頸時怎樣破解？

我的創作生涯中遇到最大的瓶頸是在 2004 年間，當時一直想要改變，但卻找不到

方向，青年畫家吳冠德形容我是：「自廢武功，從蹲馬步開始練功」，雖然我努力地不斷寫生，自己卻很茫然，2006 年兩岸水彩交流研討會，大陸名家王維新教授對我說：「畫的不夠多，就不會知道方向！」這句話給了我很大的啟發，我決心要不斷的畫，給自己定下一年至少 100 張創作的基本數量，這個過程中我慢慢地體會到畫自己想畫的畫，畫自己感動的題材，體會出自己最擅長的表現方法，就慢慢地找到自己了。

E14. Have you ever encountered a bottleneck? When trapped in creation, how can we get out of it?

I encountered the biggest bottleneck in 2004 for my creation. At that time, I struggled to change, but couldn't find the direction. A young painter Wu Guande described me as: "abandoning martial arts, and starting from basic squatting steps to practice." Although I tried to continue to sketch, I was at a loss. In 2006, at the cross-strait watercolor exchange seminar, a mainland famous Professor Wang Weixin said to me: "If the quantity of your painting is not enough, you will not know the direction!" I was greatly inspired with his words and determined to continue to create works. Setting a goal to paint at least 100 works a year, I slowly realized in the process that I want to paint what moves me. Seeking for my moving subjects and best performances, I eventually find my own way.

E15. 如你所説照片有陷阱，會讓畫家迷失在照片失真的缺陷裡，你對此有何對策？

在現代人手一機的情況下，不用照片來參考創作就如同有了飛機你還在搭船去巴黎，問題是多數的相機都已設定在一開機就是廣角鏡頭，影像已經被誇張的透視扭曲了，相機無法同時對暗處和亮處呈現完整的曝光質，所以不是暗處一片黑的曝光不足，就是亮處一片白的曝光過度，物象的色彩飽和度都被減弱，亮處和暗處的細節也都模糊不清；我的方法是，取好構圖先拍一張完整的畫面，接著拉近距離針對亮處再拍一張，此時光圈自動縮小，會拍出亮處的色彩和細節，然後在對暗處再拍一張，光圈放大便能拍出暗處的細節，如此三張照片相輔相成，便能完整地呈現應該有的色調。

E15. As you mentioned that there could be traps in photos, leading painters to get lost in the defect of distortion. Can you offer any countermeasures?

Nowadays with modern technology, nearly everyone is equipped with either a camera or a phone. If you create works without a photo to refer to is as you still ride a boat to Paris even with the convenience of an aircraft. The problem lies in the fact that most cameras have been set in a boot with wide-angle lens. The image has been exaggerated and perspective twisted. Cameras cannot show a complete exposure of the quality in both bright and dark parts. So it is either pitch darkness for black exposure, or excessive exposure of bright white. The color saturation has been weakened, and bright and dark details are also blurred. My countermeasure is the following: I would shoot a complete picture for a good composition, and then pull a distance for the bright and then take a picture. At this time, the aperture automatically shrinks, so I can shoot the bright colors and details. And then I take a picture in the dark; aperture magnification will be able to shoot the details in darkness. In this way, three photos complement each other; complete tones should be presented.

E16. 水彩畫的創作可以設定好 SOP 的流程嗎？

我想畫家應該都會有一些慣性吧，如果說這樣慣性就是創作的 SOP，也很接近。不過我認為這樣的流程大多會隨著創作環境，主題特色，天氣狀況，畫家的心境等許多因素而改變，我在上課中的示範過程也常有不同，不是隨興，是讓畫面充滿各種可能，這蠻有趣的，但是就風景水彩畫的創作來說，「由遠到近」，「由淺入深」是一種比較穩健安全的方法，僅提供參考。

E16. Is there a SOP process set in watercolor creation?

I suppose painters would probably have certain"inertia"process that they are accustomed to. If such inertia is so-called SOP, it is close to the term. But I think most of this process will be variable with the creative environment, theme

characteristics, weather conditions, the mood of painters and many other factors. Even in a class demonstration, my process is often various. It's not spontaneous but to make the picture full of possibilities, which is rather intriguing. For the creation of landscape watercolor, nevertheless, "from far to near", "from light colors to deep ones" is a relatively safe and secure method. This is provided only for your reference.

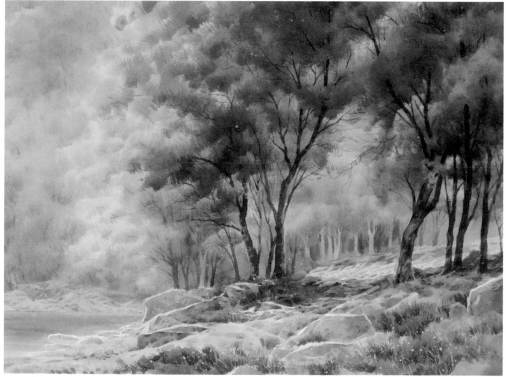

洪東標｜溪畔的小徑 37x53cm 2015

F

教育與推廣
Education and Promotion

「... 藝術競賽在每一個時代中提供機會，扮演一定的功能，讓藝術家得以嶄露頭角，但是獲獎與落選並不能決定一個畫家在美術史上應有的成就，還是要靠藝術家自己的持續努力，...」

「...art competitions provide opportunities in every era so that artists can emerge and reveal their talents. Nonetheless, winning or losing cannot determine achievements of a painter in art history. Achievements rely on artists' continuous efforts.」

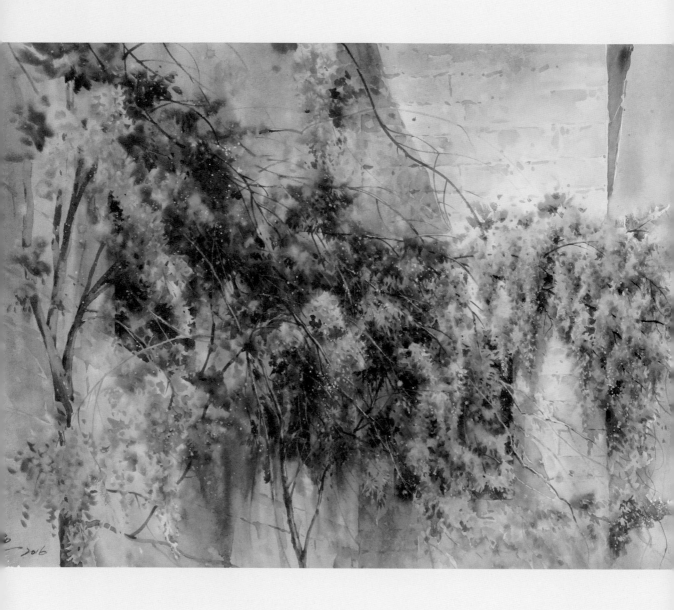

洪東標│紫色迷情　55x75cm　2016

F1. 你能對年輕的水彩畫家說一些鼓勵的話嗎？

未來，世界水彩畫壇會因為社群網路的興起而越來越開放，只要肯努力、用心學習，都有機會站上世界的舞台。有志於在世界水彩畫壇闖出一番成績的台灣年輕畫家們，別害怕，也別逃避。從現在起，你要努力鍛鍊自己的實地寫生能力。當機會來了，你就把化腐朽為神奇的實力呈現給世界看。不管把你丟在多醜的一個地方，1、2個小時後，你會變出一張傑作秀給大家看。

這種能力，說起來很簡單，做起來難如登天。它包括想像力、記憶力、腦力、體力、經驗與氣質。這可是要下幾十年的功夫啊！室內創作畫得好，但如果也同時能夠擁有強大的寫生實力，那不是更棒！而重要的是，我相信這種強大的寫生實力，必然地、肯定是，會對你的室內創作產生更大更突破性的影響！

F1. Can you offer inspirational suggestions to encourage young watercolorists?

In the future, the world of watercolor painting will be broader and more liberal because of the rise of social network. As long as you are willing to work hard and learn with your heart, you are bound to have an opportunity to stand on the world cultural stage. For those who aim to achieve worldwide success, I would suggest them not to be afraid and do not escape. From now on, you have to forge your own sketching ability. When the opportunity comes, you present to the world with magic capabilities. No matter which place you are put in, even an ugly one, after one hour or so, you will showcase a masterpiece.

Such an ability is actually easier said than done. It includes imagination, memory, mentality, physical endurance, experiences and temperament. Indeed, the efforts need to be accumulated at least in a few decades. Interior creative painting is impressive, but if you can also be endowed with strong sketch skills, it is even more fabulous! More importantly, I believe such powerful sketch strength, would certainly bring forth more impact and even breakthrough for your indoor creation!

F2. 對於年輕畫家參加美術競賽來爭取被關注的機會，你認為這是投身藝術創作正確的方法嗎？

在每一個時代中藝術競賽都提供機會，讓藝術家得以嶄露頭角，但是獲獎與落選並不能決定一個畫家在美術史上應有的成就，還是要靠藝術家自己的持續努力，我自己也是過來人，當年獲獎受到的激勵，真的是後來不斷成長的動力；近年來很榮幸多次應邀擔任國內重要美展的評審委員，也觀察許多得獎者，一件獲獎作品不能代表畫家一生的成就，還是要持續地不斷創作精進。

F2. Young artists participate in art competitions to fight for opportunities to make their mark; do you think it's the correct way to devote to art creation?

In every era, art competitions provide various opportunities so that artists can showcase their works and be heeded. Being honored with an award or not, however, cannot determine the achievements of a painter in the art history. Achievements mainly rely on the artist's continuous efforts. I have similar experiences; the encouragement and spur from winning awards indeed motivate my later continuous efforts. In recent years, I have been honored to be invited to serve as the judges of major domestic exhibitions, and also observe many winners--- an award-winning work cannot represent the painter's life achievements. We all need to continue creation to make works more refined and sophisticated.

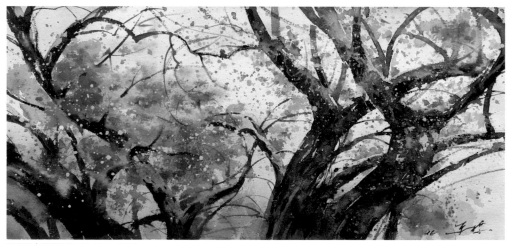

洪東標｜張揚的綠 19x44cm 2016

F3. 你對於比賽落選的畫家，你有什麼看法？

我常用這個故事分享給我的學生，對落選的畫家當然也可以分享：「1867 年在巴黎萬國博覽會，米勒的〈拾穗〉等八幅作品獲得競賽的首獎，隔年 1868 年米勒在 54 歲時獲頒榮譽勳章，從此並立足於美術史上，同樣的在 1872 年，莫內以勒阿弗爾的一處風景為背景創作了〈印象‧日出〉在當年的沙龍美展中落選，於是他在 1874 年的落選展中將此件作品展出，雖然受到藝評家的嘲笑，但是卻在美術史上贏得了『印象派』的聲名，成了印象主義的領頭羊。」

故事告訴我們，藝術競賽在每一個時代中提供機會，扮演一定的功能，讓藝術家得以嶄露頭角，但是獲獎與落選並不能決定一個畫家在美術史上應有的成就，還是要靠藝術家自己的持續努力；在國內也是如此，許多當代的著名畫家都經歷了國內大大小小的競賽而嶄露頭角，也有畫家默默耕耘，因為作品突出而受到肯定。

F3. What do you think of painters who failed art competitions?

I often use this story to share with my students, and it is also suitable for those who fail: "In 1867, at Paris World Expo, Miller's <Des glaneuses >and other eight works won the first prize of the competition. The next year, 54-year-old Miller was awarded the Medal of Honor, and from then on standing firmly in the history of art. Similarly, in 1872, Monet created <Impression, soleil levant > portraying Le Havre landscape

洪東標｜水花四濺 19x44cm 2016

in the background. This work wasn't chosen in the salon art exhibition. As a result, in 1874, he displayed it in an art exhibition with other failed works despite ridicule from the art critic. In art history, Monet won the "Impressionist" reputation, and became the leader of Impressionism. "

The story tells us: art competitions provide opportunities in every era so that artists can emerge and reveal their talents. Nonetheless, winning or losing cannot determine achievements of a painter in art history. Achievements rely on artists' continuous efforts. In our country, this is also the case. Many contemporary famous painters have experienced big and small domestic competitions and therefore become phenomenal whereas there are certain painters creating quietly and ceaselessly, their works remarkable and affirmed.

F4. 這些年來台灣水彩的蓬勃發展，有人歸功於你擔任亞太會長時的推動，你能具體的説明如何推動？

其實近年來在台灣的水彩可以蓬勃發展，是由許多人推動，是天時地利人和的條件共同促成，每一個人都在他的崗位上貢獻力量，比如說，各地方的水彩速寫團體、還有許多畫家帶動寫生的風氣，地方美展水彩的獲獎者持續不斷地創作，許多年輕畫家的投入，加上網路的發達推波助瀾，這是一個前所未有的盛況，絕對不是一個人的努力所能達到的效果。

我擔任亞太水彩協會的會長期間，舉辦多次的兩岸交流展、研討會、出版水彩書籍、編輯發行水彩資訊雜誌，免費提供水彩愛好者閱讀，應該也發揮了一些功效；促成幾個地方水彩團體的成立，擔任推廣教育的老師，對推動社會愛好藝術的朋友公開揮毫、演講，都直接或間接地促成水彩藝術的傳達，這應該都是屬於我個人所能提供的服務。

F4. Over the years, there's been a vigorous watercolor development in Taiwan; some people credit this to your recent support and promotion. Can you specifically explain how you helped promoting watercolor in Taiwan?

In fact, in recent years, that watercolor in Taiwan flourishes has been driven by many people. It is because of the favorable conditions combined together; each person in his post devotes to contribution. For example, local watercolor sketch groups, many artists' promoting sketch activities, watercolor winners of local Art Fair continuing to create, many young painters' input, coupled with the development of the network all help fueling such impressive phenomena. This is an unprecedented event, and definitely not a single person's efforts to achieve the success.

I served as president of the Chinese Asia Pacific Watercolor Association, held a number of cross-strait exchanges, seminars, published watercolor books, and edited along with issuing Watercolor Express magazines for watercolor enthusiasts to read for free. These should also cause certain impact. Additionally, I promoted several local watercolor groups, worked as a teacher to promote education, delivered speeches and offered watercolor demonstrations to art lovers; I believe they also directly or indirectly aid conveying watercolor art. Such should belong to my personal services that I can provide.

F5. 你為了推廣水彩，曾協助地方成立繪畫團體，能具體說明你實際上的做法嗎？

在我的學生中多數是一般民眾，本著對藝術的愛好開始學習水彩，雖然創作是很個人的行為，但是要維持熱誠還是需要群體的鼓勵和相互間的交流，所以我自從 2001 年開始在新莊社區大學教授水彩課程之後就鼓勵學生們成立社團，於是 2004 年新莊水彩畫會就正式成立，接著在台北和新竹都相繼成立水彩畫的團體，人數都在 30 人左右，除了一起上課、出外寫生、觀摩討論、舉辦聯展，也出版畫集，大家凝聚向心力成為好朋友，創作就能持之以恆，或許就會畫一輩子的水彩了。

F5. In order to promote watercolor, You've helped the establishment of local painting groups, can you specify the actual practice?

Most of my students are ordinary people; they pick up watercolor as hobbies of art. Although creation is personal behavior, to maintain enthusiasm requires group

洪東標｜伸展 37x53cm 2015

encouragement and mutual exchange. So since I started Xinzhuang community college watercolor courses in 2001, I've encouraged students to set up associations. In 2004, Xinzhuang Watercolor Association was formally established. Soon afterwards, in Taipei and Hsinchu, watercolor groups were set up; the number of students was around 30. In addition to classes, sketching, group discussions, joint exhibitions, there are also published works. They gather together frequently and have become good friends, thus creativity can be sustained, and probably they will paint watercolor for a lifetime.

F6. 你能說明你在發行「水彩資訊雜誌」上的努力，具體的發揮了那些效果？

1994 年我曾經在李焜培教授的召集下。和楊恩生、梁丹卉等畫家一起創辦「水彩雜誌」，在台灣這是唯一一本以單項媒材做為內容的藝術雜誌，在有限的人力和經費下只維持了兩年，在心中總是覺得遺憾；2006 年我接任中華亞太水彩藝術協會理事長，我們的宗旨就是要進行藝術教育和推廣，在一位企業家熱情的贊助經費下，我們以「水彩資訊雜誌」再度發行，為了推廣，雜誌全部透過材料商的通

路免費贈送給讀者，每半年一期的半年刊至今已經出版了 21 期，每期發行 1000 本，我擔任總編輯負責徵稿、審稿、邀稿等，這些雜誌會透過傳閱的功能不斷地為水彩發聲，也讓許多優秀水彩畫家的作品被看到，被發現，這有別於網路廣又快卻短暫的傳播，雜誌的傳播雖然慢但是源遠流長。至今每年的 6 月和 12 月出版前，我們都會接到許多人的詢問，何時出刊？這已經是台灣很受藝術熱愛者歡迎的雜誌之一了。

F6. Can you explain your efforts in issuing Watercolor Information Magazine?

In 1994 I had been convened by Prof. Li Kung Pei and Yung Ensheng, Liang Danhui and other artists together to issue this watercolor magazine. At that time, it was the only one with a single medium as the content. With limited manpower and funding, it was issued in only two years, leaving regrets in my heart. In 2006, I took over the chairman of Chinese Asia Pacific Watercolor Art Association. Our aim is to carry out arts education and promotion. We therefore re-issued "Watercolor Express" under the enthusiastic sponsorship of an entrepreneur. In order to promote watercolor, magazines are sent free of charge to readers through the material business channel. Nowadays, semi-annual publication has been published with 21 issues, each issue amounts to 1000. I served as editor-in-chief of the draft, also responsible for reviewing, inviting articles, etc., and these magazines will be circulated constantly promoting watercolor. The books also enable many excellent watercolorists to be noted and to make a mark with their celebrated works. Such is different from the network--- wide and fast, but the spread of magazines, slow but lasting. To date, every year in June and December before the publication, we will receive inquiring from plenty of people to confirm about the publication date. This magazine has become one of the popular magazines that art lovers favor in Taiwan.

洪東標｜風中迎陽 53x37cm 2015

G

期望與使命感

Expectations and Mission

「... 在耳濡目染下，選擇屬於我們生活中的素材來創作必然有屬於我們東方藝術的特質，這不需要強求，讓它自然發生，你畫的就是具有東方畫家的作品。」

「... Choosing materials belonging to our life to create would certainly include our Oriental art characteristics, which does not need any force. Just let it happen naturally, and your painting is one work of the Easterners.」

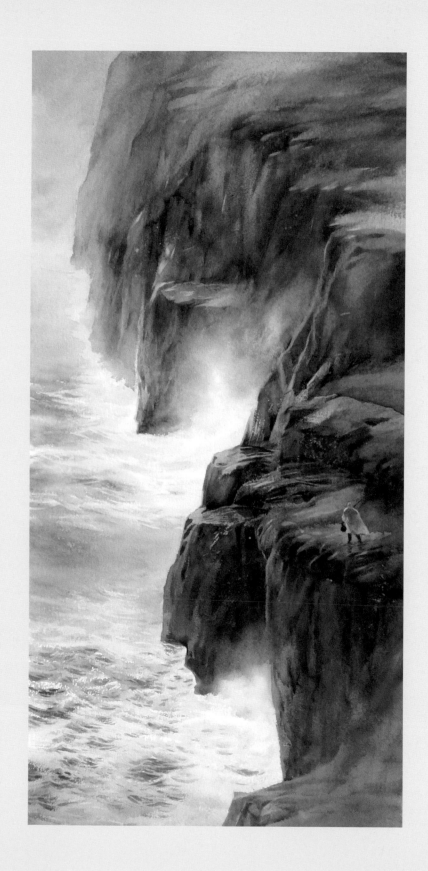

洪東標│黃雨衣
75x35cm　2016

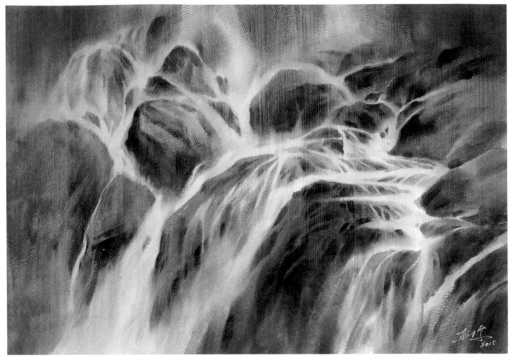

洪東標｜雨中激石（千錘百鍊）37x53cm 2015

G1. 水彩一直以來被認為不好保存，而你卻選擇水彩來創作，對繪畫市場你有甚麼話要説？

首先我們要確認保存的意義是指時間多久？要超過一百年，三百年，五百年或一千年？以達文西十六世紀的作品標準，四百年算久嗎？其實我們台北故宮有很多一千年以上的作品呢！我認為所有的繪畫都不容易保存，因為氧化原本就是自然現象，能被用心珍惜和保存的作品能流傳下來就更顯得珍貴。

長久以來台灣社會對水彩都有很大的誤解－認為不好保存，所以讓水彩市場受到很大的影響，其實所有的繪畫作品都無法抗拒大自然的氧化跟腐朽，每一種創作媒彩都面臨同樣的困難，台灣的氣候潮濕，紙質材料所受的溼氣跟蟲害，讓早期許多水彩畫作品損害，其實最主要的是導因是早期畫家使用非專業性材料，和保存環境的忽視。

近年來，水彩畫界對使用材料的態度更加嚴謹，許多國外具有數百年歷史的造紙廠跟顏料廠所研發的高級專業材料，目前在國內都可輕易取得，再加上科技及相

關保存知識的健全，水彩作品的保存已經不是問題，是大家珍藏水彩的絕好時機，我推測未來繪畫市場，水彩將是一項可以推廣的標地。

那水彩畫的保存要如何用心呢？我認為這應該是三個條件的配合，材料，創作，收藏環境都要好。現代的技術以及創作材料臻於成熟，材料就是紙張和顏料！現代的水彩專業用紙是全棉的，它和印刷用的草漿紙或木漿紙都不一樣，因為棉的纖維長，結合緊密，耐氧化度高，現存最古老的中國畫有兩千年了，就是畫在棉布上的；至於顏料就是講究細膩、濃度和附著力，也就是阿拉伯膠的成分囉！使用好的材料是畫家的責任，越是重視自己作品的畫家，就是要選擇最專業的材料。因此畫家除了創作的技巧好，使用好材料，繪畫過程中也要注意使用純淨的水，不殘留的化學藥劑和生菌，讓畫面才不易變色，不易長霉斑等；收藏及裱框時避免使用強酸性的材料，隔絕濕氣和蟲害，尤其是避免強光照射等，當這些條件都完備了，加上畫家本身的素養都能配合，相輔相成就是最完美的演出。

G1. Watercolor works have always been considered difficult to preserve, but you choose watercolor for creation. What would you comment on the painting market concerning this aspect?

First of all, we want to confirm the meaning of preservation. For how long are we supposed to preserve the works? More than a hundred years, three hundred years, five hundred years or one thousand years? If considering Davin chi's works in the sixteenth century, would we think four hundred years is long enough? In fact, a number of works in Taipei Palace Museum have been preserved for more than a thousand years! I'm convinced that all forms of paintings are not easy to preserve because the oxidation was a natural phenomenon. Those works that can be carefully cherished, preserved, and handed down are even more precious.

Taiwan society has plenty of long-held myth and misunderstanding about watercolors --- they are not easy to preserve. Accordingly, the watercolor market has been greatly affected. As a matter of fact, all paintings cannot resist the oxidation of nature and decay; each medium for creation is facing the same difficulties. In particular, because

of Taiwan's humid climate, paper materials suffer moisture and pests, so many early watercolor works damaged. The main reason is that early painters mostly used non-professional materials, and ignored the environment they kept works.

In recent years, watercolorists have used materials with a more rigorous attitude. Many foreign paper companies boast a history of hundreds of years and paint factories have also developed professional materials. Paper and paint can now be easily obtained in the country, coupled with the technology and related preservation knowledge, preservation of watercolor works is not a problem anymore. Hence, I calculate it's the best time to collect watercolor works. The future of painting markets is predicted with promising watercolor.

Then how can we deliberately preserve watercolor works? Three conditions should be well taken of--- the material, creation, and preservation environment. Modern technology has advanced skills to create materials---paper and paint. Modern professional paper is 100% cotton, which is different from straw pulp or wood pulp paper. It's because cotton fibers are long, combined closely with high degree of anti-oxidation. The oldest Chinese painting has sustained two thousand years, painted on cotton. As for the pigment, artists often demand for its delicacy, concentration and adhesion---that is, the composition of Arabic gum! The use of good materials is the responsibility of painters. Artists who pay more attention to their works would choose more professional materials. Besides wonderful skills, and good materials, in the painting process, they should also pay attention to the use of pure water with no residual chemicals and bacteria so that the picture is not easy to change colors, or become moldy. Avoid the use of strong acid materials for collection and framing, isolate moisture and pests, especially be sure to avoid strong light, etc. When these conditions are noted, the most crucial is that painters' artistic literacy and the conditions can be matched. They complement each other and present the perfect performance.

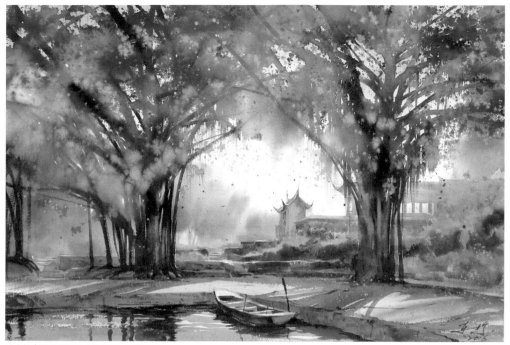

洪東標｜崇敬的旅程 37x58cm 2016

G2. 水彩被稱之為小畫種，你認為水彩在未來藝術領域裡會受到更大的關注嗎？

水彩在美術史上一直很委屈的被當作油畫的草稿，直到 19 世紀英國人才將水彩獨立成一個單一獨立的畫種（成熟又有成就的畫種），在傳入中國後，與中國水墨融合，廣受中國畫家的喜愛，水彩成了中國畫家最能接受的西方媒彩，近年來，國內外都有許多藝術家以技術性的開拓，把原本適合小品的水彩畫以更巨幅的作品來表現，獲得很好的效果，在畫中所能呈現的內容跟繪畫性的肌理，都足以和油畫媲美。在國內，我們就曾舉辦過兩次巨幅水彩畫作的聯展，分別是 2010 年的《壯闊波濤》與 2012 年的《壯闊交響》，都以雙全開（102 x 152cm）以上的尺幅做盛大的展出，獲得很好的評價，我個人也曾以〈白色初秋〉（114 x 180cm）展出，所以巨大的畫幅對水彩畫家來講已經不是難題，水彩在創作上應不再受限於速寫及小品的制約。

一種藝術媒彩的發展得以受到重視必定是根基於市場的開拓，因此大眾能更正確地來認識水彩藝術，加上我們在藝術價值的提升、專業材料的研發和保存技術的進步同時精進，未來的水彩市場必然無可限量。

G2. Watercolor is viewed as a small painting category; do you think watercolor will be paid more attention to in the future art field?

Watercolor had been very aggrieved as a draft of oil painting in the history of art until the 19th century. British people started to separate watercolor from other paintings and formed a single independent category---sophisticated and successful painting. After it was introduced to China, and fused with China ink, it became popular with Chinese painters. Among Western materials, watercolor has become most admired by Chinese artists. In recent years, there have been many local artists or foreign ones devoting to technical development, turning the original idea of watercolor for the sketch to more dramatic works. The content, effects, and texture, are comparable with oil painting. In the country, we have held two huge watercolor exhibitions: The 2010 "Magnificent Wave" and 2012 "Magnificent Symphony". Both grand exhibitions were equipped with double full (102 x 152cm) scales, and they've also received very satisfactory evaluation. I personally had <White early autumn> (114 x 180cm) on display. Thus, a huge frame and scale for watercolorists is no longer a problem; watercolor creation should no longer be limited with the constraints of sketching or small scales.

If a kind of art media is taken seriously, it must be based on the development of the market. As a result, the public can understand watercolor art more correctly. Coupled with our artistic value elated, promotion of professional materials, sophisticated technological research and development of preservation, the watercolor market is bound to be limitless.

G3. 你曾經説要推動水彩成為國民美術，要如何能實現？

「水彩：國民的美術」一詞，是在 2006 年亞太水彩協會與師大美術系在國立歷史博物館聯合舉辦《風生水起－國際華人經典水彩大展》時，由當時的師大美術系系主任－林磐聳教授提出，根據於台灣近代的美術教育，是由 1907 年日本人石川欽一郎在台灣教導學生使用水彩創作開始的，而在台灣水彩幾乎是各級學校美

術科必定會使用的一種創作媒材，再加上大學美術系入學考試術科中的「彩繪技法」，絕大多數的考生都使用水彩來創作，所以水彩在台灣有其歷史的淵源跟有利的發展條件。

水彩的輕巧、方便，可以讓許多熱愛藝術的民眾以最精簡的工具和材料成本來進行創作。我的恩師李焜培教授曾說：「水彩畫，易學難精」，對於民眾期待能夠親近藝術時，提供了一個很好的嘗試機會，對於專業創作者也提供了極具挑戰性和開拓性的空間，讓水彩成為台灣的國民美術，應該是全民藝術運動最好的選項。

我認為未來如能結合政府以及民間力量，共同舉辦水彩展覽、水彩競賽、創作研討會、發表學術研究、出版專籍與寫生旅遊等活動，藉此將讓藝術成為全民運動，讓水彩成為國民美術。

G3. You once claimed to promote watercolor to become "national art". How to achieve this ideality?

"Watercolor: National Art" was first coined in 2006. The Chinese Asia-Pacific Watercolor Association and NTNU Department of Fine Arts jointly organized the "Fengshengshuiqi - International Chinese classic watercolor exhibition" in National Museum of History. The director of Department of Fine Arts, Professor Lin Panzhun, proposed the thoughts: according to modern art education in Taiwan, in 1907, a Japanese--- Ishikawa Chinichiro started to teach students to use watercolor for creation. Currently, almost all schools in Taiwan teach this subject with the media. Besides, the "painting techniques" are required in University of Fine Arts Entrance Examination; the vast majority of candidates would use watercolor for their creation. Consequently, watercolor in Taiwan has its historical origins with favorable development conditions.

It is light, and convenient, allowing many people to love the art and use the most streamlined tools and materials to create with a low cost. My mentor, Professor Li Kungpei, once said: "Watercolor painting is easy to learn and difficult to master". For

people looking forward to be able to get close to art, it provides a very good chance to try; for professional creators, it also provides very challenging and pioneering space. Making watercolor become Taiwan's national art should be the best choice for the entire art movement.

I'm convinced that if in the future, watercolor can be combined with government and civil forces to jointly organize watercolor exhibitions, watercolor competitions, creative seminars, or publish academic research or books, and hold sketching and other related activities, it can definitely become a national movement--- national art.

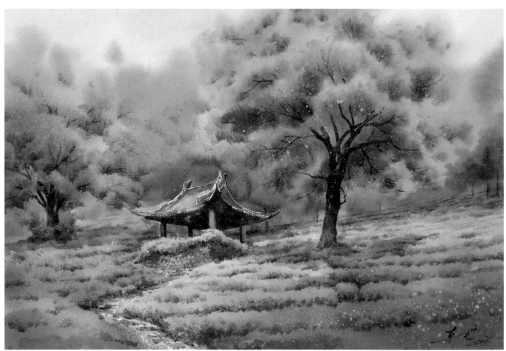

洪東標│仲夏的茶園 37x58cm 2016

G4. 你認為當代的台灣畫家如何畫出一個東方畫家的水彩畫？

其實我們都是在東方成長，在這個環境裡我們承接了傳統的美學概念和環境影響，如果我們不捨去固有的藝術基因，刻意去追求西式的體裁或樣式，多多接觸傳統藝術，在耳濡目染下，選擇屬於我們生活中的素材來創作，必然有屬於我們東方藝術的特質，這不需要強求，讓它自然發生，你畫的就是具有東方畫家的作品。

G4. In what way can contemporary Taiwanese painters create an oriental watercolor work?

In fact, we grow in the East and undertake the traditional aesthetic concepts and environmental effects. If we do not give up the inherent artistic gene to deliberately pursue Western forms or styles, and frequently contact with traditional art, oriental works can be successfully achieved. Choosing materials belonging to our life to create would certainly include our Oriental art characteristics, which does not need any force. Just let it happen naturally, and your painting is one work of the Easterners.

G5. 你認為水彩畫家要如何才能畫得更美、引發觀賞者的共鳴？

大多數的水彩畫家都在精進於表現技法，可是技巧表現的只是表象，卻不是最能感動人的元素。我認為最重要的應該是畫家對主題的深刻情感，理解和追求，比如畫人物作品，它的深刻在於準確造型之上的內在情感；風景作品的深刻在於準確造型之上的意境；人體作品的深刻在於準確造型之上的如音樂般的優美旋律。我認為感人的作品是來自畫家的內心感動，不是來自於畫家的手。海明威也說過：「故事真實，態度真誠，就會是好作品」。大陸人物畫大師關維興常說的話：「藝術的修養說到底是人的修養。是自然流露的本性，『人真畫亦真，人假畫亦假。人厚畫亦厚，人薄畫亦薄。』

G5. How can watercolor painters paint more beautifully, resonating with the viewers?

Most of the watercolorists target at being proficient in techniques, but skills of performances are only the appearance, not the most moving elements. I believe the quintessential component is the painter's deep feelings, understanding and the pursuit of themes. Take painting portraits as an example. Its depth lies in the internal emotions rather than accurate shapes. For landscape works, the mood should be above accurate shapes as well. For figures, its depth is like an enchanting melody, not accurate shapes. Moving works are filled with emotions from the painter's heart,

not from his/her hand. Hemingway also stated: "If the story is true and with a sincere attitude, it will become a good work." Mainland character master Guan Weixing also claimed: "The cultivation of art indeed is the cultivation of people. It is nature naturally reveals." "If people are naïve, their paintings are also true; if people are hypocritical, their paintings seem fake as well. If people are kind-hearted, their paintings tend to be "thick'(enriched), and if they are despicable, their works 'thin'(tasteless). "

G6. 你喜歡水彩，你能描述一下，與油畫相比，水彩有哪些優點呢？

我總覺得水彩絕不只是單純的一種繪畫的創作工具，應該如其他畫種一樣能產生偉大的作品。一幅好的水彩作品獨具的藝術感染力是其他畫種無法比擬和替代的，大陸人物畫大師關維興說：「這裏的情是水彩的情，優美是水彩的優美，韻味是水彩的韻味。並以其絢麗的色彩，明媚的光線，空濛的氣韻，瀟灑的筆觸，淋漓的水跡，像一首首流動的詩，激蕩著每個人的心。」水彩創作的技術特殊艱難，充滿著神秘莫測的曲折，以及很高的失敗率，讓很多人打退堂鼓，所以水彩就成了勇敢者的天地，對於喜歡迎接挑戰的我，自然有著極大的吸引力，輕視水彩是不公平的，水彩絕對值得開發，值得繼續探索，如能將水彩特有的表現力充分發揮出來，一定能為藝術領域帶來新的面貌。

洪東標│生命的樂章 37x77cm 2015

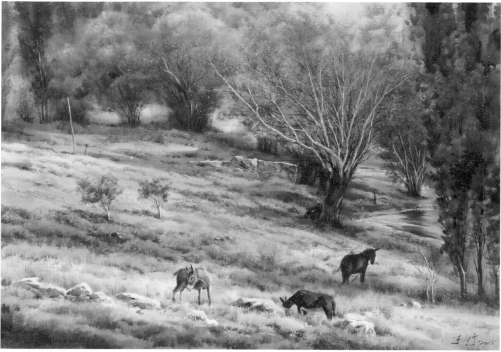

洪東標｜仲夏的午后 55x75cm 2015

G6. You certainly prefer watercolor, but can you describe what are the advantages of watercolor compared to oil painting?

I always feel that watercolor is not just a simple tool for creation; it should be valued as highly as other paintings to produce great works. The unique artistic appeal of a good watercolor work cannot be compared or replaced with other pictures. Mainland character master Guan Weixing once claimed: "The emotion here is the love of watercolor, beauty in watercolor, charm in watercolor. And with its gorgeous colors, bright light, airy charm, chic strokes, dripping water marks, it's like the flow of a poem, stirring everyone's heart." Watercolor creation is full of technological difficulties, mysterious twists and turns, and a high failure rate, so many people retreat with frustration. Therefore, watercolor has become a brave world for those who like to meet challenges of nature; there lies great attraction. Despising watercolor is not fair; potentials and possibilities are worth the development. Continue to explore, and fully express the uniqueness of watercolor. We are bound to bring forward a new art field.

洪東標｜十月上海 37x53cm 2015

G7. 在 21 世紀這樣多元的藝術表現領域裡，水彩畫既是傳統的媒材你認為還會有喜歡的觀賞者嗎？

時代不同，面貌不同，台灣的水彩在 21 世紀表現出非常多元的面貌，這是我們對水彩認知上的一大驚奇，前面我曾說藝術創作的領域裡，就好像是廚師，憑藉每位藝術家的素質與修養，烹調出不同口味的佳餚，提供不同愛好的顧客選擇。其實在 21 世紀的新時代裡我們可能對一些新藝術感到興趣，嘗鮮往往是一時的，但是我們無法改變也喜歡傳統。新的藝術的表現豐富起來，滿足不同人們多方位或不同時間的選擇，喜歡傳統水彩的人還是不會忘記的吧！

G7. In the 21st century, such a diverse field of artistic expression, watercolor is a traditional medium. Do you think there will still be faithful viewers?

There are different aspects in different times. Taiwan's watercolor in the 21st century

has shown a very diverse appearance, which amazes artists and non-artists as well. As I mentioned before, in the field of artistic creation, an artist is like a chef. With various qualities and cultivation, each creates various tastes of cuisine to suit different customers. In fact, in the new era of the 21st century, we may be interested in some new art forms--- the adoption is often in a moment, but we cannot change our inclination for the tradition. The performance of the new art is rich, to meet people's multi-direction or time choices. However, those traditional watercolor followers certainly won't forget their beloved?!

G8. 以你的經驗，你會如何對具有藝術創作憧憬的年輕人提供建議？

我要說有夢最美，有志於在水彩畫壇闖出一片天的年輕畫家們，只要肯努力、用心學習，都有機會站上藝術的舞台，藉由網路甚至可以知名於國際。但是要有吃苦的準備，藝術家雖然不是一定會像梵谷一樣的遭遇，但是默默耕耘和為藝術付出是必經的歷程。

記得我年輕時的第二次個展，一位收藏家前來觀賞我的作品，他說：「我不會買你的畫，因為我不知道你還會撐多久」，真的，一個被安排在七月展出的畫家，一般都不被好，畫廊不看好，收藏家也不看好，我就是有這股傻勁，一路畫下來，雖然物質生活不富裕，但是不會寂寞，沒有錢但是還是很快樂，看你要的是甚麼。我也曾對美術班的家長說，不要寄望你的孩子會成為有錢人，但是我知道他們會過得很快樂。

我認為青年畫家厚植自己的寫生能力很重要，台灣水彩名家簡忠威說得很好：「你要努力鍛鍊自己的實地寫生能力。能化腐朽為神奇。在一個多醜的地方，你可以秀出一張傑作給大家看。這種能力，包括想像力、記憶力、腦力、體力、經驗與氣質。是要下幾十年的功夫啊！這種強大的寫生實力，必然對你的創作產生突破性的影響！」

G8. With your experiences, how would you advise young people who dream about art creation?

I would like to say that "dare to dream" is most beautiful. For those young artists interested in exploring the watercolor world, if they are willing to work hard, and learn hard, they would have opportunities to stand on the stage of arts. Through the network, they can even become renowned worldwide. On the other hand, they need to be prepared to encounter hardships. Although artists would not necessarily experience what Van Gogh did, quietly making efforts and devoting to the art is definitely a must.

I still remember my second solo exhibition in youth. A collector watched my works and approached me: "I will not buy your paintings because I do not know how long you will stay in the art world." Indeed, a painter whose works were scheduled to be on display in July was generally not impressive. At that time, both galleries and collectors were not optimistic. Nevertheless, I just have the silliness and passion to paint all the way down. Although the material life is not rich, I never spiritually feel lonely. With no great amount of money in the bank, I'm still very joyful. It depends on what you yearn for. I once said to the parents of art classes, "Do not expect your children to be rich, but I know they will lead a happy life."

I also contend that it's very critical for young painters to enrich their abilities to sketch. A Taiwanese watercolor celebrity Chien Chung Wei said very well: "You have to train and strive for abilities to sketch the field--- to turn the decadent to the magic. Even in an ugly place, you can showcase such kind of abilities, including imagination, memory, mentality, physical endurance, experiences and temperament. This requires efforts in a few decades! This powerful sketching strength will absolutely bring a breakthrough for your creation!"

G9. 你認為應該如何展現 21 世紀台灣水彩的面貌？

近年來台灣的水彩表現令世界刮目相看，中生代已經嶄露頭角，在國際競賽中獲獎連連，但是國際如何看待台灣的水彩畫，展現 21 世紀台灣水彩的面貌，我覺得有兩個方向需要強化，一個是創作形式的國際化，另一個是創作主題的在地化；

洪東標｜山谷之春 25x53cm 2015

形式的美學是無國界的，這是表現面貌和技法的提升，但是在地化卻是最難的，就是以台灣作主題，融入在地精神和傳統的美感價值。

什麼是 21 世紀當代台灣的面貌和精神，我想起中國名家王維新所說的話：「畫家的風格是自然形成的，畫得不夠多，就不要講風格」我要說：「畫得不夠多，就不會呈現出新世紀的面貌」，所以要畫出台灣當代水彩的面貌，這是需要不斷的以台灣做題材去表現，探索和體會的。保羅‧克利說：「畫家的職責就是創造出一個充滿個人表現力的豐富世界，雖然這個世界與人們看到的世界同屬一個宇宙，但兩者是平行而無交集的，畫家應該以絕對的真誠來完成自己的職責。」因此我自許為一個創作者，一個大眾藝術的創作者在二十一世紀初的這個時期，堅持理念做自認為該作的事，畫在這個時代、這個地域所看到的、所聽到的，以真誠的態度在生活中尋求體驗生活的題材來創作，這就是 21 世紀的作品。不去想能否被收藏？作品將被流傳多久？歷史將如何定位？自然而然畫自己的感動地堅持下去，又何必在乎？

G9. In your opinions, how to manifest facets of Taiwan's watercolor in the 21st century?

In recent years, Taiwan's watercolor performance makes the world amazed. Certain promising and prominent artists have emerged in international competitions with

their award-winning again and again. But how does international watercolor view Taiwan's watercolor paintings? How can Taiwan watercolor in the 21st century showcase a new visage? I believe there are basically two directions to be strengthened: one is the creative forms need internationalization, and the other is themes of the creation need localization. There is no border for forms of aesthetics, which refers to expression forms and techniques to be enhanced. As for localization, it is the most difficult field. Utilizing themes in Taiwan, artists need to blend into local spirits and traditional values of beauty.

So what is the 21st century contemporary Taiwan's facet and spirit? I think of Chinese master Guan Weixin's comments: "An artist's style is naturally formed; if he/she paints not enough works, then do not talk about his/her style. " Accordingly, I would contend that if the quality is not enough, it will not manifest visages of the new century. " In order to reveal the facet of contemporary watercolor in Taiwan, we need to continue painting themes relating Taiwan, to explore, and to experience. Paul Kerry stated: "The painter's responsibility is to create a rich world full of personal expressions. Although such a world and what people see belong to a universe, the two are parallel without intersection. The painter should complete his/her duty with absolute sincerity." Consequently, I expect to become such a creator of popular art in the beginning of the twenty-first century. I firmly adhere to the idea of doing things that must be done. My goal is to paint what I view and hear in this area and this era. Endowed with a sincere attitude, I seek themes through life experiences to create. Such creation is one of the 21st century works. These are also the suggestions for those who aim to become artists. Do not think about the profits of painting nor for how long the works will be spread or preserved. And never be bothered by how artists would be positioned in history. Just naturally paint what touches you, and adhere to the next work. Why bother to care?

G10. 你曾經應收藏家的請求，創作你不擅長或不喜歡的題材嗎？

雖然我在教學的內容上涵蓋各種體材，偶有佳作，但並不表示樣樣精通，風景是

我的最愛，也最能表現我的風格和面貌。我曾經應收藏家的要求將同一主題的作品創作出第二件作品，但是為了區隔，我做了內容和規格的修改；我也拒絕過我不擅長題材創作的要求，因為我認為自己不滿意的作品會為自己帶來噩夢，畢竟每一個畫家都要為自己的作品負責，當時我還懷疑這位收藏家的動機，也覺得他不了解我，不了解藝術，甚至有點白目。

G10. Have you ever been requested by collectors to create a theme that you dislike or do not feel comfortable with?

Although contents of my instruction include various themes, and there're occasional masterpieces, it doesn't mean that I'm proficient at every subject. Scenery works are my favorite, and they can best reveal my style and facet. Requested by a collector, I once painted a work with the same theme for a second time. In order to differentiate, I made certain changes of the content and specifications. For collectors' requirements, I also refused to paint a subject that I felt not comfortable with creating. It's because I felt such unsatisfactory creation might bring me a nightmare. After all, every painter should be responsible for his/her work. I also doubted the motives of the collector, feeling that he did not understand me or the art, and even a little annoying.

洪東標｜寧靜海岸 19x44cm 2016

Appendix

附錄

東嶼坪碼頭 Pier Dongyu Ping

很榮幸能應邀到海洋國家公園南方四島參訪，在 2016 的某一天，和一群畫家造訪這個秘境，在四島的行程中蒐集到許多可以入畫的好題材，被世人遺忘的秘境中，隱藏許多辛酸的先民故事和遺址，都是入畫的好資料，在晴空萬里的好日子，我們到達東嶼坪，船靠岸前我立即發現這個島嶼的漁港其實和台灣許多的小漁港沒兩樣，但是在接近中午的時分除了我們一群畫家和國家公園的工作夥伴外，看不到幾個住民，或許出海了，或許休息了，不管是甚麼原因，這個遠離煩囂的小漁村，有的就是多了一份孤寂和寧靜，讓我想畫下這個寧靜的氛圍。

It was my great honor to be invited to visit the southern four islands of the Marine National Park. One day in 2016, a group of painters visited this secret wonderland to collect plenty of impressive themes. Forgotten by the world and hidden with stories and sites of many ancestors' bitterness, this secret land boasts terrific materials for painting. With the blue sky of a sunny day, we arrived at Dongyu Ping. Soon after the ship pulled over the shore, I immediately found that there's almost no difference between this small fishing port and those in Taiwan. Close to noon, however, besides our group of painters and workers at the national park, there're few residents. They probably were at the sea, or rested somewhere in the village. No matter what reason it was, this small fishing village was far from the hustle and bustle of a city. Such solitude and tranquility enticed me to paint its serene atmosphere.

這幅畫使用大量的暖灰色和冷灰色，我最喜歡以補色的概念來調出灰色，最主要是岱赭 BURNT SIENNA、和凡岱克棕 VANDYKE BROWN、焦茶 SEPIA、來調少許的群青呈現出由亮到暗的暖灰，多加一些群青就是冷調的灰色，再以濃度來分出色階。

A lot of warm gray and cold gray was used in this painting, and my favorite way is to produce gray colors utilizing the concept of complementary colors. Mostly I mixed BURNT SIENNA, VANDYKE BROWN, or SEPIA, with a little ULTRAMARINE to present warm gray, from the bright to the dark. If more ultramarine was added, then the cold gray was formed. The concentration was to separate the tone scales.

參考圖：參考照片

Reference: Reference photo

圖一：打鉛筆稿時，我刻意將視平線降低讓天空的畫面增加，再使用留白膠塗上房頂的陵線和漁船、機車、樓梯的頂部受光部分，好讓中午的強烈陽光更明亮。

Figure 1: Drawing the composition with a pencil, I deliberately lowered the visual horizon to increase the space of the sky, and then painted the white glue on top of the roofs, fishing boats, motorcycles, and stairs of the light parts. Thus, it made the sunshine at noon brighter.

圖二：染畫天空時，我增加了許多雲彩，用群青、鎘朱和少許岱赭畫出雲層的厚度。同時用調的不均勻的群青和岱赭將房子的立面染上顏色，再用群青和凡岱克棕調出更暗的不均勻灰調來畫碼頭側邊的暗處。

Figure 2: Rendering the sky, I added plenty of clouds. Using ULTRAMARINE, CADMIUM RED and a little BURNT SIENNA, I painted thickness of the clouds. At the same time, unevenly mixed ULTRAMARINE and BURNT SIENNA was added on the surface of one side of the house. A darker gray tone of ULTRAMARINE and BURNT SIENNA was then painted on the dark side of the pier.

圖三：黃赭加少許的胡克綠畫受光的邊坡和山坡上的草地，刷一層灰色在山上岩石的暗處。

Figure 3: RAW SIENNA plus a little HOOKER'S GREEN was added on the lightened slope and grass. On the hillside, a layer of gray was brushed in the dark part of rocks of the mountain.

圖四：加深的細節的顏
色，並且將房子的牆面
分出明暗轉折和前後空
間的明暗關係，再畫暗
窗戶。

Figure 4: I then deepened the color of details; the walls of the house were painted with light and shade plus a relationship between the front and the back. And then dark windows were painted.

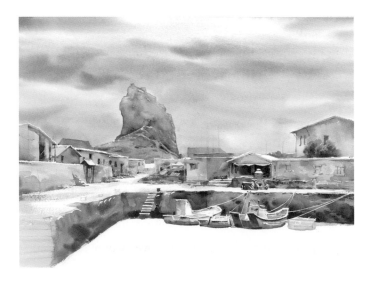

圖五：去除留白膠後，
這些生硬的白色塊都需
用小筆來修飾和柔邊，
用較鮮豔的色彩來描寫
最重要視覺的焦點漁
船。

Figure 5 : After the removal of white glue, a small pen to modify and soften edges was needed for these blunt white blocks. More vivid colors were added to describe the most critical visual focus of fishing boats.

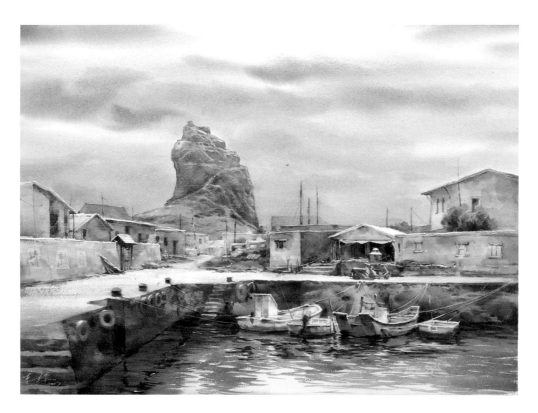

圖六：小筆勾畫電杆天線，碼頭的暗處剛好襯托出漁船有最強的明暗對比和色彩，
形成焦點，再鋪一層淡淡的藍色調後，再以橫向的筆觸來畫水，逐次加深層次，
留下倒影的色彩，表現出不同的光影層次，最後等全畫乾後，以飛刷洗水的方式
來柔化畫面，並完成作品。

Figure 6 : I used a small pen to outline antennas of electricity poles. The dark part
of the pier perfectly brought out the fishing boat. With the strongest dark and light
contrast and color contrast, it formed the focus. A layer of light blue tone was added,
and then I repeatedly used horizontal strokes to present water, leaving the color of
its reflection, and showing a different level of light and shadow. Finally, I waited for
the whole painting to become dry, rendered "flying brushes over water" to soften the
picture, and completed the work.

武陵春色 Spring in Wuling

武陵是台灣最熱門的賞櫻地點之一，每年春季遊客絡繹不絕，2015 年春應好友邀請第三次造訪武陵，適逢櫻花季節，回來後就不能免俗地畫起櫻花來；當時天氣晴朗陽光普照，我隔著七家灣溪遠眺對岸山坡拍照，因為強烈的陽光讓許多枯木的樹枝反射出許多閃爍的白光，對比後讓花色顯得灰暗了許多，創作時我試著想像當陽光減弱時的情形，好讓色彩豐富一點。

Wuling is one of the most popular cherry blossom sites in Taiwan; each spring visitors continually flock to this tourist destination. In the spring of 2015, I was invited by friends to visit Wuling three times, and it coincided with the cherry blossom season. After coming back, I couldn't avoid painting cherry blossoms. The weather was sunny with bright sunshine. I took pictures across the Chichawan Creek, overlooking the other side of the hillside. As the sunshine was so bright, many branches of the dead wood reflected plenty of flashing white light. The flowers looked much grayer with the comparison. When creating the work, I tried to imagine the sunshine was weakened, thus colors would become more enriched.

照片：這是以構圖取景的標準拍下的照片，所以我的鉛筆稿變動的內容不多，但是這是一張曝光過度的照片，所以必須調整色彩的飽和度。

Photo: This was a picture taken with a composition standard, so my pencil content didn't change much. But there was over-exposure in the photo; I had to adjust the color saturation.

圖一：在打鉛筆稿的過程中，我滿腦子都是思考著上色順序，決定以濕中濕的疊染畫法來製造出花朵盛開的繁茂氛圍。除了涼亭屋頂之外，用大排刷在畫面鋪上大量的水分後，以大蘭竹筆分別以群青 ULTRAMARINE 調入一點岱赭 BURNT SIENNA 形成的冷灰色刷出枯樹的底色；淡淡的玫瑰紅 ROSE PERMANENT 和少許的藍紫 DIOXAZINE VIOLET 刷出櫻花叢林的部分，黃赭 RAW SIENNA 和岱赭 BURNT SIENNA 刷枯黃的草坡，再以稍濃的顏色分別快速地疊染，來加深樹影和花影的暗處，這個時候，心中就有「雞蛋原理」的概念，先預設好層次的明暗關係。

Figure 1: In the process of composing with a pencil, my mind was occupied with the order of adding colors. I decided to use wet-in- wet and stacked strokes to create the atmosphere of flowers in full bloom. Except for the roof of the pavilion, I rendered plenty of water with a large brush. And I used a Chinese large "orchid bamboo pen" to blend ULTRAMARINE with a little BURNT SIENNA, cold gray, to form the base of decayed trees; ROSE PERMANENT and a little DIOXAZINE VIOLET was painted to brush parts of the cherry blossom trees. RAW SIENNA and BURNT SIENNA was brushed for the yellow grass slope, and then slightly thick colors were quickly superimposed, to deepen the shadows of trees and flowers. At that moment, the "egg principle" concept was rooted in my heart, so the relationship of layers of light and dark was pre-set in advance.

圖二：繼續加深樹林和櫻花的暗處，這是第三個層次，重疊時落筆的位置都在第二層疊色位置的下方，暗影就會有漸層的變化。

Figure 2: I continued to deepen the darkness of the woods and cherry blossoms, which was the third level. The overlapping pens fell in lower parts of the second layers, contributing to gradual changes in the dark parts.

圖三：等紙面稍乾，用胡克綠加岱赭畫常綠的針葉樹，這是高海拔的山區特色，顏色交織更顯得色彩的豐富，常綠的針葉樹顏色較暗沉，重疊暗色刻意多疊在樹的左側，好讓陽光方向更明顯。也將山坡茶園的顏色加深分出明暗。

Figure 3: After the paper became dryer, HOOKER'S GREEN LIGHT plus BURNT SIENNA was painted for evergreen conifer trees, the feature of mountains with high altitudes. Colors interwoven were more colorful; green conifer trees were darker. Overlapping dark pens were deliberately stacked on the left side of the trees so that the direction of the sun was more obvious. Besides, the color of tea gardens on hillsides was deepened to reveal bright and dark.

圖四：此時畫面中的櫻花和枯樹部分大都已經乾了，再度以中蘭竹筆同色系乾筆加深第四層的暗處，上色的位置都在第三個層次的下方，面積更小。此時樹林的立體空間更明顯地呈現出來，完全符合「雞蛋原理」的概念。

Figure 4: At this point, the majority of cherry blossom trees and decayed trees became dry, I then used a middle size of orchid bamboo pen with dry strokes, adding the same color to deepen the fourth layer of the dark. The color position was below the third level, area smaller. Currently, the three-dimensional space of the woods was more clearly presented, in full compliance with the "egg principle" concept.

圖五：勾畫樹枝在樹叢和花叢的暗處，這是展現樹形最重要的步驟，樹的姿態美感完全取決於如何展現轉折分岔的變化，這可以從寫生中獲得許多訓練。最後將涼亭和點景人物勾畫完成，全圖完成。

Figure 5: The delineation of branches in the darkness of trees and flowers was added, which is the most important step to present trees. The beauty of postures of trees depends entirely on how to reveal the turn and bifurcation, which can be obtained through a great amount of training from the sketch. Finally, the pavilion and the character were outlined; the entire picture was completed.

Plate

作品

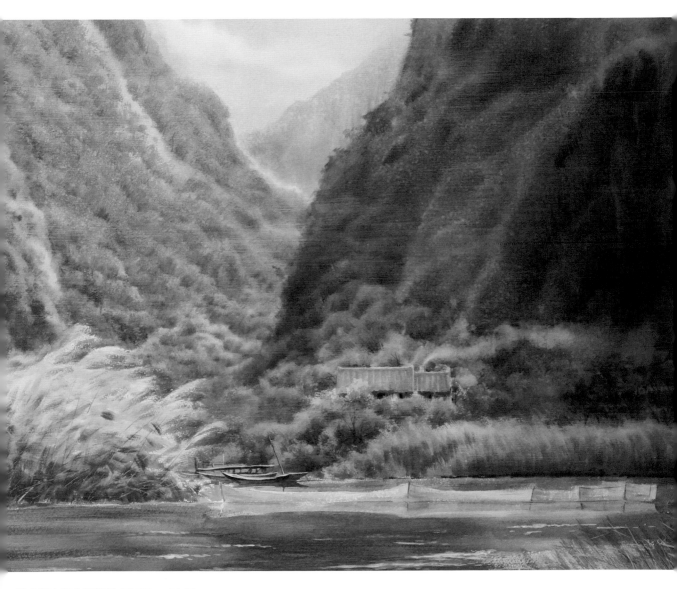

洪東標｜漁家近黃昏 55x75cm 2015

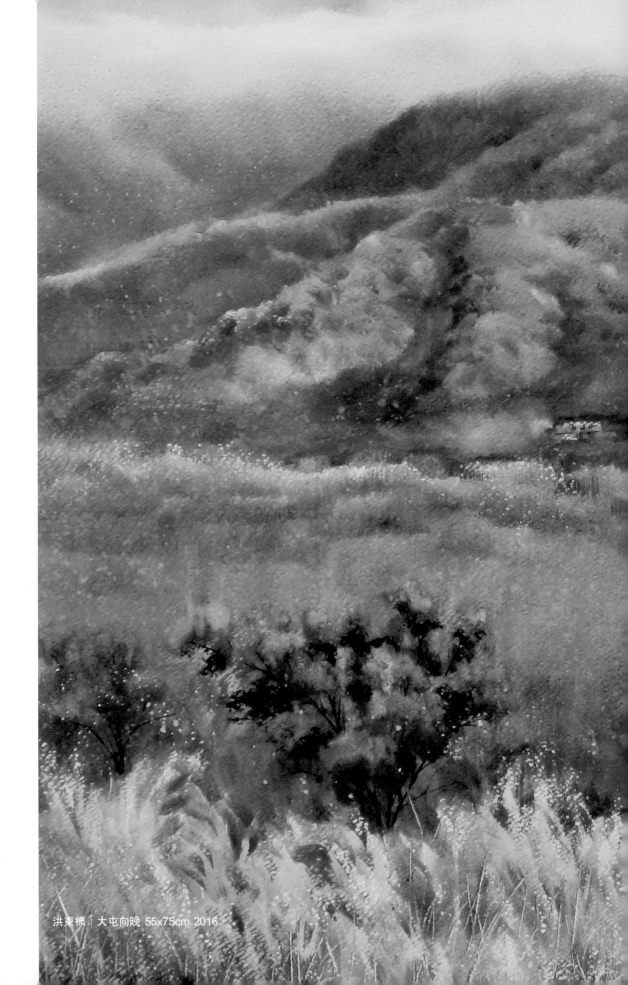

洪東標｜大屯向晚 55x75cm 2016

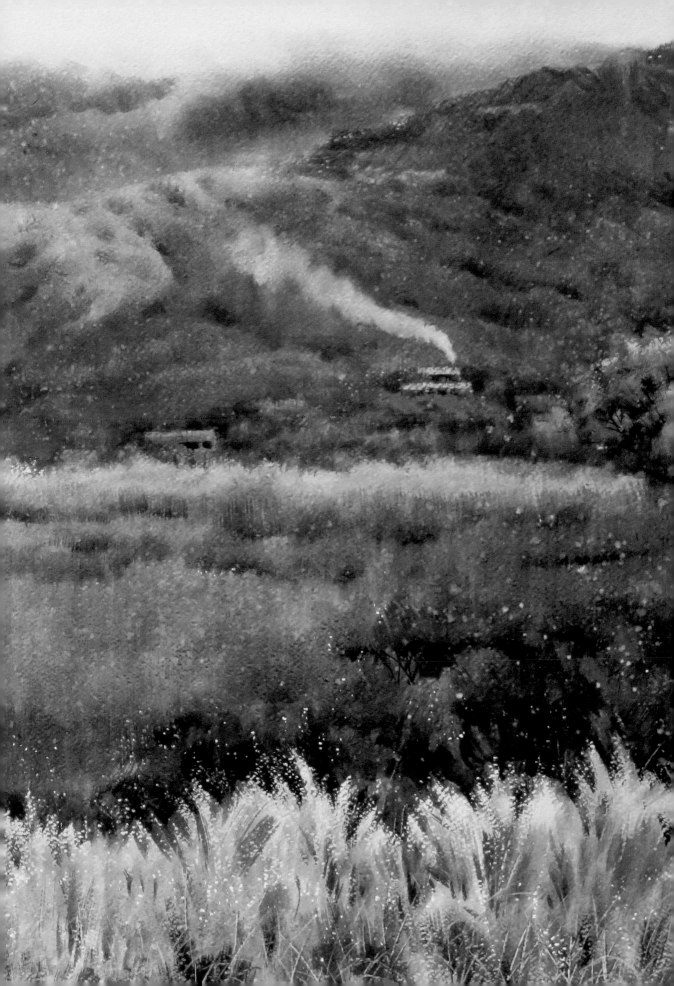

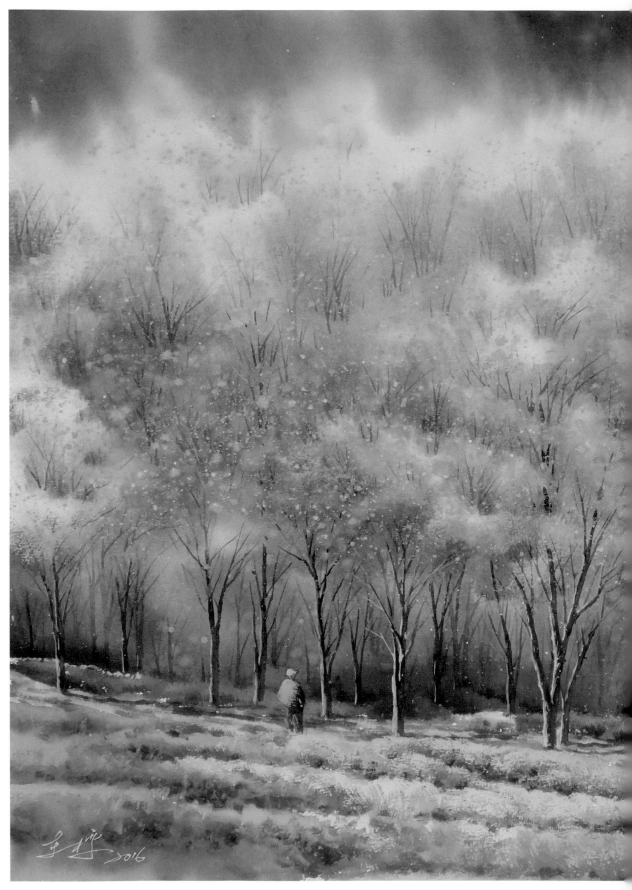

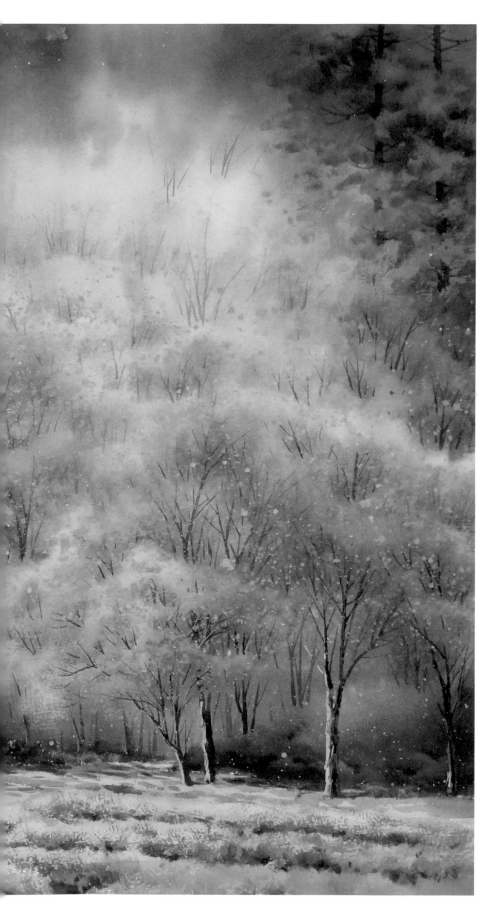

洪東標｜春天的色彩
55x75cm 2015

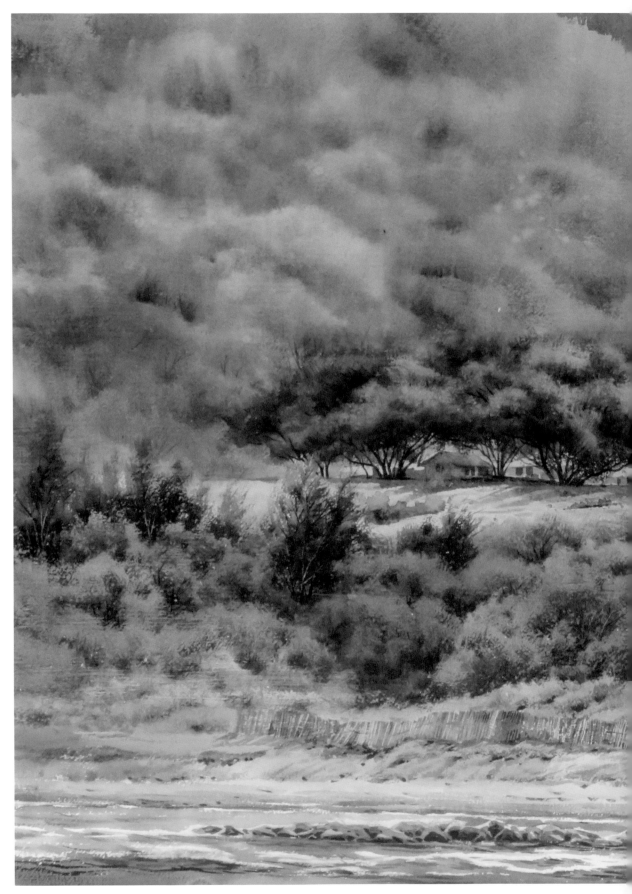

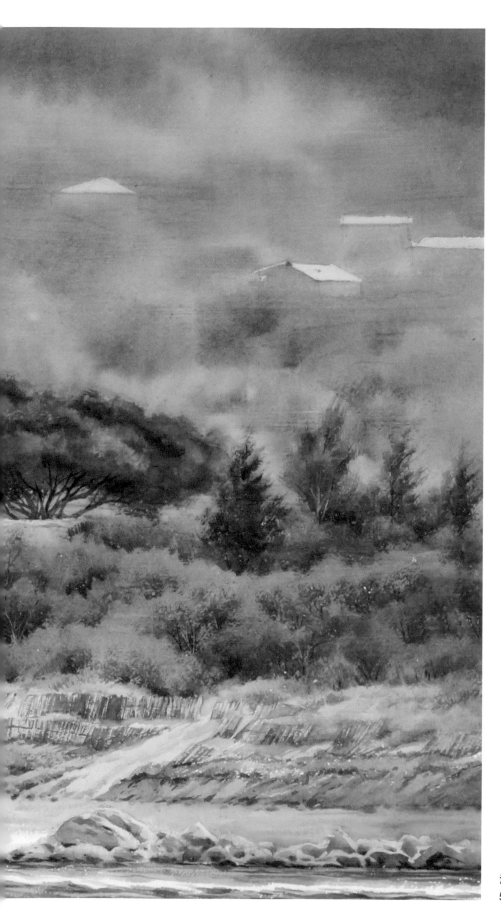

洪東標｜眺望三芝鄉間
55x75cm 2015

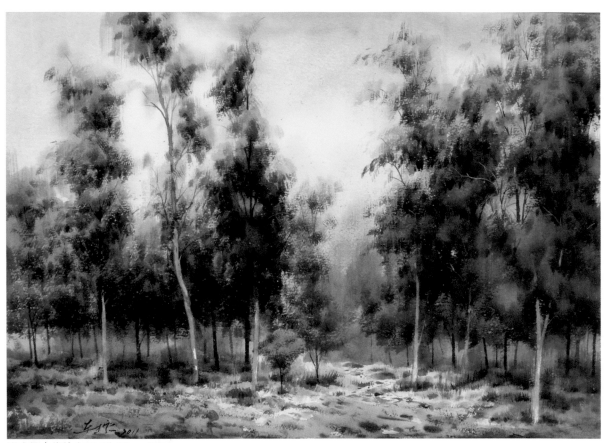

洪東標｜綠林之夏 38x53cm 2011

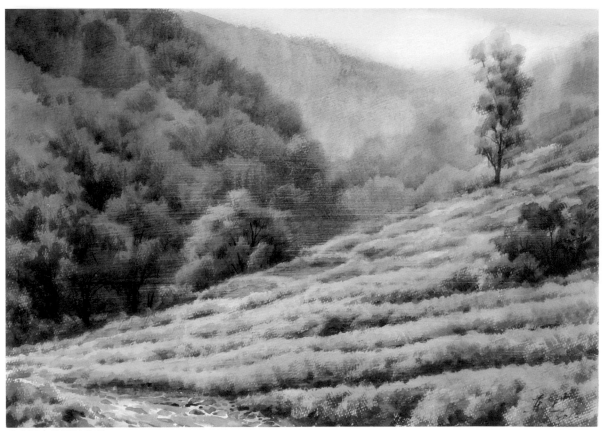

洪東標｜茶園近黃昏 37x53cm 2015

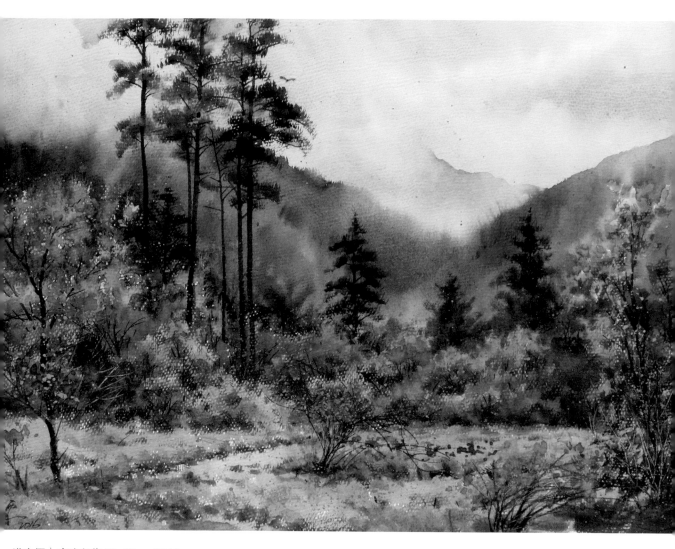

洪東標｜武陵角落 36x53cm 2016

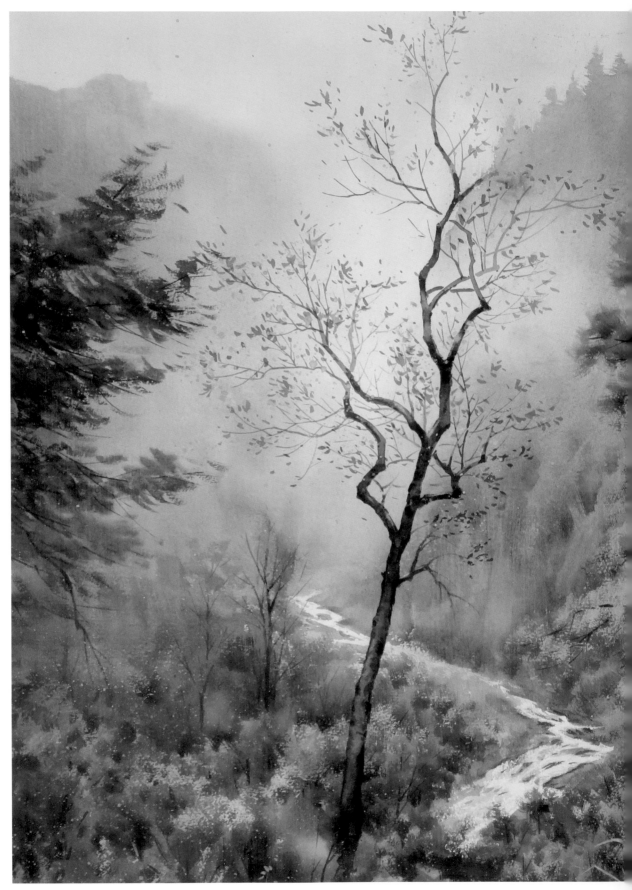

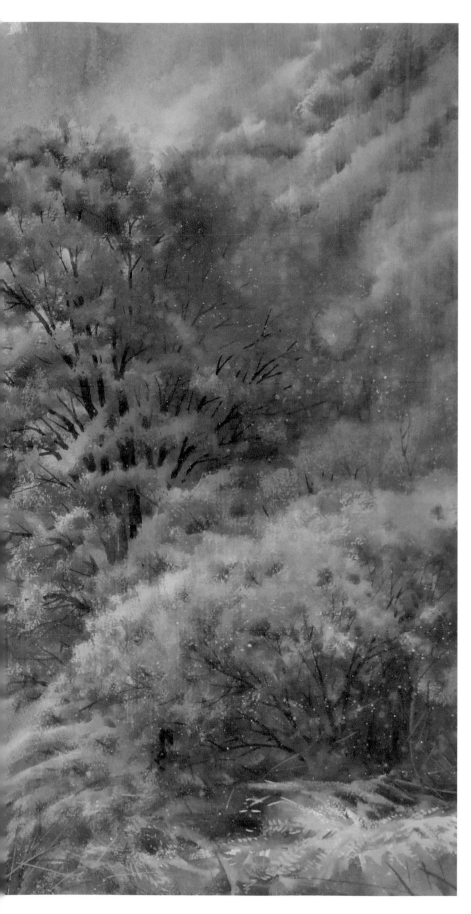

洪東標｜霧鎖溪谷
55x75cm 2016

洪東標｜靜謐的河灣 55x75cm 2016

洪東標｜水澤盛夏 55x75cm 2016

洪東標｜茶園雨後 37x53cm 2015

169

洪東標│融雪的季節 37x56cm 2016

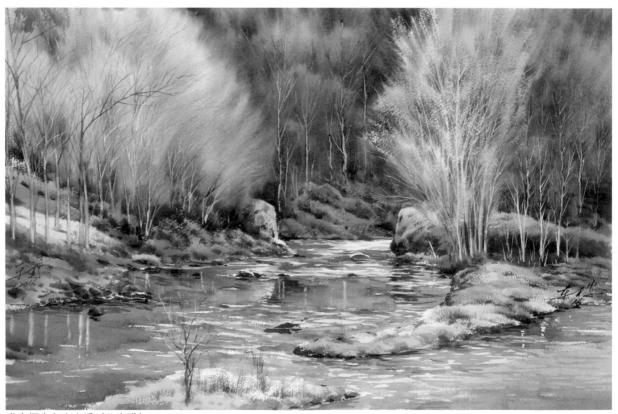

洪東標│冬末小溪（北海道）37x58cm 2016

洪東標│荒園的天空 29x45cm 2016

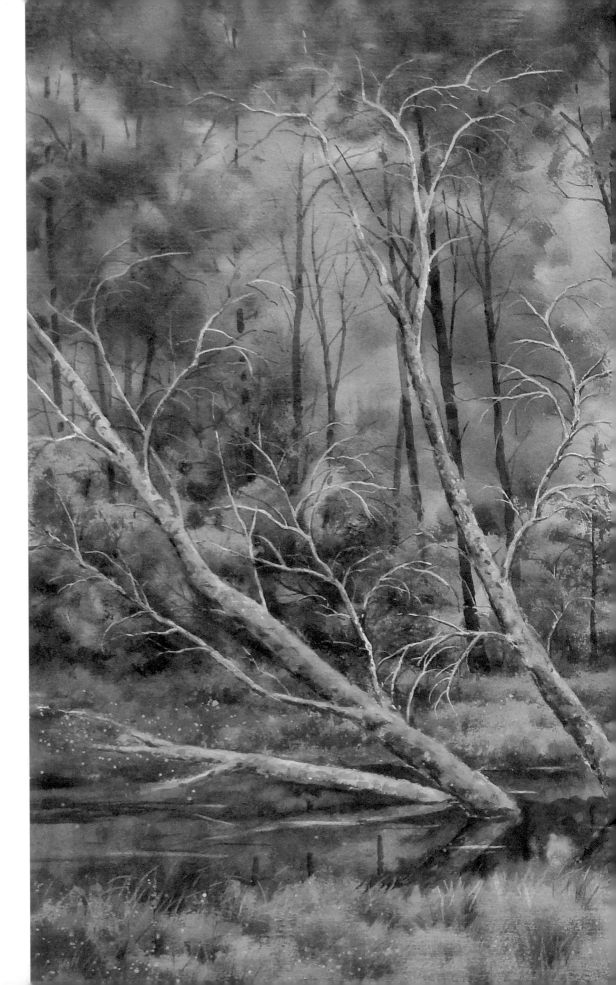

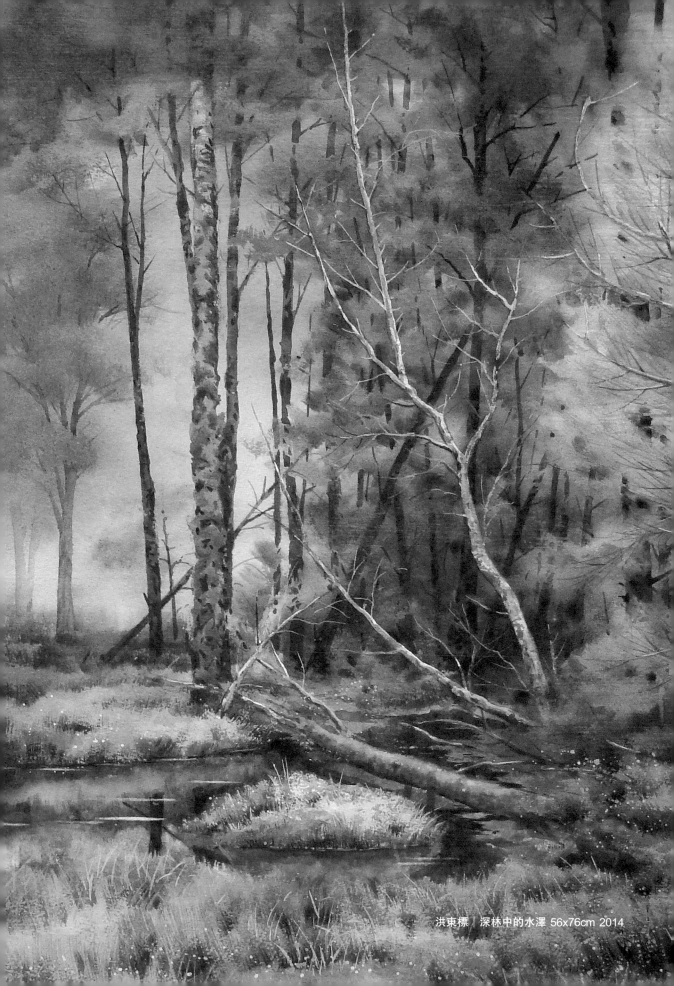

洪東標｜深林中的水澤 56x76cm 2014

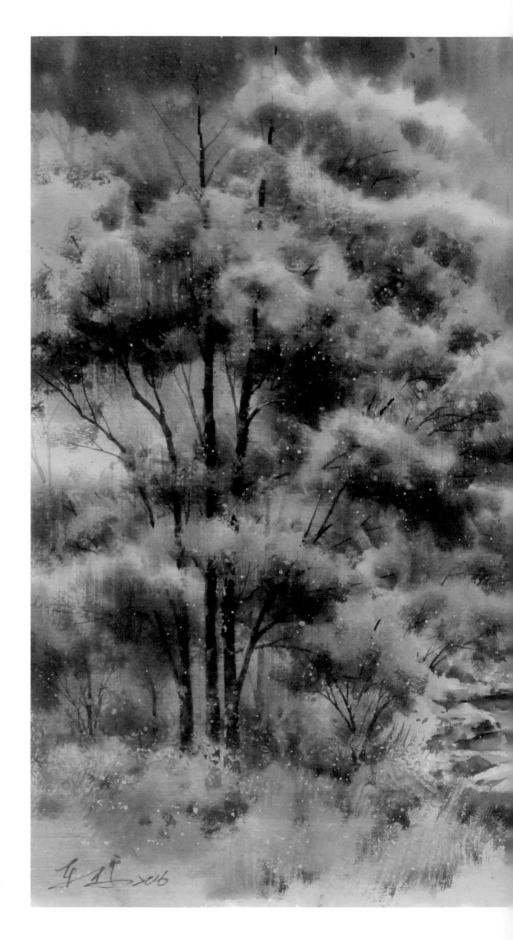

洪東標｜密林中的河灣
55x75cm 2016

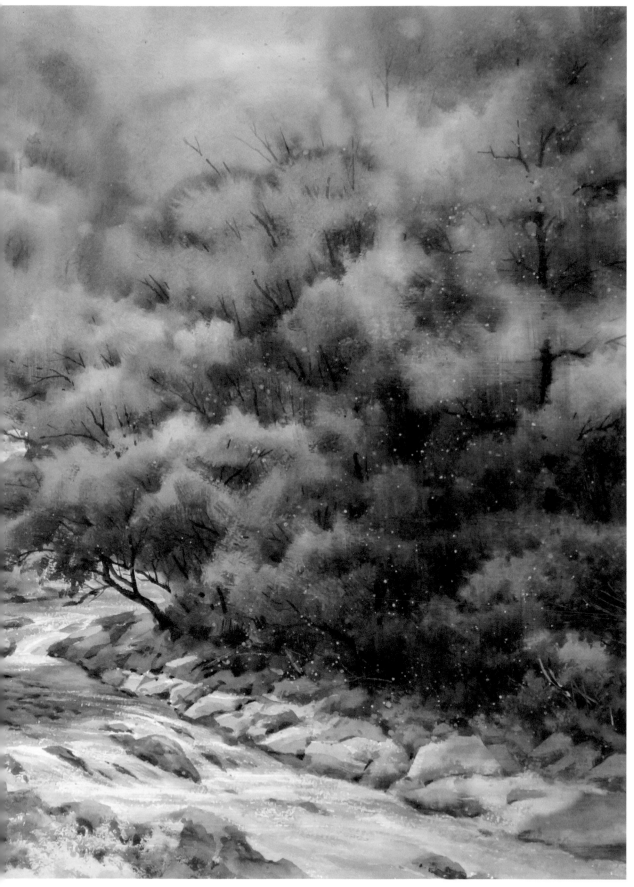

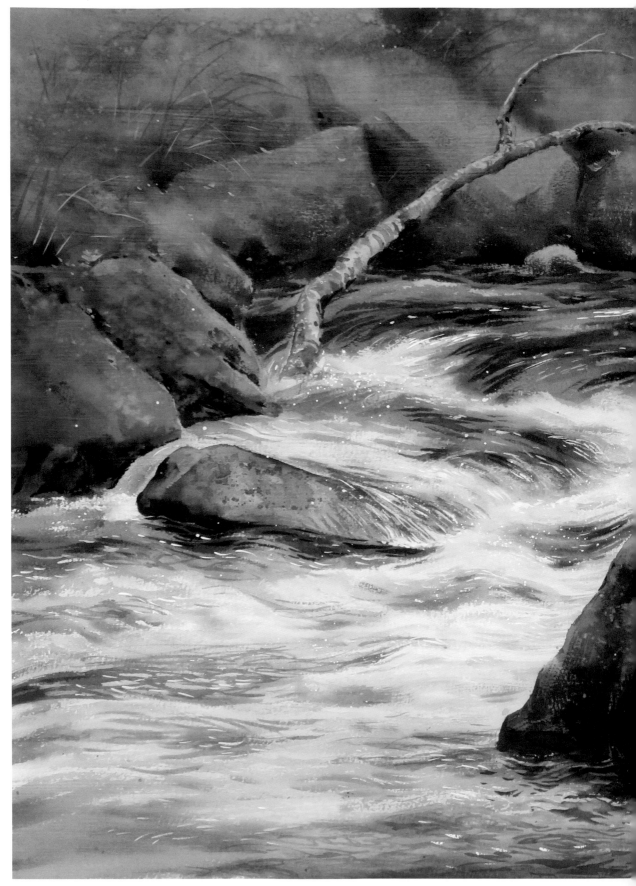

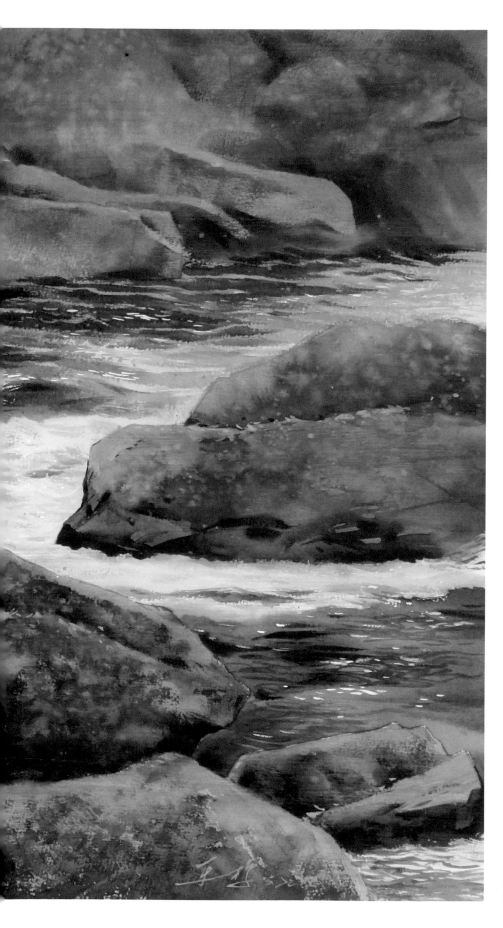

洪東標｜清流
55x75cm 2016

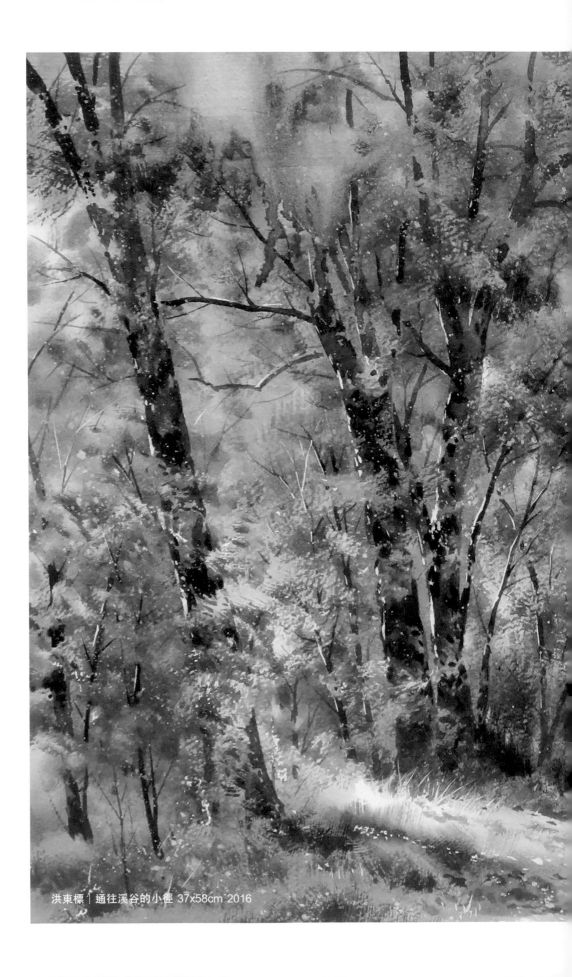

洪東標｜通往溪谷的小徑 37x58cm 2016

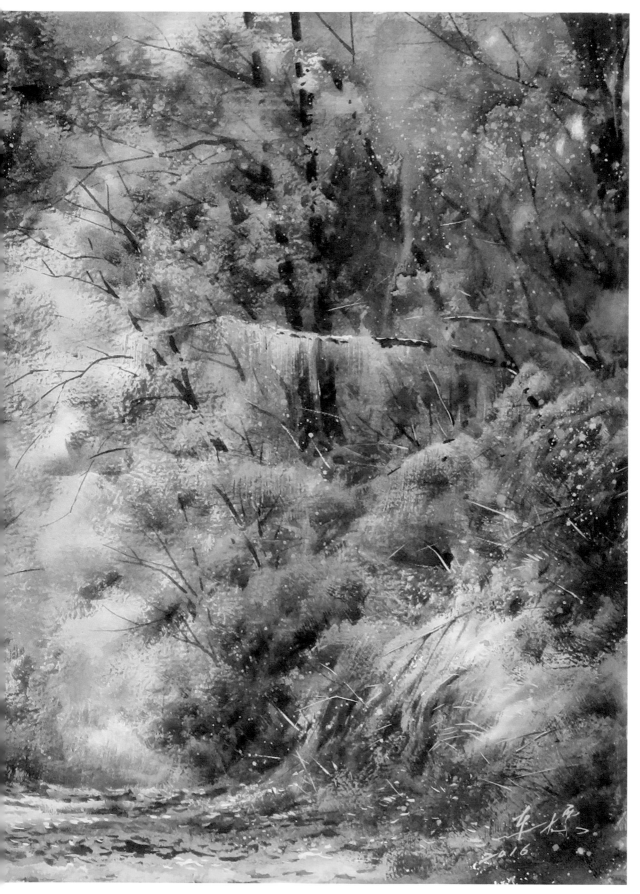

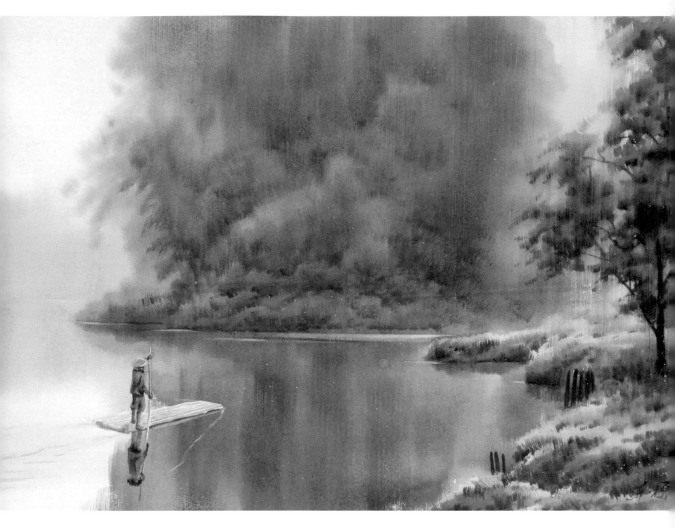

洪東標│清晨泛舟 37x55cm 2010

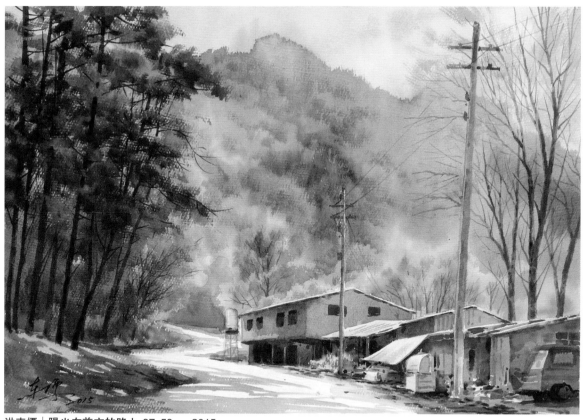

洪東標｜陽光在前方的路上 37x53cm 2015

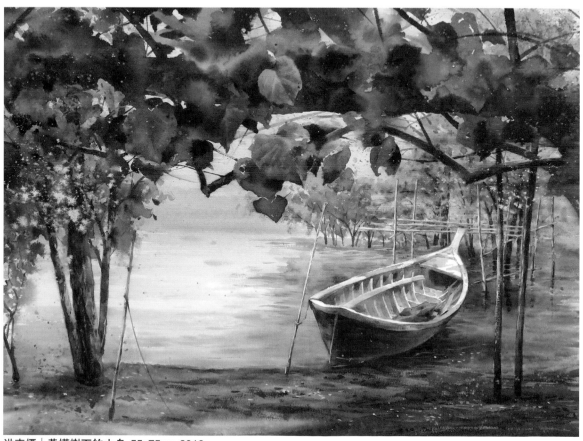

洪東標｜黃槿樹下的小舟 55x75cm 2016

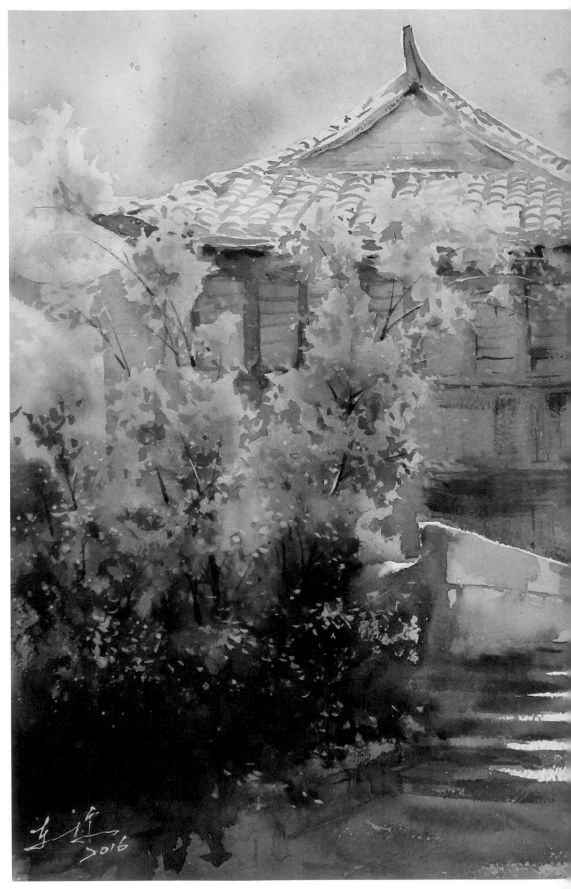

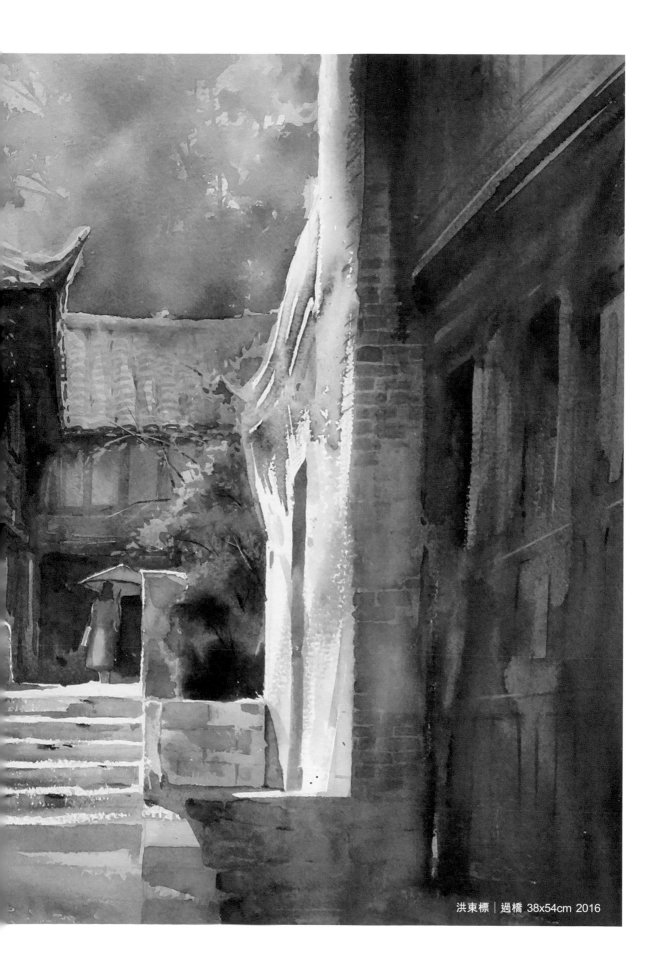

洪東標｜過橋 38x54cm 2016

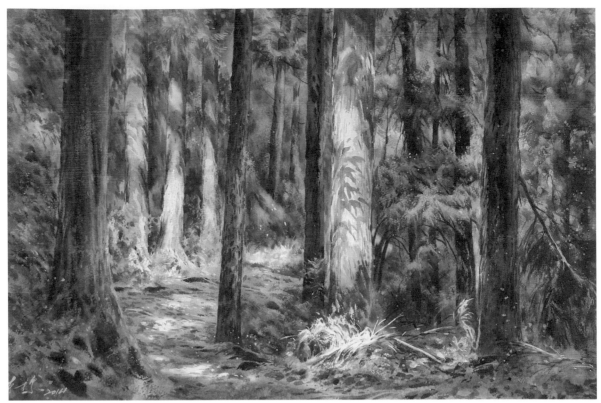

洪東標｜林間的光影 37x55cm 2014

洪東標｜鄉間福德祠 37x55cm 2016

洪東標｜搖槳的歲月 37x53cm 2015

洪東標｜白沙峽晨曦 55x75cm 2016

洪東標　記事編年錄

1955　● 出生於宜蘭市

1975　● 進入臺灣師大美術系就讀

1978　● 入選三十二屆全省美展

1979　● 師大美術系畢業美展水彩第二名

　　　　獲全國青年寫生比賽第二名

1980　● 三十四屆全省美展水彩獲台南市獎（第四名）

　　　　第一次個展於台北市龍門畫廊

1982　● 獲憲兵文藝金荷獎、新文藝金像獎

　　　　應邀參展台南市「千人美展」

1983　● 獲第十屆全國美展水彩類佳作獎

　　　　「當代畫會」與王福東、許自貴、李俊賢、黃銘祝聯展於美國文化中心

　　　　應邀參展「台北市立美術館開館特展」

1984　● 三十八屆全省美展獲首獎—省政府獎，首獎作品「古典的懷思」在馬公輪事件中落海

　　　　應邀新象藝廊參展「精銳水彩展」

1985　● 三十九屆全省美展獲優選獎

　　　　「當代畫會」（第三波）第二次主題展 —「污染」於台大

　　　　「來自龍泉街的畫家」聯展於福華沙龍

1986　● 應邀中.日.韓水彩畫交流展於歷史博物館國家畫廊

　　　　參展第十一屆全國美展

　　　　應邀「青年秀水彩」聯展於福華沙龍

　　　　應邀大韓民國漢城「亞運會亞洲水彩畫家邀請展」

1987　● 教育部文藝創作獎獲佳作獎

　　　　應邀參展第二屆亞洲水彩畫展於台北市立美術館

1988　● 應邀參展省立美術館開館特展「中華民國美術發展展」

　　　　應邀參展亞洲水彩畫展馬來西亞－吉隆坡

1989　● 第二次個展於台北市皇冠藝術中心、第三次個展於桃園中壢藝術館

　　　　應邀參展亞洲水彩畫展於泰國－曼谷亞洲水彩畫展

　　　　應邀參展全國水彩畫大展於台中省立美術館

1990　● 「歐洲風光繪畫展」於福華沙龍

　　　　四季美展「夏之歌」聯展於藝術教育館

　　　　應邀參展亞洲水彩畫展於韓國漢城

1992　第十三屆全國美展邀請展出

1993　「水漣漪‧彩激盪」聯展於首都藝術中心並追隨李焜培教授創辦「水彩雜誌」

1994　應邀參展亞洲水彩畫展於印尼－巴里島

　　　中美澳水彩畫邀請展於中正藝廊

1995　泰國－曼谷—亞洲水彩畫展

　　　應邀「全省美展五十週年特展」於國立台灣美術館，作品「古典的懷思」被典藏

1996　台北翡冷翠藝術中心—H2O 水彩畫聯展

　　　應邀參展亞洲水彩畫展於香港

1997　應邀參展亞洲水彩畫展於新加坡

1998　應邀參展台中市文化中心十五週年館慶「全國水彩邀請展」

2000　應台北縣文化基金會邀請，第四次個展，出版「疊染光影」畫輯

　　　應邀參展亞洲水彩畫展於台北中正藝廊

2001　擔任台北縣美展水彩類評審委員、新莊美展評審委員小組召集人

　　　第五次個展「女人真美麗」於輔仁大學藝術中心

2003　應邀參展亞洲水彩畫展於台灣澎湖

　　　獲遴選為 2003 屏東縣半島藝術季畫家（2004、2007 三度獲選）

2004　應邀參加歷史博物館 「玉山風華」特展

　　　擔任高雄獎美展評審委員

　　　應邀參展國際水彩畫大展於新竹縣美術館

2005　應邀參展第十七屆全國美展，擔任水彩類評審委員，評審感言撰稿人

　　　應邀舉辦洪東標、曾己議水彩雙人展於台北縣議會

　　　應邀參加「十大名家畫帝寶」作品永久陳列於台北市帝寶名廈

　　　擔任台北縣美展、高雄市美展評審委員

2006　創立中華亞太水彩藝術協會並當選第一任理事長

　　　協辦歷史博物館「風生水起」國際華人水彩經典大展與創作研討會

　　　與謝明錩、楊恩生聯合出版著作：「水彩生活畫」藝風堂出版社

　　　應邀參展福華沙龍「黃金秋色」聯展〈梁丹卉、謝明錩、洪東標、楊恩生、陳品華〉

　　　應聘玄奘大學視覺傳達設計系教授水彩課程

　　　應邀參展「中國水彩百年大展」，代表台灣畫家發言於北京中國美術館

2007　第六次個展於新莊文化藝術中心「2007 疊染光影」、「擁抱自然」雙主題展並
　　　出版專輯

　　　出版著作「旅人畫記」、「水彩小品輕鬆畫」藝風堂出版社

　　　策展中華亞太水彩藝術協會於玉山國家公園「河海山林」特展

第七次個展「洪東標的自然主義」於台北市官邸藝文沙龍

2008　　當選中華亞太水彩藝術協會第二任理事長

策展「台灣森林之美」水彩展於中央、交通、淡江、弘光、台師等大學

策展玉山國家公園處慶「塔塔加步道之美」水彩展

應邀參展「雪霸百景之美」於中正紀念堂

應邀參展「台灣當代水彩大展」

第八次個展「玉山行旅、寧靜的夜」於國父紀念館，並出版專輯

擔任歷史博物館、國立台灣美術館「台灣水彩一百年」大展籌備委員

2009　　策展新竹市「印象風城」水彩展

策展「戰地鐘聲」馬祖百景之美特展，馬英九總統親臨主持開幕式

應邀參展「台灣水彩經典」大展於中正紀念堂

第九次個展「月夜」於新莊客旅

擔任高雄市美展「高雄獎」水彩類評審委員

參展中國「中國第十一屆全國美展」獲台、港、澳區優秀獎，並於北京展出

2010　　策展「水彩的壯闊波濤」兩岸水彩交流展暨創作研討會於台北中正紀念堂

擔任「玉山獎」、「新莊美展」水彩類評審委員

福華沙龍聯展「水彩的中堅力量」—謝明錩、洪東標、黃進龍、簡忠威、程振文

獲頒中國文藝協會 52 屆文藝獎章

2011　　第十次個展於長庚大學藝術中心「尋幽系列」

擔任台中市美展大墩獎、台東美展評審委員

2012　　完成機車環島寫生，十月舉辦第十一次個展「哇福爾摩沙」台灣海岸百景之美展

出版「哇福爾摩沙」專輯、「56 歲這一年的 56 天」專書。

台灣創價學會「綠野尋蹤—洪東標的水彩世界」第十二次個展雲林、台南、台北、台中巡迴展

擔任竹塹獎評審委員

2013　　中央大學藝文中心 哇福爾摩沙台灣海岸百景之美個展

應邀參展「台澳水彩交流展」於台中、雪梨

應邀參展 2013 土耳其世界水彩畫展

應邀參展莞城美術館水彩邀請展

2014　　第十三次個展「帶著畫箱去旅行」於台北市吉林藝廊

出版「帶著畫箱去旅行」專書

應邀參展泰國 2014 世界水彩畫展於泰國曼谷美術館

應邀參展「中國第十二屆全國美展」台、港、澳區展於遼寧省美術館

擔任竹塹獎、玉山獎、新北市美展評審委員

應邀參展「泰風光」水彩畫展於泰國曼谷，及台北市國父紀念館

榮登外交部對世界發行「台灣觀察」英文雜誌專文介紹

第十三次個展「斯土斯情」於台北市第一銀行總行藝廊

應邀參展中國青島國際水彩雙年展，作品「幽林小徑」為中國水彩博物館典藏

2015　應邀參展中國水彩發展研究展於北京市中國美術館

五月應邀出席土耳其國際水彩嘉年華

獲選為中華亞太水彩藝術協會副理事長、台灣國際水彩畫協會常務理事

獲邀擔任 IWS.TAIWIN 負責人

七月應邀參展「台灣水彩的人文風景譜系」於 Tanri Gallery, New York

九月應邀在行天宮圖書館舉辦第十四次個展「大地擷萃 2015」洪東標水彩個展

主編水彩專書「水彩解密—名家創作的赤裸告白」由郭木生文教基金會出版發行

應邀參展「台灣當代水彩的 15 個面向」於郭木生文教基金會

策展「彩繪國際」世界水彩百大名家聯展於台北新光三越、高雄大東文藝中心

應邀於澳門埋工大學進行水彩與創作專題講座

應邀參展兩岸四地水彩展於澳門，並出席第七屆兩岸藝術論壇

2016　中華亞太正式會員聯展於台北市郭木生文教基金會

第十五次個展於台北市「保安捌肆」小品展

應邀參展泰國國際水彩菁英展

策展台灣 50 水彩展於台北市「築」空間藝廊

以 IWS.TAIWAN 會長身分策展「2016 台灣世界水彩大賽」於台北中正紀念堂

卸任 IWS.TAIWAN 會長

接任台灣國際水彩畫會副理事長

參展新北市現代藝術創作協會年度會員展於新北市新莊藝文中心

策展當代水彩畫研究展於台北市吉林藝廊

主編出版「水彩解密 2—水彩名家的赤裸告白」

2017　應邀參展嘉義梅嶺美術館西畫聯展

獲選代表台灣，以作品「大屯山向晚」參展義大利法比亞諾世界水彩展

應邀擔任 2017 年全國美展水彩類複評委員

舉辦第十六次個展於台北吉林藝廊「2017 大地擷萃」

出版專書「大地擷萃—七章關於水彩藝術的見解」金塊文化出版

名家創作 2

大地擷萃
Hooker's Green *on* La La Land

作者	洪東標
協力撰文	謝明錩
繪圖作品	洪東標
美術編輯	劉偉柔　陳品芳（落塵工作室）
文字編輯	洪伊柔
英文翻譯	許儀宇
校對	賴秋燕、許儀宇

發行人	王志強
出版者	金塊文化事業有限公司
地址	新北市新莊區立信三街 35 巷 2 號 12 樓
電話	02-22768940
傳真	02-22763425
電子信箱	nuggetsculture@yahoo.com.tw

匯款銀行	上海商業儲蓄銀行新莊分行（總行代號◎ 011）
匯款帳號	25102000028053
戶名	金塊文化事業有限公司

總經銷	商流文化事業有限公司
電話	02-22288841
印刷	鴻源彩藝印刷有限公司

初版	2017 年 5 月
ISBN	978-986-94714-5-9（平裝）
定價	新台幣 600 元

國家圖書館出版品預行編目資料

大地擷萃 / 洪東標作 .-- 初版 .--
新北市：金塊文化 ,2017.05
192 面；19x26cm.--（名家創作；2）
ISBN 978-986-94714-5-9（平裝）

1. 洪東標 2. 藝術家 3. 水彩畫 4. 臺灣傳記

909.933　　　　　　　　106005871